CARAVAGGIO

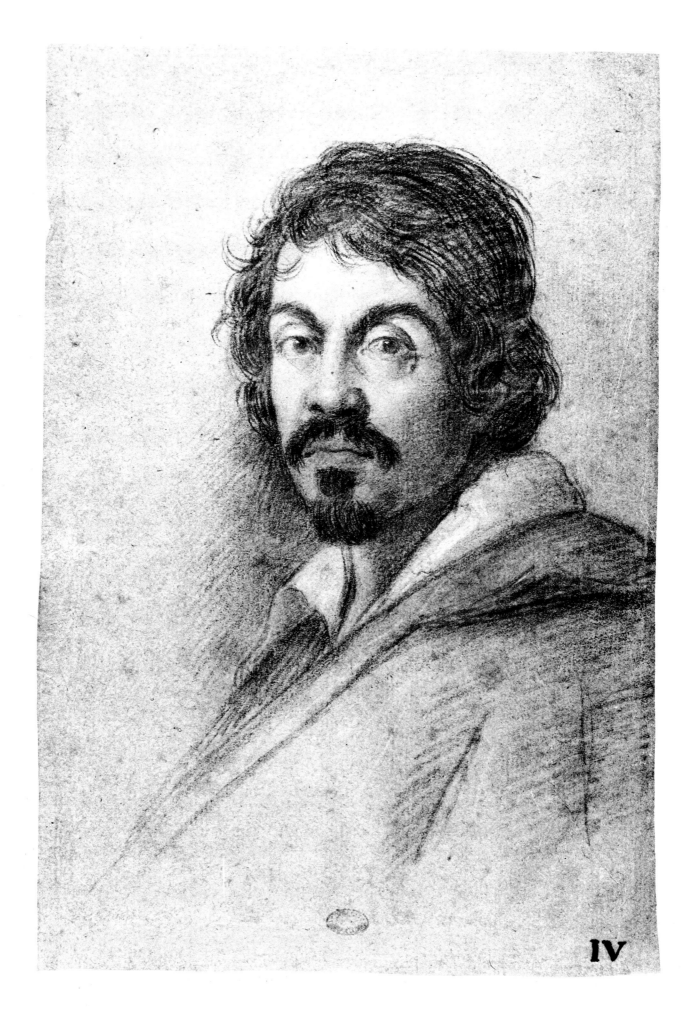

IV

CARAVAGGIO

Text by ALFRED MOIR *Professor of Art History, University of California at Santa Barbara*

HARRY N. ABRAMS, INC., Publishers, NEW YORK

To Edie and George, Stuart and Philip

Frontispiece: Ottavio Leoni. PORTRAIT OF CARAVAGGIO.
Black chalk and white. Biblioteca Marucelliana, Florence

Library of Congress Cataloging-in-Publication Data
Moir, Alfred.
 Caravaggio/text by Alfred Moir.
 p. cm.
 Bibliography: p.
 Includes index.
 ISBN 0-8109-3150-8
 1. Caravaggio, Michelangelo Merisi da, 1573–1610. 2. Painters—
Italy—Biography. I. Caravaggio, Michelangelo Merisi da,
1573–1610. II. Title.
ND623.C26M59 1989
759.5—dc19
[B]
 89–298

CONTENTS

Caravaggio *by Alfred Moir* 7

Colorplates

CARAVAGGIO

MICHELANGELO MERISI called Caravaggio (see frontispiece) died a few months before his thirty-ninth birthday, his known creative life having lasted less than two decades. During the eighteen years between his arrival in Rome and his death, he underwent the trials and enjoyed the pleasures of a young artist in a great cosmopolitan center, the triumph of spectacular success, the adventure of travel in unknown but welcoming lands, and the anguish of disgrace, exile, and a solitary death. He was exceptionally intelligent, he had ample opportunity to exercise his artistic powers, he enjoyed the protection of exalted patrons, and he usually was generously paid. Yet his personality was alienated, he was sexually ambiguous, and during most of his maturity, he was remarkably ill-behaved.

Nonetheless, he painted some of the most moving religious pictures in the history of Western art. Their worth has only recently been recognized. Already controversial during his lifetime, for three centuries afterward they were consistently scorned by informed critical opinion. His contemporary, the painter-historian Giovanni Baglione (1571–1644), wrote in 1642 that he had "ruined the art of painting." John Ruskin in the nineteenth century discovered in his work ". . . horror and ugliness and filthiness of sin." Somehow, however, most of his paintings were preserved. Today they are more universally admired than those of any other Italian artist after Michelangelo Buonarroti and before Tiepolo, and as much as those of the other giants of the seventeenth century, Rubens, Rembrandt, Velázquez, and Vermeer.

Caravaggio did not leave much behind; the forty color-plates in this book include most of the surviving works accepted by every Caravaggio expert as autograph, and even the least demanding would add perhaps a dozen more. If quantitatively this *oeuvre* is small, qualitatively it is nearly limitless. This high quality is partly the result of his using assistants rarely or not at all. If a painting is an authentic Caravaggio, from beginning to end it is by his own hand. More important, it is the product of his own remarkable mind.

H E WAS PROBABLY BORN IN MILAN during the late summer or early autumn of 1571. His parents, Fermo Merisi (c. 1540–1577) and Lucia Aratori (died 1590), had been married on January 14 of that year, and he was the first of their four children. For several generations the Merisi family had lived in the small Lombard town of Caravaggio, about equidistant from Cremona, Brescia, and Bergamo; probably the artist adopted that town name as his own when he went to Rome. His father worked as a builder for the marchese of Caravaggio. Until Caravaggio was five, he lived with his family in Milan, where the marchese maintained his principal residence. But by 1576 he had been sent back home to Caravaggio to escape the menace of the plague in the city. The rest of the family followed the next year, and in October the boy's father died.

Michelangelo grew up in the town of Caravaggio. The family was neither poverty-stricken nor without some standing. The father had been a favorite retainer in the marchese's household and had left considerable property in and around the town of Caravaggio. His brother Ludovico was a priest in Rome and his second son, Giovanni Battista, studied theology at the Jesuit college there before being appointed subdeacon to the bishop of Bergamo in 1599.

Caravaggio probably had more than a minimal formal education. He certainly was taught the catechism, to read and write, and to do sums; he may have had some competence in Latin. His artistic education began in April, 1584, when he was apprenticed to Simone Peterzano (active 1573–96), a competent Milanese painter who was moderately successful but so undistinguished that he would scarcely be remembered except for his pupil. Peterzano signed himself as a follower of Titian, but his style was as much Lombard as Venetian. In 1585 he was in Rome, and his young apprentice might have accompanied him, although no trace of such a visit has been discovered. Apprenticeship to an artist followed a long-established tradition, and there is no reason to suppose that Caravaggio's was exceptional. He surely learned how to draw and to paint in oil and fresco; he would also have been taught anatomy and perspective, the representation of space, light, and shadow, and the manipulation of color.

Some of Caravaggio's experiences in Milan may have been less wholesome. It was a notably lawless city, and the

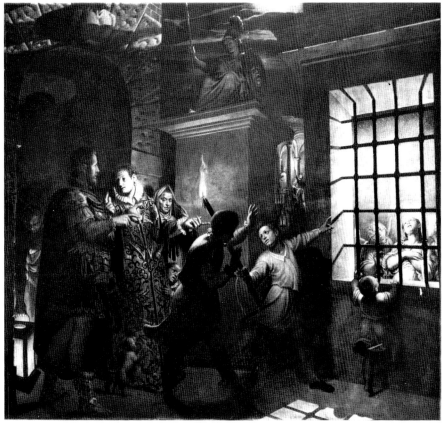

1. Antonio Campi. THE VISIT OF THE EMPRESS FAUSTINA TO SAINT CATHERINE IN PRISON. *1583. Oil on canvas. Church of Sant'Angelo, Milan*

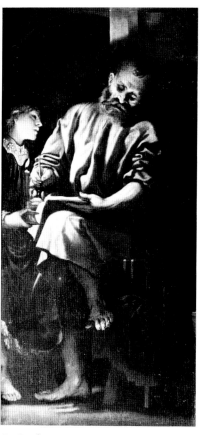

2. Girolamo Romanino. THE INSPIRATION OF SAINT MATTHEW. *1521. Oil on canvas. Church of San Giovanni Evangelista, Brescia*

adolescent artist may have acquired there the taste for violence and the disdain of authority that were to mar his adult years. The most reliable of his seventeenth-century biographers, Giovanni Pietro Bellori (1613–1696), alleges that some criminal difficulty forced him to flee the city, but no reference to him appears in the Milanese police records.

When Caravaggio completed his apprenticeship, in

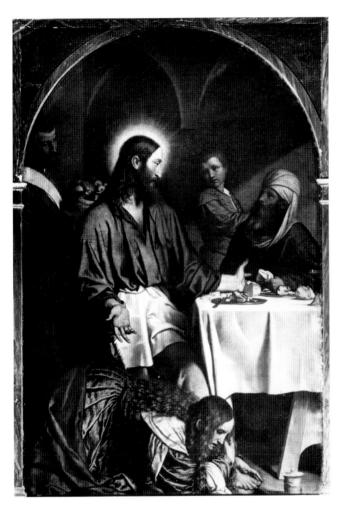

3. Moretto da Brescia. CHRIST IN THE HOUSE OF SIMON. *c. 1550–54. Oil on canvas, 90⅝ × 55⅛". Church of Santa Maria Calchera, Brescia*

1588, he was seventeen years old, too young to expect to set up his own atelier. Documents pertaining to the family property place him in the town of Caravaggio annually from 1589 to 1592, but it was too small to provide a bright young artist much support, or much to interest him. So it is likely that he traveled in Lombardy and the Veneto, even as far as Venice, as Bellori reported, picking up whatever jobs and commissions he could.

On May 11, 1592, final division of Caravaggio's parents' estates was made, his mother having died in 1590. His share was 393 *lire imperiali,* a sum large enough to support him

quite comfortably for a year or two. He must have taken it and set off for Rome. No attempt has ever been made to trace his route. Most travelers followed the ancient Via Emilia from Milan through Parma to Bologna, over the mountains to Florence, and then either through Siena or Arezzo to Rome. The Spanish painter Jusepe de Ribera was to follow this route in 1616, and probably Caravaggio did the same.

His material possessions could no doubt be carried in a knapsack on his back and in a wallet. What he possessed in his mind was not so scanty. As an apprentice in Milan, in addition to acquiring the painter's basic skills, he seems to have developed skill in portraiture and still life. And during his years of study and travel in North Italy he acquired familiarity with the work of the principal painters there, living and dead. He absorbed their manner of painting light: as a rather curious and labored mannerism in Antonio Campi's experiments with artificial sources—the most ambitious having been painted in Milan just a year before Caravaggio arrived (fig. 1); as lyrical revelation in the *oeuvres* of Girolamo Romanino, Moretto da Brescia, and Giovanni Savoldo (figs. 2–4); and as dramatic force in Jacopo Tintoretto's (fig. 5). He discovered the intimate flash of insight into personality to be found in Lorenzo Lotto's portraits— he might even have seen the *Portrait of a Boy with a Book* (fig.

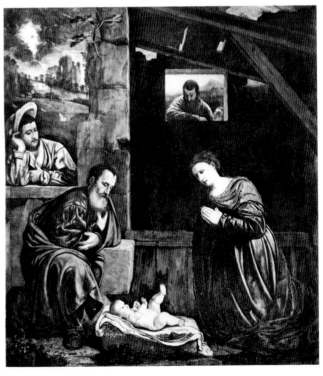

4. Giovanni Savoldo. THE ADORATION OF THE SHEPHERDS. *c. 1535. Oil on panel, 75¼ × 70⅞". Galleria Martinengo, Brescia, from the church of San Barnaba*

5. Jacopo Tintoretto. THE MIRACLE OF SAINT MARK AND THE SLAVE. *1548. Oil on canvas, 13' 9½" × 17' 9". Accademia, Venice*

6), then in Bergamo—and must at least have seen the ennobling grandeur of Paolo Veronese's and Titian's portraits (figs. 7, 8). He had the opportunity of studying composition, some of it as simple as Giorgione's genre groups (see fig. 9), much of it borrowed by such artists as Peterzano, Ambrogio Figino, and Jacopo and Francesco Bassano (fig. 10) from their betters, and some of it very grand and powerful, as in Titian's narrative paintings (see fig. 11), or Tintoretto's lively crowds, or even Raphael's giant cartoon for the *School of Athens* (still in the Ambrosiana in Milan), which came into Cardinal Federico Borromeo's possession in 1610 from some of his Milanese kinsmen.

He recognized that the daily pastoral experiences of his youth in the country were worthy of the dignity of art, inspired by seeing such charming details as the basket of roses and fruit in Bergognone's altarpiece (fig. 12), by Jacopo Bassano's discovery of the poetry of the familiar, by Savoldo's respect for the sober old and his affectionate appreciation of the simple, and by Vincenzo Campi's pan-

6. Lorenzo Lotto. PORTRAIT OF A BOY WITH A BOOK. *c. 1525–26. Oil on panel, 13¾ × 11". Civiche Raccolte d'Arte, Castello Sforzesco, Milan*

oramic displays of farm produce. He no doubt studied North European still lifes too (see fig. 13). En route to Rome, he would have been exposed to the wealth of art in Emilia and Tuscany, not only such paintings as Pellegrino Tibaldi's in Bologna and Federico Zuccaro's in Florence (fig. 14), but also such great sculptures as Michelangelo's *Victory* (fig. 15). Impressionable as he was, he responded to much of what he saw and stored it away in his memory for future reference. Reminiscences that appear much later in his career—of Nicolo Moietta's altarpiece in the town of Caravaggio (fig. 16), of Giulio Campi's *Burial of Saint Agatha* (fig. 17), of Moretto's *Conversion of Saint Paul* (fig. 18), and of Ambrogio Figino's unique *Madonna of the Snake* (fig. 19)— make clear how retentive his mind was, how vast a store of imagery it contained, and how much he used it.

Probably Caravaggio arrived in Rome by the autumn of 1592. By modern standards, its population was small; in 1600, just 109,729. It was a spacious, handsome city despite recurring natural catastrophes—flood, famine, and the plague—with a benign if absolute local government, and a tranquil, prospering, increasing population. Naples and Venice were larger, and Florence and Milan were more important commercially, but most roads still led to Rome.

The Church dominated the city. The papal dominion occupied all of central Italy, and despite the advent of Protestantism, the pope was still the preeminent religious leader in Christendom, and Rome, as the papal capital, remained a focal point of European diplomatic activity and intrigue. As an artistic center it was unrivaled. Rare indeed the European artist of promise who did not feel the need to visit the city. Most did, the few notable exceptions being mainly in the Protestant North.

Rome was cosmopolitan. Few artists active there were native. Most had come both to study and to find patronage. Their patrons went there to find the latest art by the best artists. Although Caravaggio did not enjoy the favor of the newly elected pope, Clement VIII Aldobrandini (r. 1592–1605), or of his family, he profited from the support of those who did. Once he had established himself, they vied for his services.

It was a small world. By 1603 Caravaggio could state that he knew nearly all the painters there, and his acquaintance-ship extended much further. For it was also a multifaceted world. The pope and his court formed the center. But there were many other circles—ecclesiastical, ambas-sadorial, aristocratic, commercial, and intellectual—and they overlapped. Caravaggio had contact with all of these groups. His patronage came from rich individuals and religious establishments. He belonged to the Accademia di

San Luca and had many friends among the literati, as individuals and as members of such associations as the Accademia degli Insensati. Its membership was small but varied: Cardinal Pio, Monsignor Maffeo Barberini (the future Pope Urban VIII), the poets Aurelio Orsi and Gaspare Murtola, and the painter Giuseppe Cesari called the Cavaliere d'Arpino (1568–1640). Other friends in-cluded the poet-courtier-adventurer Giovanni Battista Ma-rino and the jurists Marzio Milesi and Andrea Ruffetti. Caravaggio arrived in Rome while Saint Philip Neri was still alive, and although he probably never heard him preach, he was certainly responsive to the popular revival-ist teaching of the Oratory the saint had founded. Asso-ciations with the intellectual community continued throughout Caravaggio's life—in Syracuse, for example, he

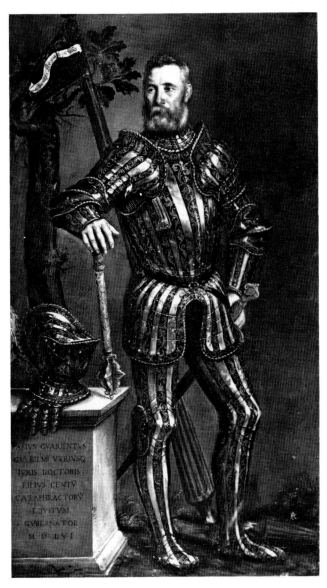

7. Attributed to Paolo Veronese. PORTRAIT OF PASE GUARIENTI. *1556. Oil on canvas, 78¾ × 45¼". Museo del Castelvecchio, Verona*

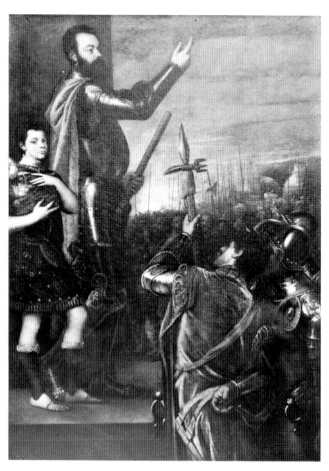

8. Titian. PORTRAIT OF ALFONSO D'AVALOS, MARCHESE DEL VASTO WITH HIS SON. *1540–41. Oil on canvas, 87⅞ × 65″. The Prado, Madrid*

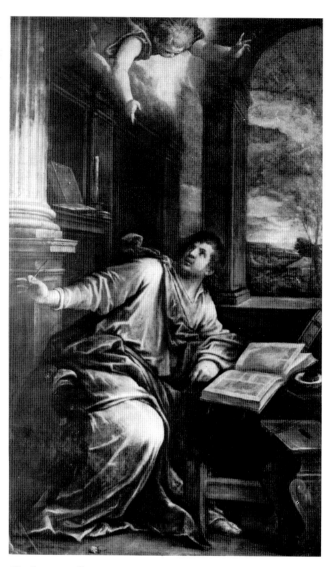

10. Francesco Bassano. THE INSPIRATION OF SAINT JOHN THE EVANGELIST. *Oil on canvas, 8′ 5″ × 5′ 1″. By courtesy of Birmingham Museum and Art Gallery, Birmingham, England*

9. Giorgione. THE CONCERT. *Oil on canvas, 30 × 39″. Hampton Court. Copyright Reserved, United Kingdom*

was friendly with the archeologist-litterateur Vincenzo Mirabella. Bellori's statement that Cardinal Francesco Maria del Monte (fig. 20) "gave him an honored place in his household with his gentlemen" indicates that whatever a terror Caravaggio may have been in the streets of Rome, he was not that in the cardinal's *salone.*

When he arrived in the city he was just twenty-one. He may have dreamed of future success, but to a casual observer he must have seemed unexceptional among the scores of talented unknown youngsters appearing every year with lots of hope and little else. Precisely what happened to him, and when, no one bothered to record. Thus his chronology poses knotty problems: from 1592 until 1599, it is without a single firm date and can be reconstructed only hypothetically, on the bases of stylistic analysis and of the events mentioned by his biographers.

Baglione describes him as needy and ragged. But he was not without resources. He was an able portraitist and still-life painter. He may have saved some of his inheritance, although it could not have lasted long, and chances are that he was improvident.

Perhaps his uncle Ludovico housed him when he arrived and found him his first patron, Monsignor Pandolfo Pucci (c. 1530–1614), a Vatican lawyer from Recanati. Pucci was not the ideal patron. He required his young *protégé* to copy devotional images that he sent back to Recanati, where they were soon lost and forgotten. Caravaggio named him "Monsignor Insalata" because he fed him nothing but salad for supper. Caravaggio soon left. He found work with two hack painters who have disappeared from history, and he ground out three heads a day for one and potboilers for the other. He made contact with an art dealer near San Luigi dei Francesi, Valentino, who paid him miserable prices but may have publicized his work. He made some friends: a fifteen-year-old painter from Syracuse, Mario Minniti (1577–1640), who had arrived in Rome soon after him in December, 1592, and who remained his companion and perhaps his helper until 1600; Bernardino Cesari (1571–1614), the younger brother of the cavaliere and as prone to escapade as Caravaggio himself; and Prospero Orsi (c. 1558–1633) called Prosperino delle Grottesche, a painter of ornamental friezes, garlands, and the like (see fig. 21), who helped Caravaggio establish himself.

Caravaggio certainly was poor. Judging from such pictures as *The Little Bacchus* (colorplate 2), however, life was amusingly Bohemian, carefree, and rich with pleasures that cost little or nothing, rather like the pre-Beat generation that centered on the Piazza di Spagna in the Roman days of Tennessee Williams. It was not without incident. Caravaggio was kicked by a horse, probably in 1593, and convalesced in the Ospedale della Consolazione. He was treated kindly there and painted some pictures for the prior. They have disappeared, but we can guess that they were modest—still lifes, charming genre, and a portrait or two. None of his youthful portraits has been identified. The sitters were humble, an unknown innkeeper and the like, and no doubt their identities, and the artist's, were soon forgotten, and the pictures came to be considered simple anonymous genre. The *Boy Peeling Fruit* might have been such a portrait—of Minniti, Bernardino Cesari, or some other friend. Many copies of it still exist although the original has never been found. Its ambiguity—is it a portrait or genre?—persisted throughout Caravaggio's career, in genre painting that was allegorical and religious painting that seemed to be contemporary genre.

11. Martin Rota after Titian. THE DEATH OF SAINT PETER MARTYR (*engraving after a destroyed painting formerly in the church of Santi Giovanni e Paolo, Venice*). The Metropolitan Museum of Art, New York City. Purchase, Joseph Pulitzer Bequest, 1917

12. Ambrogio da Fossano called il Bergognone. THE MADONNA ENTHRONED WITH SAINTS AND DONOR (*detail*). *c. 1480–85. Panel. Ambrosiana, Milan*

Gradually Caravaggio built up a little reputation and his circumstances improved. Sometime during 1593 or 1594 the Cavaliere d'Arpino, who was the most stylish late Mannerist artist in Rome, hired him to paint fruit and flowers. He lived with the D'Arpino brothers only eight months or so, but they brought him into contact with a sophisticated circle, and he did not leave the atelier untouched. Traces of the cavaliere's influence on his art persisted for years, for example in the Holy Family in the *Rest on the Flight to Egypt* (see fig. 22 and colorplate 8) and in the angel in the first *Inspiration of Saint Matthew* (figs. 53 and 62).

Sometime in 1594 Caravaggio found a rich and wellborn new patron, Monsignor Fantino Petrignani (1540–1600), a high-ranking Vatican official. Caravaggio painted *The Fortune-Teller* (colorplate 3) while under his protection, and probably as a pendant, *The Cardsharps* ("*I Bari*"; it has recently been rediscovered and is known through more than fifty copies and variants; see fig. 24). Based on a Holbein print (fig. 25), according to the German artist-historian Joachim Sandrart (1608–1688), *The Cardsharps* caught Cardinal del Monte's eye, perhaps alerted by Valentino or Prosperino, and he took Caravaggio into his service. When Caravaggio moved into Del Monte's residence in the Palazzo Madama about 1595, his fortune was all but made.

Francesco Maria Borbone del Monte had been born in Venice in 1549, into a patrician family from the Marches. Elevated to the cardinalate by Sixtus V in 1588, shortly before his distant cousin, Henri IV of Navarre, came to power in France (1589–1610), he served as the Medici representative in Rome, surrounded by a coterie of young artists, musicians, and literati. When he died in 1626, his estate included eight Caravaggios. *The Fortune-Teller* and the *Bari* he had bought. The *Youth with a Ram* (colorplate 23) he had been bequeathed. The five others he must have commissioned—a lost *Carafe of Flowers, The Musicians* (colorplate 4), *The Lute Player* (colorplate 5), *The Ecstasy of Saint Francis* (colorplate 6), and the *Saint Catherine of Alexandria,* as well as the *Jupiter, Neptune, and Pluto* ceiling (colorplate 11) in his villa. To this number the *Bacchus* (colorplate 10) can be added. Two other paintings, the *Magdalene* (colorplate 7) and the *Rest on the Flight* (colorplate 8), must have been painted during the first three or four years that Caravaggio was with Del Monte, but both were in other collections when the cardinal died.

The earliest of these Del Monte paintings, *The Fortune-Teller* and *The Cardsharps,* should not antedate 1594. The latest—the *Saint Catherine*—must have been completed by the end of 1598. During these four or five years Caravaggio

13. Jan Brueghel. STILL LIFE OF FLOWERS IN A GLASS. *Oil on copper, 17 × 11¾". Ambrosiana, Milan*

14. Federico Zuccaro. BACCHUS. *1584–85. Fresco. Casa Zuccaro, Florence*

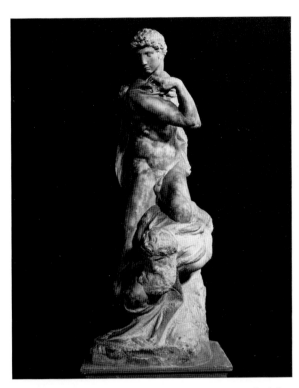

15. Michelangelo. VICTORY. *1527–28. Marble, height 8' 6¾".
Palazzo della Signoria, Florence*

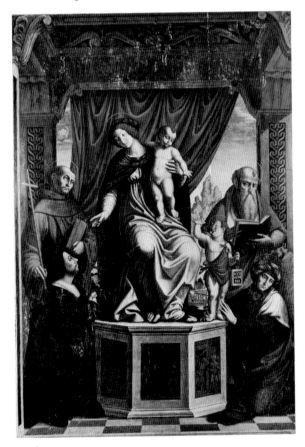

16. Nicolo Moietta. THE MADONNA AND CHILD WITH
INFANT SAINT JOHN THE BAPTIST, SAINTS FRANCIS, JEROME,
AND ELIZABETH, AND THE DONOR. *1521. Oil on panel,
80¾ × 57⅛". Hospital, Caravaggio, formerly in the church of San
Bernardino*

increased his range to include multifigure, full-length, and
religious paintings. He liberated his figures from any linger-
ing trace of confinement by the flat plane that the picture
actually is and learned to represent them as convincingly
solid in convincingly three-dimensional space; in the latest
works he turned from daylight to artificial light. He mas-
tered illusionism. And his figures began to be monumental.

The Del Monte pictures form a coherent group. Theirs
is a natural, unpretentious world of mute poetry, youthful
not only in the age of the models but also in its sense of
recent and intoxicating discovery, in the frequency of
themes of love, and in the volatility and the range of its
moods. It is a charming world—even *The Fortune-Teller* and
The Cardsharps are playful rather than sordid—delightful in
its color and light, and full of beautiful objects. It is rather
too good to be true: the prettily dressed, graceful young
people may pretend to be ordinary but they are too un-
flawed to be quite real. Most of it is on the surface;
emotions are fleeting, and if disappointment may appear,
tragedy does not. It has no past, an existential present, and
an undaunting future.

These pictures do raise the question of the content of
Caravaggio's *oeuvre* and the intellectual processes used to
formulate it. Far more may be in them than meets the eye,
and their apparently straightforward images may conceal
symbolic meaning. The hypothesis that Caravaggio's secular
paintings disguise Christian content is disconcerting. If
they do form a kind of visual acrostic, Caravaggio did not
permit their secret meanings to compromise what they
appear to be. They suffer from no visual inconsistencies;
nor do they include any editorial comments as clues to
symbolic intent. Whatever recondite symbolism may be
concealed within them is so inaccessible as to be hardly
relevant.

The relatively simple symbolism that is apparent in the
Bacchus, The Lute Player, and comparable pictures, Caravag-
gio might have picked up from other works of art or from
literary sources. The likeliest of these, Cesare Ripa's *Ico-
nologia,* had just been published in Italian in 1593, and had
no illustrations that might have directed or inhibited Cara-
vaggio's metamorphosis of its words into his own visual
images. Learned advice would, however, have been re-
quired for the more elaborate allegory of *Jupiter, Neptune,
and Pluto,* for any arcane symbolic meaning in the secular
paintings, or for the iconographic complexities of the *Saint
Francis,* the two *Inspirations of Saint Matthew* (colorplate 15
and fig. 53), or *The Madonna of the Snake* (colorplate 29). This
kind of help was certainly available from Murtola, Milesi,
and Marino, from members of Cardinal del Monte's circle,

and from the clergy with whom Caravaggio may have been in contact. To whatever extent he took advantage of it, he produced pictures that may secretly be recondite but are openly as direct as the *Bacchus* or as blunt as the first *Saint Matthew*'s naked foot. Whatever his paintings may owe to scholarly advice, the realization of their content in memorable visual imagery was his own.

Caravaggio did not leave the Palazzo Madama, and Del Monte's protection, until 1600 at the earliest. However, none of the paintings he made during the year or so before the Contarelli Chapel in 1599 is listed in the posthumous inventory of the cardinal's collection, although stylistically all are close to the *Saint Catherine*. Del Monte gave the *Medusa* of 1600–1601 (colorplate 16) away, and perhaps gave or sold others. But as far as we know, the rest of Caravaggio's work from 1598 onward was commissioned by other patrons: the *Judith Beheading Holofernes* (colorplate 12), and perhaps *The Conversion of Mary Magdalene* for Ottavio Costa, a rich banker from Genoa; *The Calling of Saints Peter and Andrew* for Ciriaco Mattei; and *The Taking of Christ* (fig. 26) for Ciríaco's brother Asdrubale. Evidently Caravaggio's continued residence in the Palazzo Madama after he had completed the *Saint Catherine* did not require that he work primarily for Cardinal del Monte.

These post-Del Monte paintings were anticipated by the almost caricatural *Boy Bitten by a Lizard* (colorplate 9). The model appears to be the same as the *Bacchus* and the style of the drapery antedates his. But the forceful action, the sharp contrast between light and dark, and the sense of disillusionment already manifest Caravaggio's maturing style and personality. The picture marks Caravaggio's initial use of the intensely contrasting light and shadow that were to characterize his work for the rest of his life. Its violence reappeared in the *Judith* and the *Medusa* and occasionally during the following years until *The Sacrifice of Isaac* (colorplate 24) of late 1603. Its light system reappears in the *Saint Catherine*, the *Phyllis,* and the more ambitious *Judith.* These three paintings are also linked by Phyllis, who sat not only for her own portrait but also, without aging, for Saint Catherine and for Judith (see figs. 27–29), and perhaps for the newly converted Magdalene (fig. 30)—the least ambiguous instance of Caravaggio's use of the single contemporary model in several paintings, and the only instance where the model can be identified, however unspecifically.

Judith's relief-like composition of three-quarter-length figures must have pleased him. Probably its source was a palace wall fresco (fig. 31). He used it again in the two lost Mattei paintings, known through copies, presumably for its effect of confined mass in action. But relief space tends to

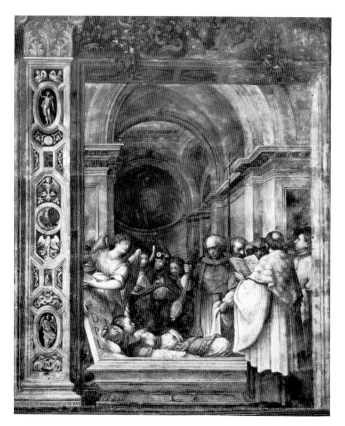

17. Giulio Campi. THE BURIAL OF SAINT AGATHA. *1537. Fresco. Cathedral, Cremona*

be nearly impenetrable, and he soon discarded it for the opening depth of the London *Emmaus* (colorplate 18) and the astonishing projecting effects of the Ambrosiana *Basket* (colorplate 17) and the *Medusa* (fig. 32). The *fattura* of all these later paintings is like the Del Monte pictures, still smooth and almost slick. But the charm of the Del Monte pictures has turned serious, and Caravaggio has begun his dedication to sober religious painting.

By the end of the 1590s he was already known to the *cognoscenti.* He was made famous by his first public commissions, in the Contarelli and the Cerasi chapels. The history of the Contarelli Chapel began in 1565, when a rich and influential French cleric, Monsignor Mathieu Cointrel (1519–1585; elevated to the cardinalate in 1583), known in Italian as Matteo Contarelli, obtained the patronage of a chapel in the French national church in Rome, San Luigi dei Francesi, just across a side street from the Palazzo Madama. At that time, Cointrel commissioned the Brescian artist Girolamo Muziano (1528–1592), who was active in Rome most of his adult life, to paint the side wall and ceiling frescoes and an altarpiece in oil, all commemorating his patron saint, the evangelist Saint Matthew. There is no record that any of these paintings were ever even begun.

When Cardinal Cointrel died, he left responsibility for

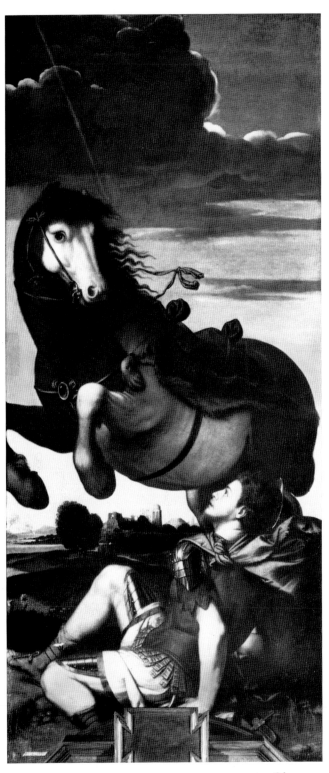

18. Moretto da Brescia. THE CONVERSION OF SAINT PAUL. *Oil on canvas, 10′ 11¾″ × 4′ 9½″. Church of Santa Maria presso San Celso, Milan, formerly in the Mint*

decorating the chapel and funds to pay for it to his executor, Virgilio Crescenzi, the senior member of an old Roman family long dedicated to and highly placed in the service of the church. In a note appended to his will, Cointrel also left the plan for the iconography of the decoration, taken from the first edition of the *Breviarum Romanum* (1568). The frescoes at the lower sides of the barrel vault were to represent the prophets Isaiah, Daniel, Ezekiel, and Jeremiah, and the one in the center Saint Matthew's baptism of the king of Ethiopia. The frescoes on the lateral walls were to represent the Calling and the Martyrdom of Saint Matthew, and the altarpiece, in oil on canvas, the saint's Inspiration. Except that the subject of the central panel of the vault was changed to Saint Matthew's resurrection of Iphigenia, the king's daughter, Cointrel's plan was followed.

In 1587 a contract was given to a Flemish sculptor, Jacob Cobaert (active 1568–1609), to carve marble figures of Saint Matthew and an angel as the altarpiece, instead of the oil painting originally specified in the will; and in 1591 the Cavaliere d'Arpino was commissioned the chapel frescoes. By the end of that year the stucco ornament of the chapel had been completed; two years later, in June, 1593, D'Arpino was paid for the vault frescoes. But at the end of 1596, the chapel remained boarded up, its decoration still incomplete. In a petition to the pope, the clergy complained that the Crescenzi family (Virgilio had been succeeded as executor by his son, the abbot Giacomo) was using the funds for its own purposes rather than for completion of the chapel. Six months later, after an investigation, the pope turned responsibility for the chapel over to the Fabbrica di San Pietro, the Vatican equivalent of a Ministry of Fine Arts and Public Works, of which Cardinal del Monte was a leading member. By 1599 D'Arpino had not yet begun the wall paintings, and on July 23 Caravaggio was commissioned to carry them out, but in oil on canvas instead of in fresco.

They were among the first Roman chapel wall paintings in oil (colorplates 13, 14), an innovation—quite possibly derived from similar gallery-chapels Caravaggio had seen in Venice—that would hardly have been acceptable without the influence of a sponsor as powerful as Cardinal del Monte. Caravaggio completed the paintings rapidly, but they were troublesome. X-rays of the *Martyrdom* show two previous versions underneath the final image (figs. 33, 34). The early versions recalled the fresco of *Saint Lawrence Among the Poor and Sick* that D'Arpino had painted in 1588–89 for the Roman church of San Lorenzo in Damaso: the figures were small and mannered; their poses histrionic; the compositions were rather two-dimensional and failed to focus on Saint Matthew; and the architecture was so prominent as to overwhelm the action. The *Calling* was begun after the first or the second version of the *Martyrdom*, and later underwent less drastic changes (fig. 35). Saint

Peter was added, Christ's raised arm was extended and his gesture transformed, and the other poses were adjusted slightly. Only after the *Calling* had been completed was the third—the present—version of the *Martyrdom* carried out. It must have been finished by July 4, 1600, when Caravaggio was paid.

Caravaggio had never before painted two such large pendant works for an architectural setting, although the ceiling at Cardinal del Monte's villa must have made him aware of the problems involved. He used several devices to unify the two paintings. All the figures are in the same scale, and the model for Saint Matthew even ages between his Calling and his Martyrdom. The light, from the right in the *Calling* and from the left in the *Martyrdom*, appears to enter both from the same source above the chapel altar. So the paintings are complementary.

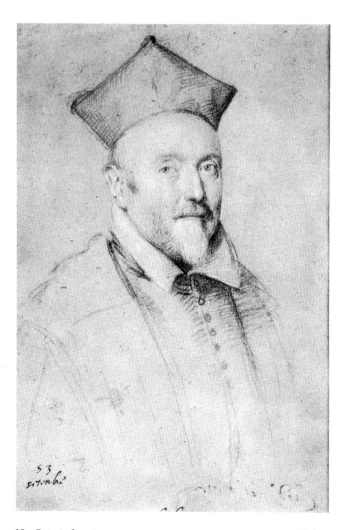

20. Ottavio Leoni. CARDINAL FRANCESCO MARIA DEL MONTE. *Black chalk heightened with white on blue paper, 9 × 6½". John and Mable Ringling Museum of Art, Sarasota, Florida*

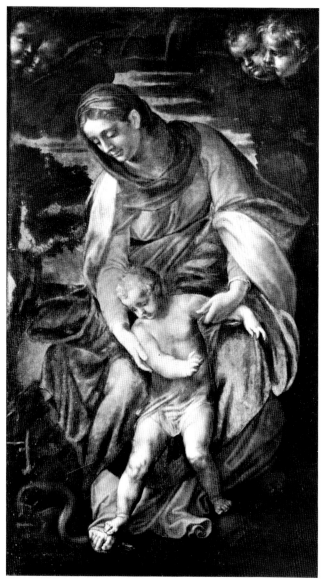

19. Ambrogio Figino. THE MADONNA OF THE SNAKE. *c. 1580. Church of Sant'Antonio Abate, Milan, formerly in the church of San Fedele*

Perhaps some of Caravaggio's difficulty in composing them derived from his effort to relate them to the space of the church as well as to each other. The chapel, the last at the east end of the left aisle, is so dark that the mid-seventeenth-century historian Francesco Scanelli complained that he could hardly see the lateral pictures. Now they are well lighted—perhaps too well. Originally the flickering candlelight would have intensified the effects of action in the *Martyrdom* and of surprise in the *Calling*. Caravaggio must have anticipated these effects. He had only to step across the street from his studio in the Palazzo Madama to study the light in the chapel and to imagine how it would fall on the paintings.

As he walked down the nave, he must also have been struck by the impact their locations in the chapel would have (fig. 36). Probably he consciously developed an anamorphic effect in the *Martyrdom*, realizing that it would be seen from an angle (fig. 37). Inside the chapel, the chrono-

logical sequence of events, from the *Calling* to the *Inspiration* to the *Martyrdom,* reads logically from left to center to right like a printed line. But the *Martyrdom,* the last historic event, is the first to be seen, while the *Calling,* the first event, becomes visible only at the entrance to the chapel. Taking this circumstance into account, he devised different compositions for the paintings. The depth and architectural vastness of the *Martyrdom* continue the actual space of the church into the painted space; the shallow confinement of the *Calling* brings the viewer up short, like the chapel itself. The former painting draws the worshiper into its action, and the latter engages him. Caravaggio's self-portrait in the *Martyrdom* (fig. 38) establishes the scene's actuality no less than does its continuity with actual space; Christ's position

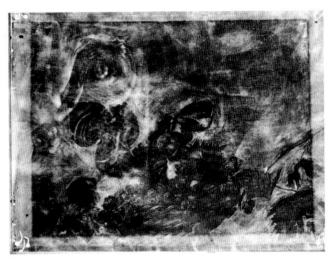

21. Attributed to Prosperino delle Grottesche. GARLAND OF PUTTI AND RINCEAUX *under* Caravaggio's BASKET OF FRUIT *(colorplate 17).* *X-ray. Ambrosiana, Milan*

at the altar end of the *Calling* causes his gesture to become an invitation not only to Saint Matthew but also to the worshiper. The first event, the call, is the last to be seen, and Caravaggio has established it as the climax of the narration, the event of preeminent significance. Because all three pictures are conceived as extending actuality, the *Calling* is not simply a record of the historical event of Saint Matthew's becoming an apostle, but it is also a contemporary appeal, following Oratorian teaching and methodology. The message is simple: the indispensable act for all Christians is, like Saint Matthew's, to accept Christ's summons.

Having obtained the commission through the influence of Cardinal del Monte, and in succession to D'Arpino, his former employer who had failed to carry it out, Caravaggio

must have been anxious to make a great success of it. Perhaps the envy implied by Federico Zuccaro's belittling comment that he saw in the *Calling* only Giorgione revisited manifests just how successful it was. Followed by a series of major public commissions, the project must have been recognized as an exceptional achievement, establishing the young artist as a major new force in contemporary painting.

The decoration of the chapel was not completed until 1602. In January of that year Cobaert at last delivered his marble Saint Matthew for the altar, although not the angel, and it was installed. The response to the statue was instantaneously negative and in a few days it was removed. The next month Caravaggio was put under contract to do the altarpiece, in oil on canvas as Cardinal Cointrel had originally intended. It was to be completed by Pentecost, which in 1602 fell on May 23. Caravaggio painted two versions on separate canvases. Baglione, and Bellori after him, report that the clergy rejected the first version as indecorous (see fig. 53), although in fact it was derived from the most respectable sources. They could see no sanctity in the yokel saint, and his naked foot—in effect projecting over the altar—must have distressed them, particularly when they elevated the Host. Bellori may have been too prim to point out also that the angel was disconcertingly androgynous and the saint apparently illiterate. There is good reason to doubt the historians' account of the rejection of this first version. Whether they were correct or not, Marchese Giustiniani acquired it for his own collection, and Caravaggio painted the second canvas, which remains today as the altarpiece (colorplate 15). He was paid for it on September 22, 1602.

The first sign of recognition of the success of the Contarelli Chapel lateral paintings was another public commission. In September of 1600, just two months after Caravaggio had been paid for the *Calling* and the *Martyrdom of Saint Matthew,* he signed another contract. It called for two paintings on cypress panels, to represent the Conversion of Saint Paul and the Crucifixion of Saint Peter, for a family chapel acquired earlier that year in the church of Santa Maria del Popolo by the papal general treasurer, Monsignor Tiberio Cerasi (fig. 39). Preliminary studies were to be submitted for the patron's approval, and the panels were to be completed within eight months. Just eight months later, in May, 1601, Cerasi died. Whether or not the paintings on cypress had been completed by then is unknown. Caravaggio was paid in November, 1601, for those now in the chapel (colorplates 19, 20), but they are a different pair, the same size but on canvas rather than on

wood. The original *Conversion of Saint Paul* on cypress still exists in the collection of Prince Odescalchi, Rome; the original *Crucifixion of Saint Peter* can only be imagined through a clumsy picture in Leningrad that may be a copy.

Caravaggio's canvases were painted for the lateral walls of the inner room of the chapel, the *Saint Peter* on the left and the *Saint Paul* on the right. Over the altar is Annibale Carracci's *Assumption of the Virgin,* the only other oil painting in the chapel. The ceiling frescoes, with subjects related to the wall paintings, were designed by Annibale and carried out by one of his assistants, Innocenzo Tacconi. The outer room of the chapel is slightly broader. It contains two sculptural memorials with portrait busts, on the left Tiberio Cerasi looking inward toward the *Conversion,* and on the right his father, Stefano, looking toward the *Crucifixion.* Overhead, frescoed in panels on a flat dome, are the Four Evangelists around the dove of the Holy Ghost, executed by Giovanni Battista Ricci da Novara (1537–1627). The altar of the chapel was not consecrated until 1606, so pre-

sumably the frescoes and possibly Carracci's altarpiece were not completed until then.

Probably Monsignor Cerasi had chosen the subjects of the paintings and the frescoes himself for their appropriateness in a mortuary chapel, and had designated the position

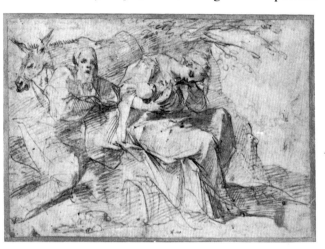

22. Cavaliere d'Arpino. REST ON THE FLIGHT TO EGYPT. *1591–97. Black chalk, 7¹⁄₁₆ × 9⅞″. British Museum, London*

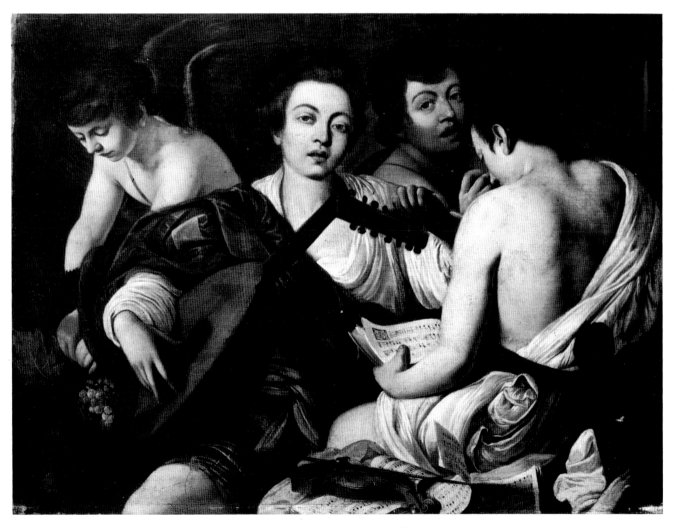

23. Copy of Caravaggio. THE MUSICIANS. *Oil on canvas. Private collection*

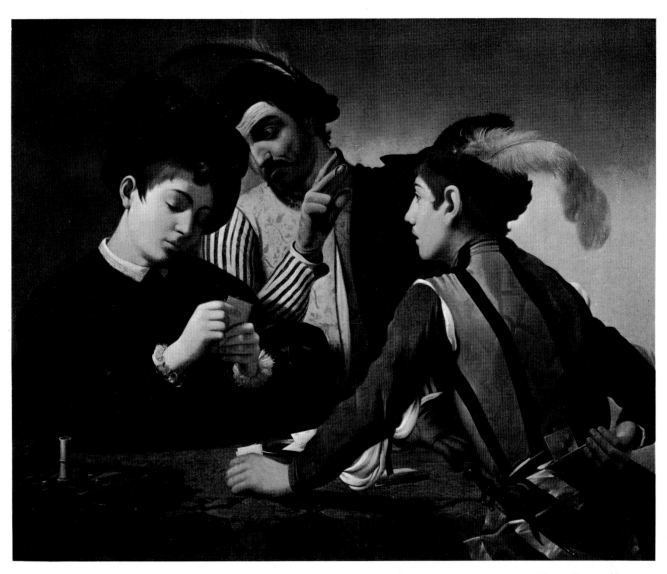

24. Copy of Caravaggio. THE CARDSHARPS ("I BARI"). c. 1594–95. Oil on canvas, 39 × 54". Private collection; the original is now in the Kimbell Art Museum, Fort Worth

of the monuments so as to integrate the chapel aesthetically and iconographically. The contract with Caravaggio specified the subjects, but left to his discretion inclusion of "all and sundry figures, images and ornaments which seem fit to [him]."

Although Saint Peter and Saint Paul, as patrons of Rome, often appear together, this combination of events in their lives has only one prototype, Michelangelo Buonarroti's huge frescoes in the Pauline Chapel in the Vatican, which Cerasi must have had in mind when he designated the subjects. For the most part Caravaggio avoided citing them in his final paintings. Both subjects offer the opportunity for crowd scenes, which Michelangelo used but Caravaggio did not. He reduced the number of figures, concentrating on the two saints as private persons rather than as participants in public events. Both are physically helpless, subject

to superior forces, and unresisting. The underlying theme uniting them is their translation from one world into another; Saint Paul's from the pagan and state-serving to the Christian and God-serving, Saint Peter's from the City of Man to the City of God.

In giving form to the subjects, Caravaggio again took into consideration the position of the paintings in the chapel space. He probably intended them to be seen from the triumphal arch opening from the transept to the chapel (see fig. 40), a distance of about seventeen feet. The large scale of the figures and their limited number, the simplicity of the compositions and their intensely focused effect, all make the images more visible. Quite possibly these paintings, like The Martyrdom of Saint Matthew, were composed to be anamorphic, and for the same reason, that they would usually be seen at an angle from the entrance to the chapel.

Hence the prominence of the soles of Saint Peter's feet, and the recessive diagonal of Saint Paul's body from the right foreground to the left, following (or establishing) our direction of regard from beyond the chapel precinct. By half-opening this book and looking at the colorplates of these paintings obliquely, the effect can be duplicated. The debt to Tintoretto's similar arrangement of the paintings facing each other across the choir of the church of San Cassiano, in Venice, seems evident (fig. 41).

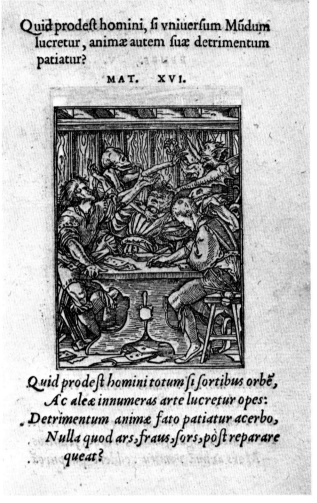

Quid prodeft homini, fi vniuerfum Mūdum lucretur, animæ autem fuæ detrimentum patiatur?

MAT. XVI.

Quid prodeft homini totum fi fortibus orbĕ, Ac aleæ innumeras arte lucretur opes: Detrimentum animæ fato patiatur acerbo, Nulla quod ars, fraus, fors, pòft reparare queat?

25. Hans Holbein the Younger. THE CARD PLAYERS *from* THE DANCE OF DEATH *series. 1545. Woodcut, 2⁹/₁₆ × 1⁷/₈". British Museum, London*

The Cerasi pictures, like those on the lateral walls of the Contarelli Chapel, are lighted from opposite sides, as if from a single source of illumination beyond their frames. This source, however, is not above the altar but opposite, apparently from the dove of the Holy Ghost in the dome over the memorials. The natural light in the chapel comes from the same direction, from a window high in the transept wall opposite the chapel entrance. The effect is to integrate the pictures with their architectural context.

Among those mentioned in Caravaggio's contract for the Cerasi Chapel were Monsignor Alessandro Ludovisi, the future Pope Gregory XV, as a witness, and Vincenzo Giustiniani (1564–1637), identified as a "merchant active in Rome" (fig. 42). This is the first documentary reference connecting Giustiniani to Caravaggio. Exceptional in intelligence and in range of interests, Giustiniani has been described as the most cultivated European of his time. The family, Genoese in origin, had for two centuries been *de facto* rulers of the Aegean island of Chios, with the courtesy title of prince, but in 1566 the island was lost to the Turks and the family transferred to Rome. There its members prospered. One of Vincenzo's uncles was a cardinal, and his brother Benedetto (1544–1621) became one also, serving as papal treasurer and as legate to Bologna. In 1590 his father acquired a palace just across the street from the Palazzo Madama and San Luigi dei Francesi, and began remodeling it into the family residence. The Giustinianis were much richer than Cardinal del Monte, and even before his father's death in 1600, Vincenzo had begun assembling the lavish collections of ancient sculpture and painting for which he is most remembered. He is also memorable for his discerning analysis of contemporary painting in Rome. When he died he owned over three hundred paintings by both old and contemporary masters. No fewer than fifteen were by or attributed to Caravaggio.

Although the collection included Caravaggio's *Phyllis* (fig. 27) and some other youthful pictures, the earliest religious painting Giustiniani is known to have owned is *The Incredulity of Saint Thomas* (colorplate 21). It must have been contemporaneous with the Cerasi Chapel paintings, and with these canvases begins another cluster of related works, all religious and most of them major. Enough documents have survived to make possible a more detailed chronology for them than for the works of the 1590s: the two *Inspirations of Saint Matthew,* between February and September, 1602; *The Entombment* (colorplate 25), between January, 1602, and September, 1604; *The Sacrifice of Isaac* (colorplate 24), between June, 1603, and January, 1604; *The Madonna of Loreto* (colorplate 26), between September, 1603, and late 1604; and the *Ecce Homo* (colorplate 27), after April, 1604. The *Victorious Amor* and the *Youth with a Ram* (colorplates 22, 23) also belong in the group.

A break occurred in Caravaggio's style about 1601. The compositions are still compact, but the figures now come out in the full round. There is more pictorial space for them to occupy, but they fill it nonetheless. Incidentally, for this reason I doubt the ingenious proposal, reasonable as it seems, that when Giustiniani acquired the first *Inspira-*

tion of *Saint Matthew* (7′ 7½″ × 6′) he had it cut down from an original size which was about the same as that of the second *Inspiration* (9′ 8½″ × 6′ 2½″). The crowding of the figures in the more compact dimensions of the first *Inspiration* is consistent with the other works of 1601–4; in all these pictures the figure masses are compressed within the frame, picture plane, and background. If the bodies were less heavy and their movements less deliberate, they would seem ready to burst out. Instead the ponderousness of the clumsy peasant models confirms their sober dignity. The *fattura* is consistent, with impasto as thick as Courbet's, for example, and palpable and malleable rather than fluent. Despite generally varied hues and high intensities of color, the mood is as matter-of-fact as the beings that Caravaggio has brought into existence.

Perhaps he hoped in the paintings of his last couple of years in Rome, 1604–6, to repeat the acclaim that had earlier greeted *The Entombment*. Three of them, *The Madonna of Loreto, The Madonna of the Snake,* and *The Madonna of the Rosary* (colorplates 26, 29, 31), are closer to the customary Counter-Reformation formulas of votive and hieratic imagery. These Madonnas are handsome and somewhat ennobled in their elevated positions, their impressive stature, and ample drapery—the contrast between the favorable reception of *The Madonna of Loreto* and the cruel attacks on *The Death of the Virgin* (colorplate 30) shows that the public expected the Madonna to be represented as of superior social status. Furthermore, Caravaggio modified the formal means that had made the paintings of 1601–4 so overpowering; already *The Madonna of Loreto* is more open and spacious. For the rest of his life, except in *The Seven Acts of Mercy* (colorplate 32) (for reasons inherent in the commission), he developed this spaciousness.

He did not desert the humble populace, even temporarily, as the peasants in the *Loreto* and *Rosary* altarpieces show. Nor did he give up religious narrative subjects. His

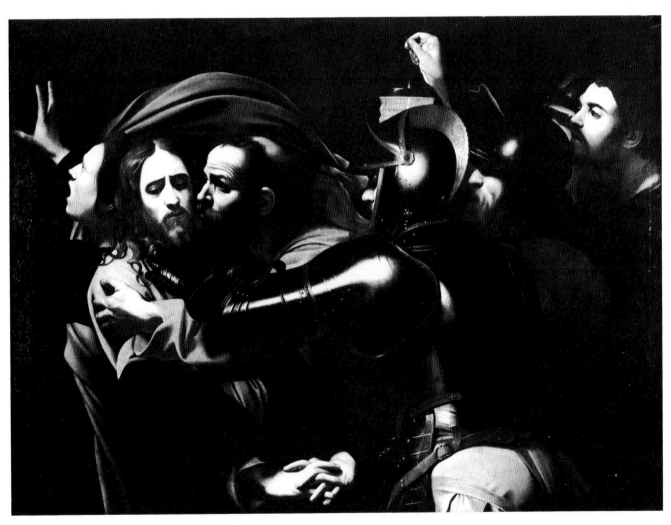

26. Copy of lost Caravaggio. THE TAKING OF CHRIST. *c. 1598–99. Oil on canvas, 52¾ × 69″. Museum of Eastern and Western Art, Odessa*

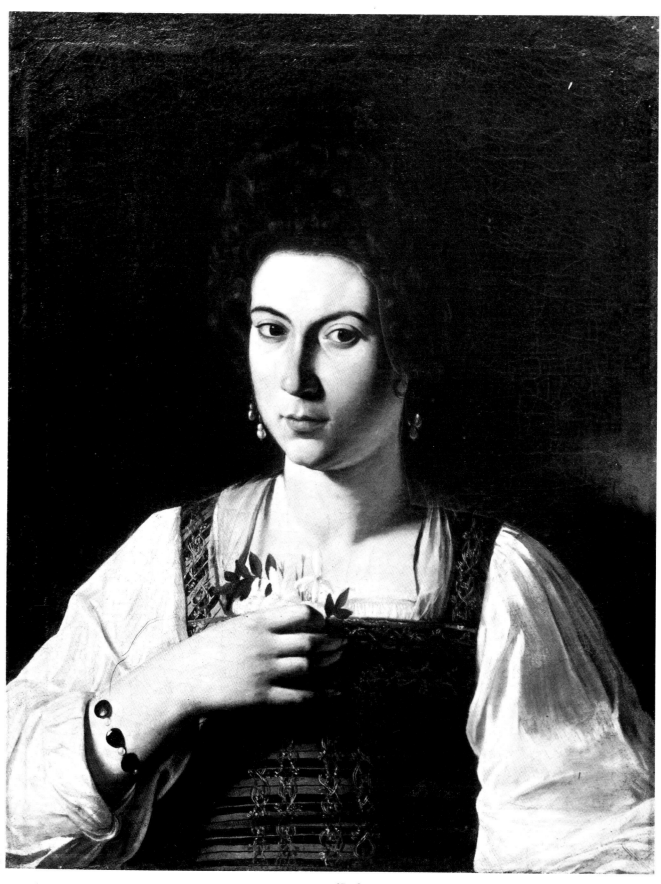

27. Caravaggio. PORTRAIT OF THE COURTESAN PHYLLIS (*destroyed 1945*). *c. 1598. Oil on canvas, 26 × 20⅞″. Formerly Kaiser-Friedrich Museum, Berlin*

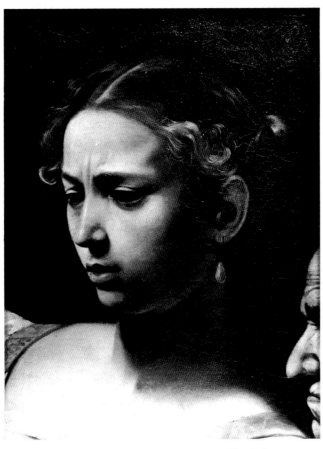

28. Caravaggio. JUDITH BEHEADING HOLOFERNES (*detail of colorplate 12*)

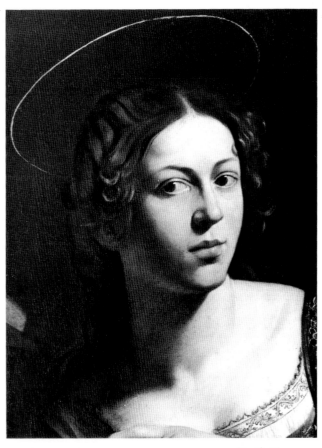

29. Caravaggio. SAINT CATHERINE OF ALEXANDRIA (*detail*). *Thyssen-Bornemisza Collection, Lugano, Switzerland*

late Roman works included the *Ecce Homo* (colorplate 27), the *Christ on the Mount of Olives* (in the Giustiniani collection, then the Berlin Museum, then destroyed by war during 1945; fig. 43), *The Death of the Virgin,* and the Brera *Supper at Emmaus.* The sorrow that first appeared in *The Entombment* became, with humility, his central theme. It is intensified by simplicity to the point of austerity; he restrained his love of painting rich details to exclude all but the most relevant. He also reduced the slick *fattura* of the three Madonnas, correspondingly developing a softly atmospheric light. Conveyed through a more somber palette and a looser, more blurred handling, this light is reminiscent of Titian's late works and anticipatory of Rembrandt's (see fig. 44). Like the works of those artists' last years, Caravaggio's seem to become increasingly personal, gentle, and intimate. The figures withdraw a little from the picture plane and become self-contained. Perhaps manifesting an increasing sense of isolation in the artist, their presence imposes a sense of privacy, as if the viewer were in solitude, sharing helplessly in their sorrow.

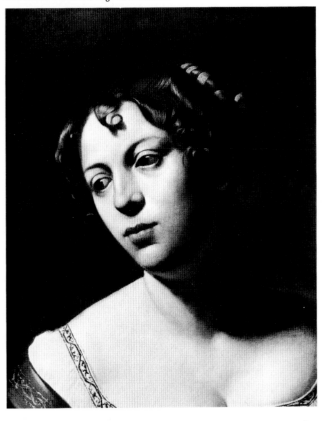

30. Copy of lost Caravaggio. THE CONVERSION OF MARY MAGDALENE (*detail*). *Detroit Institute of Arts. Gift of the Kresge Foundation and Mrs. Edsel B. Ford*

Paradoxically, while Caravaggio was painting these serious, clearly heartfelt religious pictures, his personal life was outrageous. From 1600 onward he appeared regularly in Roman police records. Most of his offenses were petty: he wrote or at least passed around scurrilous doggerel about his rival Baglione (1603), threw a plate of artichokes into the face of a waiter who had offended him (1604), cursed the police obscenely (1604), carried a sword without permission (1605), and threw stones at his estranged landlady's window shutter (1605). Some offenses involved serious bodily violence (1600, 1601, 1605). All told, he was cited in police records fourteen times during a period of slightly less than six years. He was jailed six or seven times, but he always got out. Probably he was absolved of most of his crimes by the intervention of his highly placed patrons: he was once reported to have run home to Cardinal del Monte and another time he sent to him for help; and the French ambassador intervened in the Baglione incident on his behalf. To do him justice, most of his offenses were by no means exceptional in an only superficially law-abiding city.

After his first years in Rome, he was not poor. Baglione wrote enviously that one head by Caravaggio brought more than whole narrative paintings by others. His earnings must have averaged not less than eight hundred *scudi* a year during the last decade of his life, four times the annual allowance the papal-nephew Cardinal Pietro Aldobrandini gave Torquato Tasso, and only two hundred *scudi* less than the salary during 1597 of the most famous professor at the Sapienza University. He was paid the same sum for the lateral canvases in the Contarelli Chapel, four hundred *scudi*, that D'Arpino had been promised. By the time the duke of Mantua bought his *Death of the Virgin*, his price for a single painting was up to four hundred *scudi*. In September, 1605, Caravaggio was described as having no fixed abode, although he did have possessions, including a rug valued at forty *scudi*. Bellori reports that he dressed in rich clothing but wore it to tatters, and that he used an old canvas as a tablecloth. Such nonconformity must have been deliberate rather than the result of poverty.

On May 29, 1606, Caravaggio lost ten *scudi* in a tennis match with Ranuccio Tomassoni, a young man from Terni. An argument broke out and then a fight, with the two players beating each other with their tennis racquets. A challenge ensued: that evening, accompanied by a few friends, they met armed with swords and fought. Tomassoni, cut on the thigh, fell, and Caravaggio ran him through and killed him. Himself wounded, Caravaggio took refuge in the foothills east of Rome. Different sources reported him at Paliano, Zagarola, and Palestrina, all fiefs

31. School of Daniele da Volterra. *Detail of a facade fresco representing* JUDITH BEHEADING HOLOFERNES. *Palazzo Massimo alla Colonna, Rome*

32. Caravaggio. *Diagram of spatial illusion of* MEDUSA (*see colorplate 16*). *The dotted lines indicate the apparent surface of the shield, the unbroken line the actual surface of the shield.*

of Don Marzio Colonna. Papal authority did not extend beyond the walls of Rome, except in theory, so Caravaggio was safe from prosecution outside the city and he stayed away several months. During this time he painted *The Fainting Magdalene,* now lost but remembered through many copies (see fig. 45). He may also have painted the Brera *Supper at Emmaus,* and perhaps he began or continued to work on *The Madonna of the Rosary*. But he must soon have become restless, and by October he was in Naples.

Naples was very different from Rome. The city and its

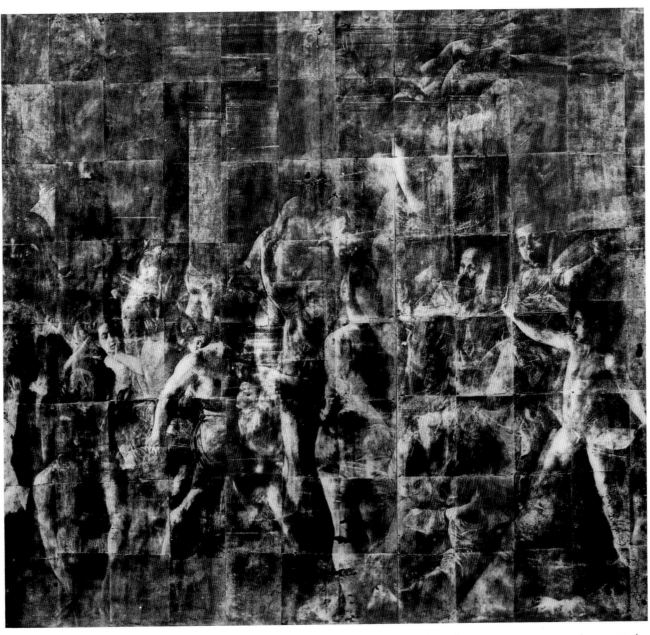

33. Caravaggio. *X-ray of* THE MARTYRDOM OF SAINT MATTHEW (*see colorplate 14*)

territories belonged to Spain. The miseries of rural life in the kingdom forced migration to the capital, making it the largest city in Italy, with a population of two hundred and eighty thousand. But conditions there were no better than in the country. Its governance, in the hands of a Spanish viceroy, was ruthlessly despotic and economically exploitive, and it was a lawless, teeming, disease-ridden, and poverty-stricken city. But it had a court, an aristocracy, and a rich mercantile class, and Caravaggio's work was in immediate demand. Two altarpieces are documented in 1606–7: *The Seven Acts of Mercy* (colorplate 32) in the autumn and *The Flagellation* (colorplate 34) in the winter and spring. None of his other surviving Neapolitan works is dated by

document, and several are lost: *The Resurrection* for the Fenaroli Chapel of Sant'Anna dei Lombardi, destroyed by an earthquake in 1805; a *Stigmatization of Saint Francis* in the same chapel, which may also have been by him; and *The Denial of Saint Peter* with several figures that was sold as a Caravaggio to the Monastery of San Martino in 1655. Several surviving works were painted in Naples: *The Crucifixion of Saint Andrew;* the *Salome* (colorplate 33); the three-figure *Denial of Saint Peter* (fig. 46); the *David with the Head of Goliath* (colorplate 35); and perhaps the *Saint John the Baptist,* the latter two acquired by Scipione Borghese. Despite some external evidence, the principal basis for placing these works during this or Caravaggio's later visit to Naples is

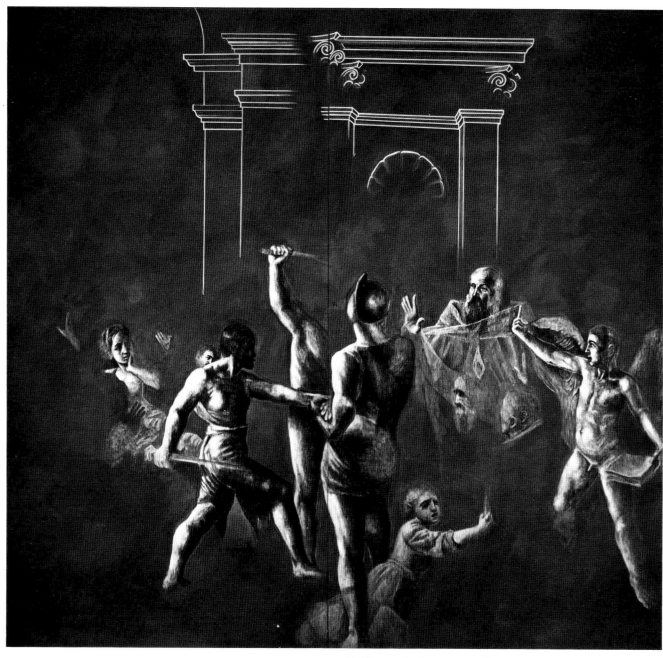

34. Caravaggio. *Reconstruction of previous versions of* THE MARTYRDOM OF SAINT MATTHEW (*see colorplate 14*)

stylistic, and in dispute. It is clear, however, that he was successful, busy, and solvent.

Both D'Arpino and Baglione had been knighted "*cavalieri*," and Bellori and Sandrart report that Caravaggio wanted to be too. So he seized the opportunity that arose to go to Malta, arriving on the island by July 13, 1607. No state in the world was quite like Malta. The Knights of Saint John of Jerusalem had been founded early in the twelfth century as a semimonastic military and charitable Order, responsible only to the pope; in 1530, seven years after the knights had been driven out of their previous headquarters on Rhodes by the Turks, they took over Malta (see fig. 47). Their membership of about two thousand was recruited

from all over Europe, and consisted of a majority of noble-born knights, others, like surgeons, who were of less exalted origin but useful, and lay associates. The island was heavily fortified, and the Order maintained an army and navy, used mostly against pirates and Moslems. They also operated hospitals famous for their medical services. Most knights served first on the island and then were sent to one of the Order's six hundred priories throughout Europe.

In addition to the *Saint Jerome* (stolen in 1985) and the *Sleeping Cupid* of 1607–8, Caravaggio undertook two major projects in Malta: the giant *Decapitation of Saint John the Baptist* (colorplate 37), and the portrayal of the Grand Master of the Order and *de facto* ruler of the island, Alof de

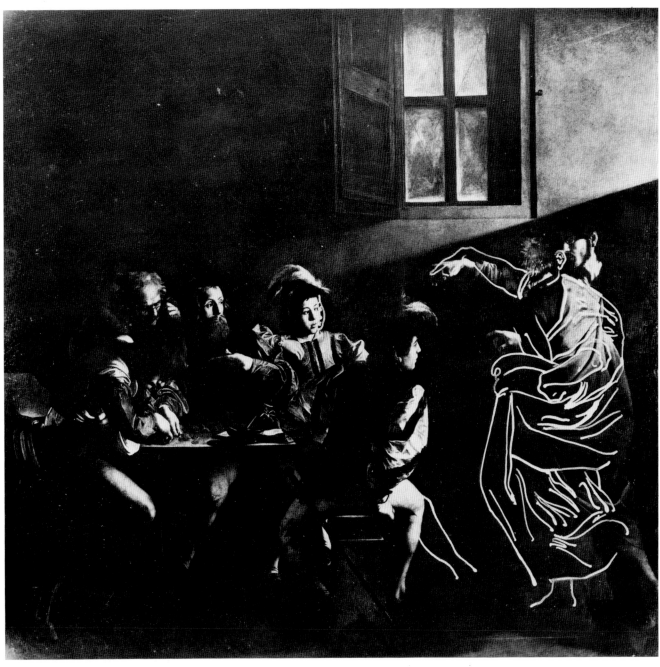

35. Caravaggio. *X-ray with overpainted elements of* THE CALLING OF SAINT MATTHEW *outlined* (*see colorplate 13*)

Wignancourt (1547–1622). Bellori describes two portraits of Wignancourt. In one, he was seated, wearing his official robe; no picture has ever come to light that is convincing as either the original or a copy. The other is the portrait of an armored figure standing with an attendant page, in the Louvre (colorplate 36). Recently a third has been identified in the Pitti (fig. 48). Without painted understructure or any *pentimenti,* and with the right hand incompletely sketched in, it appears to have been done from life, presumably as a preparatory study for the head, though not the pose, of one or both of the formal portraits.

Portraits of notables, such as the Louvre *Wignancourt,* the

Maffeo Barberini of about 1598–99 (fig. 49), and the lost *Paul V,* required Caravaggio to characterize the sitter's official position in preference to—and we may suspect sometimes in contradiction of—his understanding of the actual personality. The *Maffeo Barberini* demonstrates that Caravaggio could make such a portrait without petrifying his exalted model in rigid formality. It is formal, but the spontaneous oblique pose, the animated gesture, and the vitality of the face make it a vigorous, speaking likeness. Perhaps Barberini's relative youth, his relatively accessible rank (he had not yet become a cardinal), and his literary and artistic interests permitted him and the painter to relax a little.

Wignancourt was more grand; one of his achievements was obtaining the dignity of Serene Highness for himself and future Grand Masters. Caravaggio discovered two aspects of his character. The likeness in the Pitti study is more sympathetic, revealing a pensive, even mournful, man beneath the brusque, resolute, authoritarian official of the Louvre portrait. The rosary in his right hand may provide an explanation for the different characterization. It is as if Caravaggio discovered—or created—one of his own worn old men within Wignancourt's pomp. This metamorphosis was completed in the Maltese *Saint Jerome,* probably also a portrait of Wignancourt, again as a contemplative man rather than an active commander.

Wignancourt was pleased. In July, 1608, a year after his arrival, Caravaggio achieved knighthood. If he had not already, he must then have joined his brother Italian knights in the living quarters they shared and participated in their communal activities. These were less monastic in practice than in theory, and Caravaggio was presumably no more resistant to the pleasures of gambling, drinking, dueling, and carousing in La Valletta than he had been in Rome. In less than three months he was in jail again, having insulted a noble knight. Here there was no indulgent Roman patron to help him, only the stern Grand Master. So he got himself out, escaping from prison and fleeing to Syracuse in Sicily. The Order retaliated by expelling him.

In Syracuse Caravaggio found his old friend Mario Minniti, at best a mediocrity but the leading painter in the city. Minniti made him welcome and arranged for the town senate to commission him the first of his great Sicilian altarpieces, *The Burial of Saint Lucy* (colorplate 38). Caravaggio must have been disappointed by the outcome of his visit to Malta and disillusioned and apprehensive about his future. The documents relating to his imprisonment and expulsion hint at pursuit; he apparently continued to style himself a knight, and the Order's vengeance could be terrible. Yet the *Lucy,* the *Lazarus* (colorplate 39), and *The Adoration of the Shepherds* (colorplate 40) are marked by calm, resignation, and restraint, the grandeur of their scale and vastness of their space only emphasizing the humility of their protagonists, and the austerity of their color and form, their sincerity.

Caravaggio soon moved on to Messina, then already a large and important city. Opportunities for a painter were fewer than in Rome but not wanting. Caravaggio must have arrived early in 1609 because he was paid for *The Resurrection of Lazarus* on June 10; he had completed a *Via Crucis* (now lost) by August; he had made a contract for three other scenes of the Passion that may never have been done;

and he had yet to paint *The Adoration of the Shepherds* in Messina and *The Nativity with Saints Francis and Lawrence* for the Oratory of the Rosary in Palermo—all before returning to Naples by October. He was very well paid—a thousand *scudi* each for the *Lazarus* and the *Adoration.* His temper had not improved, and his months in Messina were eventful. His biographer there, Francesco Susinno, reports the de-

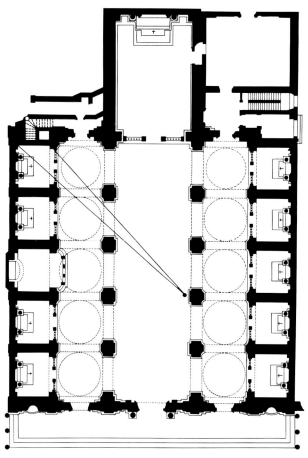

36. *Plan of San Luigi dei Francesi, marked with sight lines from the nave into the Contarelli Chapel*

struction of a first version of the *Lazarus* in a fit of rage occasioned by some minor criticism, his reign of terror over the employees of the hospital where he was provided a studio and models, and a dispute with a schoolmaster whose male students he had eyed rather too admiringly.

The Palermo *Nativity* was stolen in 1970 and is reported to have been destroyed in the earthquake of 1979. Caravaggio had little time to carry it out, particularly if, as Susinno says, he did some other paintings in Palermo. It is surprisingly retrospective: as colorful as the Cerasi Chapel canvases, with Saint Lawrence's strangely contorted pose reminiscent of Moretto, and the angel (in reverse) and Saint Francis derived from Pellegrino Tibaldi's *Conception of Saint John the Baptist* in Bologna. Doubt has therefore been cast

on this visit to Palermo, otherwise undocumented except by his biographers. Perhaps the altarpiece was actually painted earlier. Its dimensions (8′ 9½″ × 6′ 3⅝″) are comparable to those called for in the contract of 1600 that Caravaggio had made in Rome with Fabio de'Sartis, for a painting with no subject specified. Caravaggio was paid two hundred *scudi* for the picture, which would have been an appropriate sum at that time for the *Nativity*.

The uncertainties surrounding the *Nativity* are symptomatic of the last year of Caravaggio's life. Back in Naples in October, 1609, he was reported killed or at least badly cut up in a brawl at the famous Taverna del Cerriglio near the port. He survived and recovered, remaining in Naples for another nine months. Only one work is documented to these last months: perhaps he dedicated the time to the paintings for Sant'Anna dei Lombardi that were destroyed, to the canvas later at San Martino and now lost, and to some smaller pictures. One of the smaller pictures, the *Saint Ursula* in an Italian private collection, has recently been documented to these last months. Commissioned by a Genoese nobleman, Marcantonio Doria, it was shipped north to Genoa at about the same time that Caravaggio himself left Naples. Its three-quarter length format, with the figures submerged in shadow against a murky, featureless background, is so similar to the Swiss *Denial of Saint Peter* and the London *Salome* that they too must have been painted during these last months of his life. Despite their smaller scale, the three paintings seem logical successors to the great Syracuse and Messina altarpieces, and suggest a rich painterly late style, which, premature as it was, nonetheless seems comparable to those of the aged Titian and of Rembrandt.

Time was running out. Caravaggio's Roman protectors rescued him once again. In the spring or early summer of 1610 Cardinal Ferdinando Gonzaga, soon to succeed to the dukedom of Mantua, arranged absolution for the 1606 murder of Tomassoni, so that Caravaggio could return to Rome. For some reason, perhaps doubt that the pardon was absolute, he sailed to a southern Tuscan enclave under Spanish jurisdiction, rather than going overland or sailing to Civitavecchia, the port of Rome. Upon landing, he was jailed, mistaken for another man, a knight fugitive from justice. When he was released two days later, all of his possessions had disappeared, and perhaps he had come down with malaria. He set off along the beach below the Monte Argentario under the blazing summer sun. By the time he reached Porto Ercole, he was sick and raving. He survived a day or two but the fever consumed him, and on July 18, 1610, he died.

ARAVAGGIO's methods of painting have been much discussed. Probably none of his seventeenth-century biographers ever set foot in his studio — in fact only Mancini and Baglione were alive and in Rome while he was there — so we have no firsthand information from them. If we are to believe Mancini, Caravaggio did not lay brush to canvas without a live model before him. During his early impoverished years in Rome, he no doubt flattered and amused his friends by painting them; he may have picked up models casually on the street, as Bellori reports. Possibly later he occasionally hired professional models. Some physiognomies appear more than once in his pictures, and some, like the *Victorious Amor* (colorplate 22), actually age before our eyes in a sequence of paintings. But

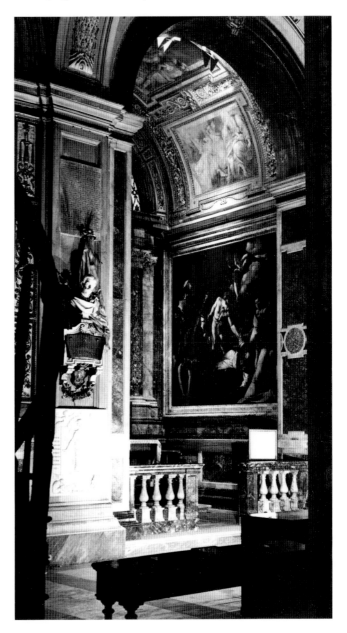

37. *View of* THE MARTYRDOM OF SAINT MATTHEW *from the nave*

38. Caravaggio. THE MARTYRDOM OF SAINT MATTHEW (*detail of colorplate 14 showing the self-portrait of Caravaggio*)

39. *Plan of the transept end of the church of Santa Maria del Popolo, Rome, with the Cerasi Chapel indicated*

he had no preferred physiognomies such as those repeated over and over in the works of D'Arpino, so the faces in his pictures all appear to have been painted from life. But he was certainly also able to paint without models, from memory; during his maturity particularly he must have often done without them.

Mancini thought Caravaggio's large compositions were flawed. He recognized the impossibility of painting from a crowd of models posed together in front of the artist, and concluded that Caravaggio must have composed his pictures piecemeal, with no overall preparatory design. This is not possible. The extensive underpainting revealed by X-ray of his early works may have served as their preparation. But it is inconceivable that he could have painted compositions with more than two or three figures so rapidly, or at all, without knowing how he was going to arrange them. His contemporaries normally composed multifigure paintings by means of preliminary drawings, and he probably did too; his teacher Peterzano made such designs and would have trained him to do so. In two of his contracts, preparatory sketches were required by the patrons. The fact that no drawings have been identified as by him is not surprising; they were probably made on scraps of paper and discarded as soon as they had served their purpose. And he had no band of adoring assistants to pick them up and save them.

Caravaggio's revisions of *The Martyrdom of Saint Matthew,* drastic as they were, do not necessarily mean that he had not made preparatory sketches, but rather that he was not satisfied with the painting as it advanced. Unquestionably he did revise as he painted, as is demonstrated by the number of *pentimenti* in the Roman pictures and later. Another sign of improvisation are lapses such as the table in *The Calling of Saint Matthew,* with legs on the left but none to support it on the right, or the pair of feet under the dead Virgin's bier that do not match the body standing over it. Most of these lapses are petty. Why he did not correct others as prominent as Saint Peter's oversized right hand in the London *Emmaus* (colorplate 18) is inexplicable.

Caravaggio appears to have begun his pictures by drawing an outline for each principal figure on the primed and underpainted canvas. Occasionally he outlined by scoring shallow grooves in the moist priming with the blunt end of the brush, a method typical of fresco painting that was already being used in easel paintings as early as the fourteenth century. Having established the general composition, Caravaggio then began to paint. Whatever use he made of models probably came at this point. He painted very fast. While he must have worked on one figure and

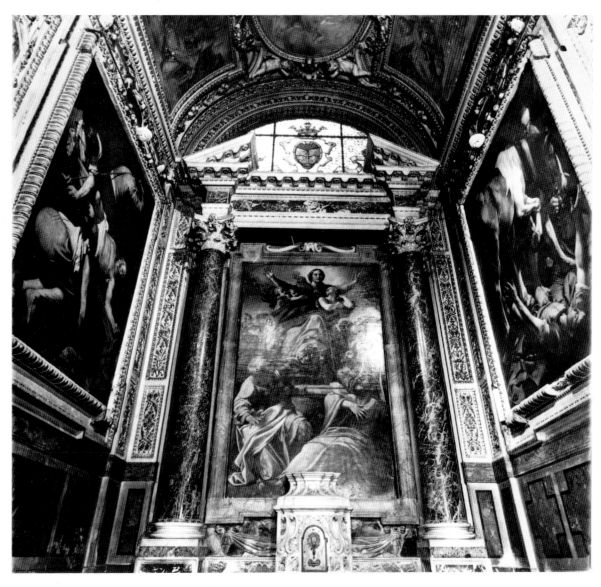

40. *View of the Cerasi Chapel, Santa Maria del Popolo*

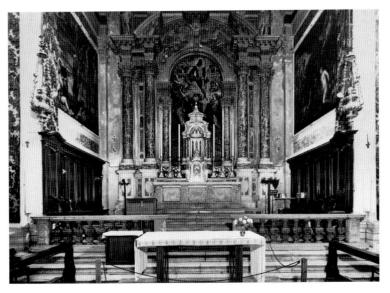

41. *View of the choir of San Cassiano, Venice*

42. Claude Mellan. PORTRAIT OF VINCENZO GIUSTINIANI. *Frontispiece of* Galleria Giustiniani. *1631. Engraving. Rijksmuseum, Amsterdam*

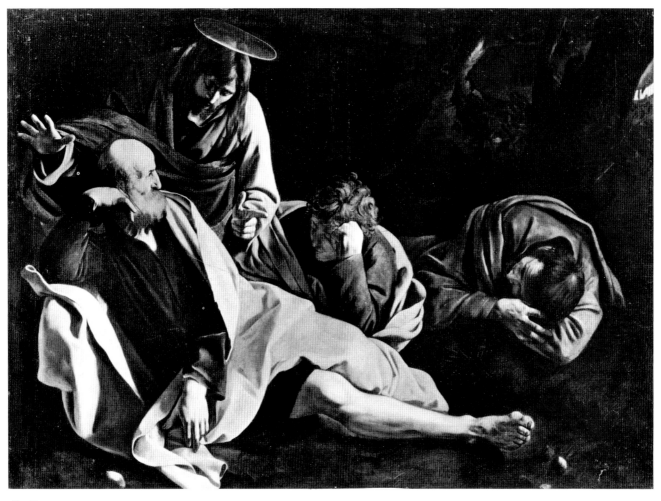

43. Caravaggio. CHRIST ON THE MOUNT OF OLIVES (*destroyed 1945*).
*c. 1605. Oil on canvas, 60⅝ × 87½". Formerly Kaiser-Friedrich Museum,
Berlin*

then another, X-ray and close examination of the paint
surfaces seem to show that he carried the whole painting
along as a unit.

In his early works such as the *Rest on the Flight* he fit the
different areas together as carefully and neatly as pieces in a
jigsaw puzzle, with the effect of painting the whole picture
simultaneously, although outlines and spots of dark and
light were added as final touches. When Caravaggio began
to paint large-scale canvases, his *fattura* became looser,
and the neutral brown ground tone was allowed to show
through increasingly. Eventually he reached the extreme of
the highlights that seem to float boldly on the bare grounds
of the Maltese and the Sicilian paintings; but the *fattura* was
much tighter and more detailed in relatively small paintings
like the *Saint Jerome* than in the larger canvases. The ex-
posed ground served as his standard middle dark, but not
his darkest tone. Usually he worked into this ground tone,
modeling figures within their contours from light to dark.
Thus in *The Calling of Saint Matthew,* while the ground is
covered by the almost opaque impasto representing the

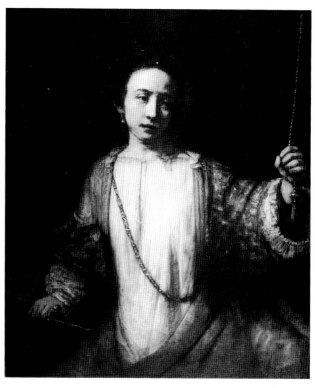

44. Rembrandt. LUCRETIA. *1666. Oil on canvas, 41⅜ × 36⅜". The
Minneapolis Institute of Arts. The William Hood Dunwoody Fund*

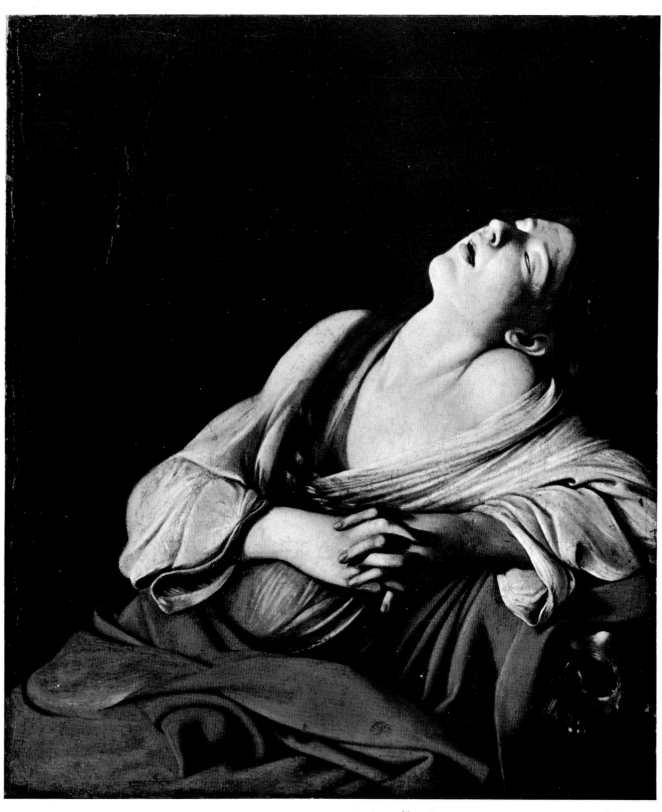

45. Copy of lost Caravaggio. THE FAINTING MAGDALENE. *Oil on canvas,
39 × 33". The Hermitage, Leningrad*

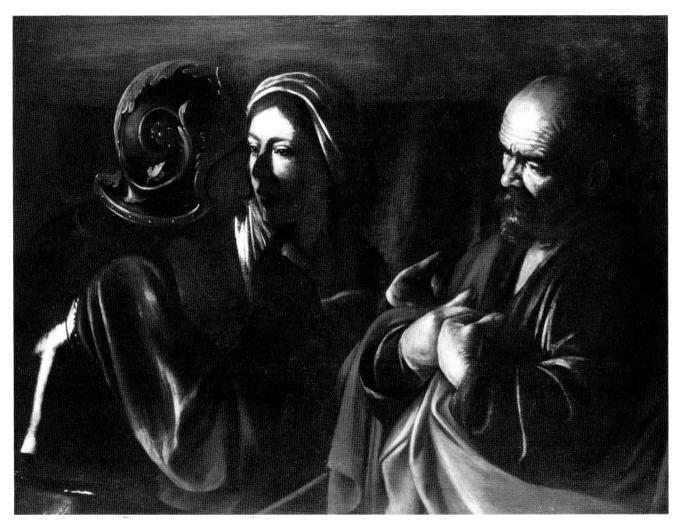

46. Caravaggio. THE DENIAL OF SAINT PETER. *c. 1609–10. Oil on canvas, 37 × 49⅜". Private collection, Switzerland*

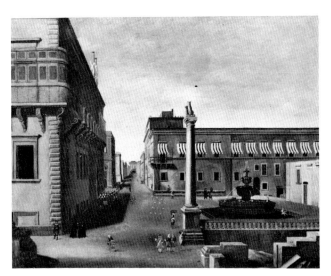

47. Anonymous Italian. CENTRAL SQUARE, LA VALLETTA, WITH GRAND MASTER'S PALACE. *Before 1741. Oil on canvas, 35⅞ × 46½". National Museum, Malta*

saint's illuminated face and beard, on the back of the head the dark tone of the ground emerges from this layer of pigment to serve to characterize the shadows (fig. 50). When the painting had been carried to the point where the figures and the furniture were established as solids in space and light, he then worked it over again, reinforcing outlines, lights and darks, and perhaps adding details. So in order to bring Saint Matthew's cap out, he painted it darker still over an area that was already darker than the ground.

Other information about Caravaggio's studio and study practices is very limited. He did have a servant or two, whose duties may have been professional as well as personal. However, he did not ordinarily utilize assistants except perhaps for menial tasks like cleaning brushes or mixing pigment and priming canvases. Possibly he left a few pictures incomplete, and they were finished by other hands. Artists often had a few unfinished paintings in their studios, and Caravaggio from 1606 until his death moved often and fast enough to be quite likely to have left some behind.

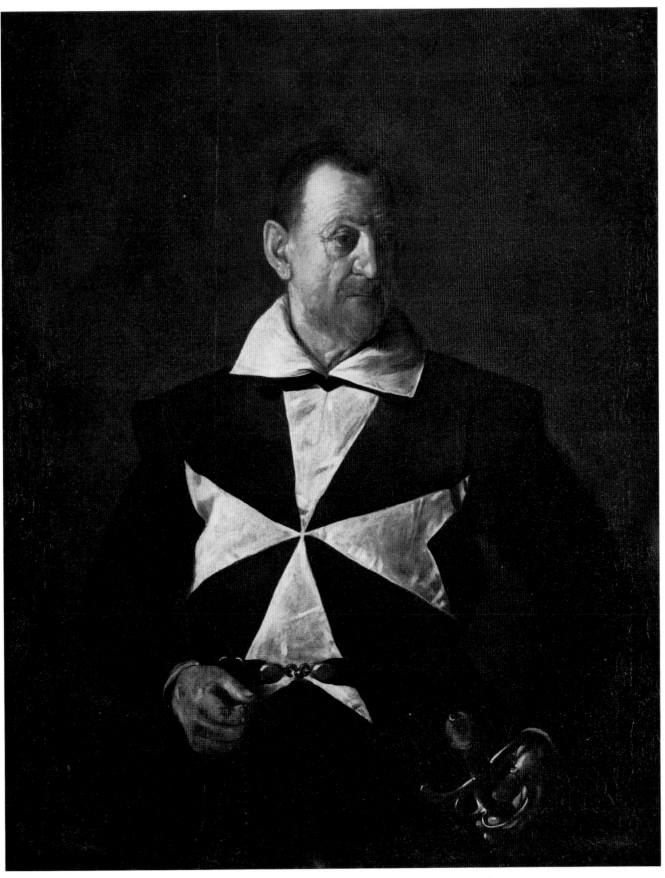

48. Caravaggio. PORTRAIT OF ALOF DE WIGNANCOURT, GRAND
MASTER OF THE KNIGHTS OF MALTA. *1607–8. Oil on canvas,
56⅝ × 37⅝". Palazzo Pitti, Florence*

Possibly the *Calling* records Caravaggio's studio in the Palazzo Madama. The tiled floor appears also in the first *Inspiration of Saint Matthew* and the *Victorious Amor,* and the oiled paper covering the windowpanes is in keeping with Sandrart's description of the restriction of light in the studio. The furniture in the paintings is spare and simple. So, presumably, was that in the studio: the Savonarola chair in the first *Inspiration,* the *Calling,* and the London *Emmaus;* the stool in the *Calling* and the second *Inspiration;* and some tables, can all be identified. Caravaggio may have borrowed the musical instruments from Cardinal del Monte's collection, or perhaps he owned one or two himself. Only a few of the other props appear more than once in any of his paintings: the glass carafe with the plain neck in the *Magdalene,* the London *Emmaus,* and perhaps the *Boy Bitten;* the straw basket in the London *Emmaus* and the Ambrosiana *Fruit;* several pieces of fabric, notably the patterned damask of Saint Catherine's cushion; and the *bravo* costumes, which may have been Cardinal del Monte's servants' livery. Most accessories may have been borrowed from the household or from friends, as the need arose.

49. Caravaggio. PORTRAIT OF MONSIGNOR MAFFEO BARBERINI, LATER POPE URBAN VIII. *c. 1598–99. Oil on canvas, 47⅝ × 37⅜". Private collection*

How was this studio lighted? Ordinarily Caravaggio painted with the primary source of illumination from above to his left. This practice may explain why the covered window appears only in the *Calling,* which is lighted from the right; normally he would have been working with his back to it rather than facing it. There must have been another window in the studio. If the reflections in the carafe in the *Boy Bitten by a Lizard* and the *Magdalene* are to be trusted, the glass in this window was clear, with two vertical panes. The carafe in the London *Emmaus* seems to reflect the same window, partially covered, with daylight entering from the upper corners only. In the last years of the 1590s, Caravaggio began to use artificial light, probably from windowed lanterns, and from about 1600 he must have used this primarily. In compositions with many figures, whether he worked directly from a model or not, he could not be dependent on the changing conditions of natural light. Artificial light, completely under his control, would have had the advantage of constancy. Most of his pictures are nocturnal or interiors in any case, and artificial light was appropriate, particularly as rooms were usually ill-lit in those days.

Caravaggio's light effects were certainly contrived, fictitious, and deceptive, convincing as they may appear to be. Even in his early paintings in natural daylight he did not actually set up the whole scene in front of him. So he made such "mistakes" as failing to register any refraction of the drapery folds seen through Bacchus's carafe. And he took such liberties as decorating the walls behind *The Lute Player* and the *Magdalene* with little triangles of light, and excising the shadow Bacchus should cast on the wall. Complex systems of illumination, as in the *Calling,* are his own invention rather than the observed working of the laws of physics. Saint Peter does not cast any shadow, the illumination of the legs under the table is inexplicable, and the sources themselves are inadequate in spread and intensity to illuminate the figures so fully. Caravaggio's approach to light was that of a painter concerned with appearances, so he was willing to tamper with it.

Ordinarily he kept the source of light out of view. Once only, in the *Seven Acts,* did he reveal a source actually functioning within a picture: the priest is illuminated by the flaming taper he holds in his hand (fig. 51). But it is merely incidental illumination, not coordinated with that of the whole painting. Other potential sources of light appear elsewhere: a burning candle in *The Martyrdom of Saint Matthew,* a glowing lantern in *The Taking of Christ,* and the moon in the *Christ on the Mount of Olives.* But none of these is effective as a light source.

50. Caravaggio. THE CALLING OF SAINT MATTHEW (*detail of colorplate 13*)

Light served him for composition, to give relief to the figures and accessories, and in a few crowd scenes to increase agitation by disrupting forms. Its primary effect was theatrical. It dazzles the fallen Saint Paul, spots the artist's own portrait in the murky background of *The Martyrdom of Saint Matthew,* and makes Saint Jerome's inspiration radiant. It permitted the veiling of Christ's eyes in *The Calling of Saint Matthew* and of his whole face in the *Lazarus.* And not only in the *Conversion* does it imply a divine presence, but also in the *Saint Francis,* the *Saint Jerome,* the *Lazarus,* and perhaps elsewhere.

Light evidently was never simply a mechanism for Caravaggio. The clear daylight of his early pictures is inextricable from the delights in the bright physical world that it reveals, and from his pleasure in it. Dark invaded his pictures simultaneously with violence, which was soon superseded by tragedy. By the time of his arrival in Naples, the world of his paintings had become dark and inhospitable, often under the control of such malevolent forces as

Christ's torturers. Its inhabitants are imprisoned in its shadows. Only the rays of light stealing from a distant unknown source through its oppressiveness offer any relief.

We can only speculate how conscious Caravaggio was of light and dark as symbols. Surely he must have felt conflict between them. The imagery is as old as mankind and as universal. It is central to Christianity, and the analogy between the light invading the dark world of his mature painting and the Christian message infiltrating the real world of suffering and sorrow is irresistible. Perhaps he remembered Christ's mission to Saint Paul (Acts 26:18): "To open their eyes that they may be converted from the darkness to the light and from the power of Satan to God, that they may receive forgiveness of sins and a lot among the saints by the faith that is in me."

Caravaggio possessed extraordinary powers of observation. His youthful enchantment with the physical world led him to study the appearance of objects. So when he painted a rapier, it was worthy of an armory; his musical scores can

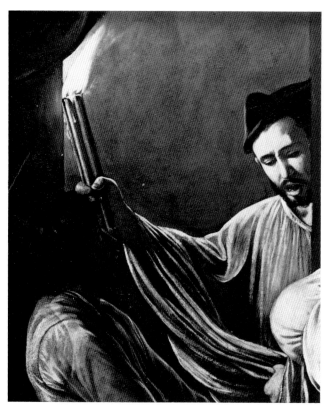

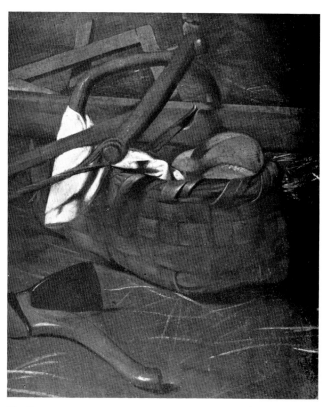

51. Caravaggio. THE SEVEN ACTS OF MERCY (*detail of colorplate 32*)

52. Caravaggio. THE ADORATION OF THE SHEPHERDS (*detail of colorplate 40*)

still be performed; and the instruments he painted could be played. He took pleasure in varied sense experiences, gathering together objects of different texture, shape, and substance, and contrasting them. He never lost his fascination with inanimate objects or his skill in representing them—the skull in the *Lazarus* and the basket in *The Adoration of the Shepherds* (fig. 52)—although as he matured he increasingly concentrated his attention on persons. Many details in his paintings seem likely to have been based on daily observations fortuitously made—a nicely shaped glass that caught his eye, or some incident outside the Taverna del Cerriglio, or a gypsy girl he glanced at on the street. He observed the human condition also: the different degrees of consciousness of the sleeping infant, the dying Virgin, and the dead Saint Lucy; the withdrawal characteristic of the aged in Saint Anne, advancing into senility in the old servant in the Brera *Emmaus;* Saint John as the dreaming adolescent and Saint John the awakened zealot (colorplate 28).

Caravaggio saw hands not only as objects and mechanisms but as symbols. Even apart from the gestures they make, they are like little portraits. The tapering long-fingered boneless hands of *The Lute Player,* the vigor of Saint Paul's short fingers and square hands, the gnarled right hand of Saint John the Beloved kneeling over the Virgin's

body—these speak no less eloquently than the faces of condition and personality. Hardly less expressive are the feet in the *Rest on the Flight* or in *The Calling of Saint Matthew.* The insight and authenticity of his observation of the natural world are uncanny.

Yet when Bellori chided Caravaggio for this preoccupation with nature and for disdaining to learn from other artists, he was wrong. Art was no less a part of Caravaggio's world than nature, and he had much recourse to it. Quite apart from his general debts to Lombard, Venetian, and Roman painting, his specific debts to other artists were beyond number. He pillaged antique sculpture, plundered the Renaissance and particularly the art of Bellori's hero Raphael, and plagiarized his own immediate predecessors and his contemporaries. Even his most forthrightly "realistic" paintings turn out to be anagrams of sources. The first *Inspiration of Saint Matthew,* for example, stems from an early medieval tradition of manuscript illumination (figs. 53, 54). Saint Matthew's head is derived from the standard portrait of Socrates, perhaps from an antique marble (fig. 57) or from Raphael's use of it in *The School of Athens* (fig. 58). The pose comes from Pythagoras in the same fresco, or through its metamorphosis into Saint Luke in Agostino Veneziano's print (fig. 55). The intertwining of Saint Matthew and the angel was inspired by Raphael's *Jupiter and Cupid* in the

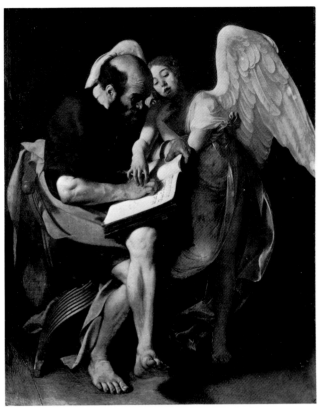

53. Caravaggio. THE INSPIRATION OF SAINT MATTHEW (*first version; destroyed 1945*). *1601–2. Oil on canvas, 7' 7½"×6'. Formerly Kaiser-Friedrich Museum, Berlin*

54. THE INSPIRATION OF SAINT MATTHEW. *MS 1190 fol. 14v. Bibliothèque Sainte-Geneviève, Paris*

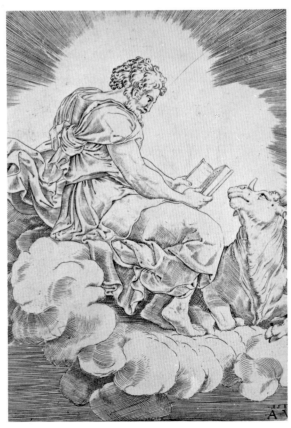

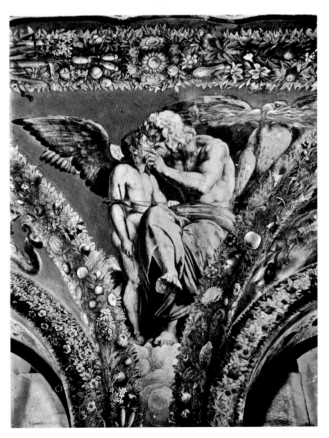

55. Agostino Veneziano after Giulio Romano. SAINT LUKE. *Engraving. The Metropolitan Museum of Art, New York City. Gift of Burton Emmett, 1929*

56. Raphael. JUPITER AND CUPID. *c. 1517. Fresco. Farnesina, Rome*

57. Roman. HEAD OF SOCRATES. *National Museum, Naples*

58. Raphael. THE SCHOOL OF ATHENS (*detail of Pythagoras and Socrates*). *1509–10. Fresco. Stanza della Segnatura, Vatican, Rome*

59. Ambrogio Figino. STUDIES FOR SAINT MATTHEW. *Pen and ink with red chalk, 7¾ × 13". Royal Library, Windsor Castle. Reproduced by gracious permission of Her Majesty Queen Elizabeth II*

60. Simone Peterzano. THE INSPIRATION OF SAINT MATTHEW. *1583. Fresco. Certosa of Garegnano, near Milan*

61. Simone Peterzano. ANGEL. *Black chalk and white, 15¼ × 10⅞". Castello Sforzesco, Milan*

62. Cavaliere d'Arpino. SAINT BARBARA. *c. 1597. Oil on canvas, 9' 4½" × 4' 9⅛". Church of Santa Maria in Traspontina, Rome*

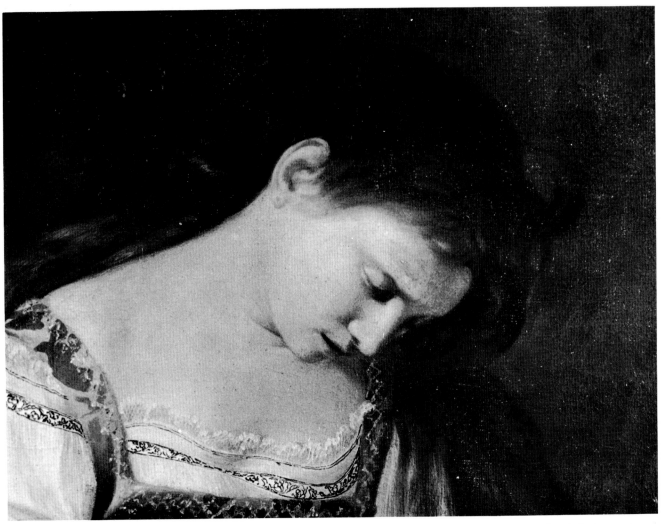

63. Caravaggio. PENITENT MARY MAGDALENE (*detail of colorplate 7*)

Farnesina in Rome (fig. 56), which Caravaggio must have already known through Ambrogio Figino's drawings (now at Windsor Castle; fig. 59) and Peterzano's fresco at Garegnano (fig. 60). And when he came to create the angel, what could have been more natural than to borrow its pose from Peterzano (fig. 61), and its physiognomy and revealing drapery from the *Saint Barbara* that D'Arpino had painted a few years previously for the Roman church of Santa Maria in Traspontina (fig. 62)? The failure of Caravaggio's biographers to recognize his sources lies no more in their lack of insight than in his skill in concealing them. He used them to construct figures and groups of figures, to help him discover the patterns within ordinary life. He reversed the theoretical ideal of forming perfect art from imperfect nature by clothing his artfulness with nature. If little that he painted seems contrived, even less was accidental.

He was a master of staging. Most of his paintings of more than one figure resemble the modern theater. We can imagine the genesis of a painting from a shallow stage, shadowy and empty, awakening as stagehands bring in and place a few props and a lighting technician tries out a spot or two or a bank of lights, and coming to life as the actors take their places. He favored very simple sets. Scenery was elaborated only to convey information relevant to the action. His basic unit of scale was the human figure. He did no very small paintings that we know of. When the figures in his big canvases are larger than life—Saint Lucy's gravediggers, for example—they serve a special purpose, often so subtly as to be as unnoticeable as the giantism of the decapitated Saint John.

Caravaggio directed his characters to act naturally. Like nonprofessional actors recruited from the streets for modern Italian films, they act with conviction and with a sense of the significance of their actions, as ordinary people transformed by extraordinary circumstances. When Christ gestures, the sense of His will and absolute power is irresistible. When Saint Matthew responds, or Lazarus, he acknowledges this power with individuality. But all are

under the director's control, and are not allowed to pose or arrange themselves haphazardly: thus the niceties of Lazarus's right hand reaching toward the life-giving light while his left still stretches toward the skull beneath it, or of the juxtaposition of hands, palm, and cross in the altar cloth of *The Martyrdom of Saint Matthew*.

Caravaggio insisted on syntactically correct images. The Magdalene has cast off her jewels but we can still see that her ear is pierced (fig. 63). When Saint Jerome writes, he has pen, inkwell, and books within reach, and a table littered like that of any scholar, and only syntactical analysis of his pose and the setting makes clear the precise meaning of the image. The few lapses in syntax—where is the first Saint Matthew's inkwell? and what use is the drapery at the head of Saint Peter's cross?—are purposeful: an inkwell would require the support of a table, which would destroy the solidarity of the two figures; and the drapery provides the turn for an awkward corner.

Action in Caravaggio's paintings is always in suspense. This suspension may be the inevitable pause between challenge and response, as in *The Calling of Saint Matthew.* In most of his pictures, however, it is more arbitrary, as if a director had commanded his actors to "Hold it!" Whether dictated by psychological necessity or by command, its effect is reverberation in time, an implication of what has happened before and what will happen next. Caravaggio gives us clues to the temporal sequence: Holofernes's hands, still tensely resistant; the choreography of Christ's feet, already turned to lead Saint Matthew away; Pilate's look of expectation toward the spectators.

Caravaggio's theater was silent but filled with echoes. He did use the most obvious means of suggesting voices, the open mouth. But he realized also that voices coincide with gestures. So Christ's hands speak reassuringly to Saint Thomas as he prods His wound, and quietly rebuke the drowsy Saint Peter. Caravaggio made use of situation too: the tension of the spectators in *The Resurrection of Lazarus* released in the thrilled incredulous hiss of their held breath, and the noises of the crowded city in the *Seven Acts*. Not all the sounds he intimated are vocal: some of the musicians are actually tuning or playing their violins and lutes; the snake of heresy hisses; and the money in *The Calling of Saint Matthew* clinks. Sound plays a particularly important role in the Contarelli Chapel, intensifying the drama by contrasting the tumult of the *Martyrdom* with the near-silence of the *Calling*, in which the sense of routine discussion of the day's business is suddenly broken off and an astonished response is imminent, reinforcing the effect of suspended action. So also Christ's silence emphasizes the subtle evocation of

64. *Commemorative medal for the foundation of the church of Sant'Anna dei Palafrenieri, Rome (obverse). 1565. Bronze. The Warburg Institute, University of London*

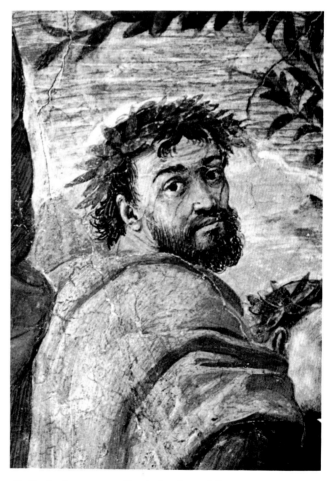

65. Raphael. PARNASSUS (*detail of Michelangelo?*). 1510–11. *Fresco. Stanza della Segnatura, Vatican, Rome*

sound in the *Ecce Homo:* Pilate, having just spoken, gestures wordlessly; the responding shouts are to come from us, the spectators.

Caravaggio was a painter of character. The focus of his paintings is personality, revealed by facial expression, pose, gesture, costume, age, and condition in life, and in multifigure compositions by interaction among the protagonists. His compositions are staged around a central episode, with each figure involved in it and responding individually: the two men who count money in *The Calling of Saint Matthew,* unaware of what is happening; the prisoners who watch the decapitation of Saint John, aware but detached; the mourners who surround the dying Virgin or the row of silent witnesses to the burial of Saint Lucy. All of these supporting roles direct attention to the center—to Christ's gesture of benediction in the *Emmaus* pictures, to His dead body in *The Entombment,* or to the Madonna and Child in the *Adoration.* Their different reactions, in differing degrees, echo the central theme, its effect emphasized by the varied responses of their different personalities.

Caravaggio may have been his own director, but he was not an independent producer. More than half of his paintings were certainly done on commission, and the subjects of his altarpieces were ordinarily determined by the patron. But he could and did refuse commissions that seemed unsuitable, and probably the subjects of his works for private patrons were not so prescribed. The only one that we know to have been dictated was the *Ecce Homo,* although a number of others, notably the lost Radolovich and di Giacomo commissions, are likely to have been also. He rarely repeated subjects. Those he did are always different enough from each other to show that he deliberately reinterpreted them. By the end of his life, he had depicted most of the Passion of Christ, as if he had intended a complete cycle. The omissions from his *oeuvre* are also significant. It may well be more than accidental that our only record of the Radolovich commission for a *Madonna and Child with a Chorus of Angels* is documentary; perhaps he never began it. This kind of devotional subject he appears to have avoided, as he did classical narratives and religious fantasy, the purely inspirational, divine apparitions, and most miracles, except those of Jesus.

Caravaggio was concerned with the interaction of man and God, but his point of view was that of an ordinary man. His main purpose in directing his dark theater was to extricate his themes from legend and to return them to the living world. Most of his actors' experiences—delight, cruelty, injustice, astonishment, sorrow, submission—were no novelty to his audience. But painting usually alienated

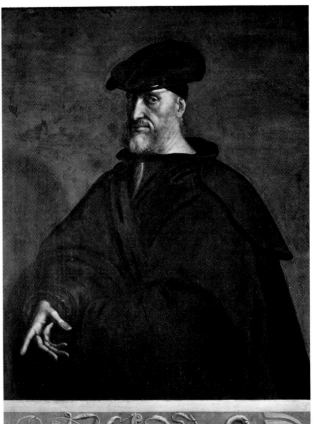

66. Sebastiano del Piombo. PORTRAIT OF ANDREA DORIA. *1526. Oil on panel, 60¼ × 42⅛". Galleria Doria-Pamphili, Rome*

these experiences from ordinary life by presenting them through idealistic forms. Caravaggio gave them back to his audience so that it could identify with them, and could relive them. In this respect he was profoundly in accord with the teachings of the Oratorians. His method was to present his subjects as dramatically and compellingly, but with as much authenticity—of detail, setting and illusion, and particularly of human behavior—as he could muster. He accepted as remarkable, beyond the normal man's ken, such experiences as Saint Paul's conversion or Saint Francis's mystical revelation. But he kept them personal. He shows the saint undergoing a vision, but the transcendent presence is more often intimated by light than personified. He could not refuse, like Courbet, to paint angels when tradition required him to. But he could paint them in the image of man and of the same flesh, even those that fly, and make them all the more miraculous for their material human credibility.

Caravaggio was too concerned with his saints' humanity, and too conscious of their human flaws, for them to be heroic. Saint Peter is weak in the *Denial,* disappointing at

67. Taddeo Zuccaro. THE FLIGHT TO EGYPT. *Pen, ink, and wash with white highlights, 22½ × 13⅞". Cabinet des Dessins, Louvre, Paris*

Gethsemane, and helpless on his cross. Even Christ Himself, beaten, reviled, and humiliated, suffers and is shamed as a man. Caravaggio must have studied his textual sources very carefully, less to assure their doctrinal correctness than to confirm them as human experience. Despite idealistic critics from Bellori to Berenson, who saw his models' simplicity as vulgarity, Caravaggio respected the sacred word too much and felt too much affection for the humble poor, not to maintain their dignity; they never slip into genre.

He had no political intentions. Christ and His apostles were poor people of lowly origin, and the models he chose for them were too. We may now describe them as proletarian, and recognize political significance in that identification. But its implications are of our era, not of his. Sympathetic as he was to the poor, there is no evidence that he was revolutionary in any twentieth-century political sense. His rebelliousness seems to have been entirely per-

sonal, and to have manifested itself in his chaotic private life rather than through any political message in his art.

He seems certainly to have been resentful of his relatively inferior position in the stratified and hieratic society of seventeenth-century Italy. It cannot be merely coincidence that only when he achieved public success did he also pursue public notoriety. Presumably his glimpses into aristocratic society, and his sense of exclusion from it, made him resentful, frustrated, and rebellious—without hope but without fear, as he is reported to have said in a different context. Perhaps he also felt a sense of inferiority in his character—he did portray himself fleeing from Saint Matthew's martyrdom with all too human cowardice; he wrote his name in Saint John's blood; and ultimately he represented himself as brought to justice. He is also reported to have said that all his sins were mortal. Perhaps by concerning himself with the blessed meek, whose humility and submission he never achieved in his own life, he found some hope, guilt-ridden as he may have been and as hopeless as his world and his vanity seemed to be. The great late paintings, with their sincerity and their sobriety, may have been confessional; and Lazarus, clinging to death through sin but miraculously drawn by Christ to a better life, a spiritual self-portrait.

Caravaggio must have been aware of more than elementary contemporary theology. But if some of his pictures make theological points, nothing could be more contradictory of his attitude as a religious painter than to turn them into theological tracts. In his works is a recognition of misery, injustice, and sorrow in the world, and by implication a disdain for human institutions and their power. Of this world his pictures may appear to be, but they are not. They foster belief in the transcendent power of humility, resignation, and faith. They speak through the visible, but they speak of the invisible. They focus on man's body, but their interest is in his spirit and in his soul.

COLORPLATES

BOY WITH A BASKET OF FRUIT ("IL FRUTTAIUOLO")
1593–94

Oil on canvas, 27 1/2 × 26 3/8"
Borghese Gallery, Rome

Expropriated from the Cavaliere d'Arpino on May 4, 1607, this picture was acquired on July 30, 1607, by Cardinal Scipione Borghese and has been in the Borghese Gallery since. It is likely to be Caravaggio's earliest surviving recognized work, painted soon after his arrival in Rome late in 1592. Probably it was done during the eight months he spent working in the studio of the Cavaliere d'Arpino; this would explain D'Arpino's possession of it in 1607. Caravaggio's lively and muscular *garzone* must have seemed misplaced among the languorous exquisites who people the cavaliere's *oeuvre*. But the delectable still life might have appealed to the older painter's sensuality, and he may have kept the little picture as a charming souvenir, which, incidentally, became increasingly valuable as the younger artist became more successful.

Red, black, and white grapes, apples, pears, apricots, figs bursting open, pomegranates, and grape, pear, and lemon leaves form an opulent bouquet of fruit, almost as aromatic and luscious as it is tactile and visual. The image needs no explanation. It is as if Caravaggio had stopped a delivery boy on his way to the cavaliere's dining room with the basket already arranged for lunch and had preserved the instant as fresh and crisp as the fruit itself. Among Caravaggio's early paintings only the lost *Boy Peeling Fruit* seems as spontaneous, intimate, and candid. The image is akin to Velázquez's *bodegones*, without social, economic, or evident symbolic or erotic intention, but valid existentially. Perhaps Caravaggio's juxtaposition of the pretty boy and the lush autumnal fruit was not so innocent, and perhaps the boy himself was not so innocent either. But neither is a necessary implication. If the boy is knowing, he is not as yet fully defined, and he is without sexual conviction or malice. And if Caravaggio reflected on the boy's losing his youth almost as quickly as the fruit would rot or wither and dry, he left that melancholic thought inexplicit.

Bellori admired Caravaggio's "sweet and clear" early manner, and credited its origin to Giorgione. The bright natural colors and the lyricism of the picture do recall Giorgione and his successors, but the still life owes more to Caravaggio's Lombard predecessors like Moretto da Brescia (fig. 3) and Vincenzo Campi. In the articulation of the neck and shoulders, in the musculature, and in the drapery Caravaggio's hand was still a little insecure, as if waiting to learn the lessons of the Roman monumental tradition. However, he had evidently already worked out the basic light system he was to use throughout his career. The source, the natural daylight common to his early works, is from a window offstage to the left, between and above the artist and his model. Its rays illuminate the boy's right side fully, but only the upper third of the background. Thus the picture is composed of contrasting areas of light (most of the figure and the still life, and the upper background) and dark (the model's hair, his right side, and the lower background). The result is an emphasis on the tangibility of the objects in delicately atmospheric space, confirming both the illusion of the eyes and the authenticity of the episode, not as a fabrication of the painter's imagination but as a transcription of his experience.

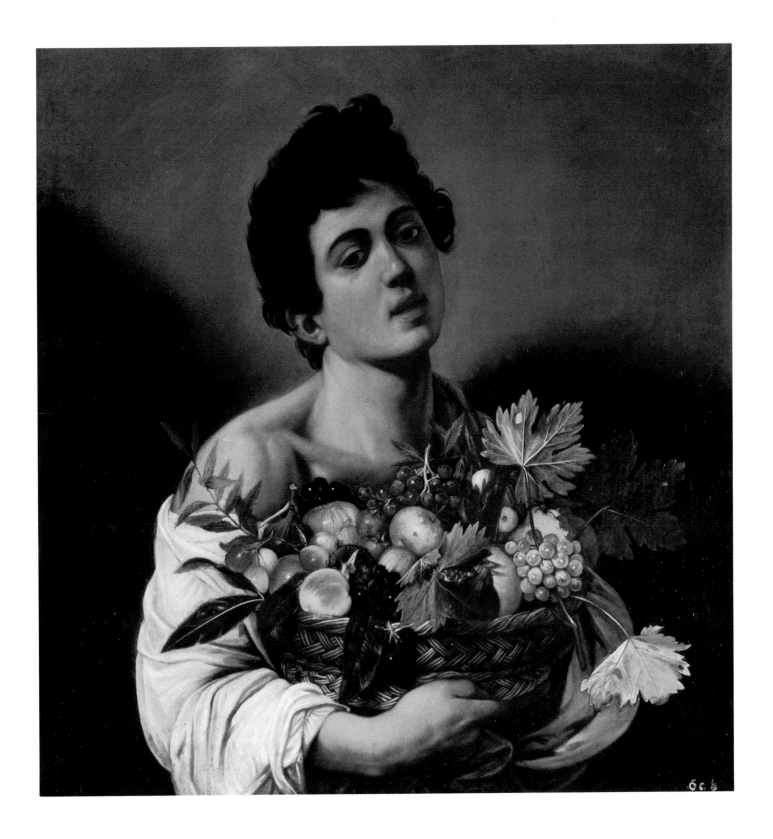

THE LITTLE BACCHUS ("IL BACCHINO MALATO")
1593–94

Oil on canvas, 26 × 20 1/2"

Borghese Gallery, Rome

Another of Cavaliere d'Arpino's possessions taken over by Cardinal Scipione Borghese in 1607, this painting has remained in the Borghese Gallery. It is likely a self-portrait of the artist as a sixteenth-century Jean-Paul Belmondo. The same face appears, a little older, in the authentic portraits of Caravaggio, all from later in his life (see fig. 38 and colorplate 35). The sallow complexion corresponds to Bellori's description of him as dark-skinned, as do the dark eyes and black hair. And the temperament already shows signs of that tempestuousness for which he was to become notorious.

Baglione reported that after leaving D'Arpino's studio, Caravaggio was too impoverished to hire models, so he painted several mirror-image self-portraits. This must be the first, described as "Bacchus with some bunches of grapes." If Baglione's chronology is correct, Caravaggio would be twenty-two. But probably he painted it in the cavaliere's studio, as the provenance suggests, in which case he is a year or two younger.

The face is singularly unidealized. However, the wreath of ivy leaves adorning his head may denote some allegorical meaning. In the 1607 inventory the model was described only as "a youth with a wreath of ivy around his head and a bunch of grapes in his hand." Mancini mentioned a "*bellissimo*" Bacchus belonging to the Borghese, and it was no doubt this picture. Except for a mid-eighteenth-century description of the model as a satyr, old sources offer no other explanation. Recent scholars have spilled much ink attempting to explain the iconography, their interpretations ranging from pagan to Christian; none, however, has been entirely convincing.

Caravaggio was still fresh from the country when he painted it. He must have been responsive to his new Roman environment and sufficiently inspired by the example of the learned subject matter of D'Arpino's paintings to incorporate some symbolism into his own. The image corresponds to Cesare Ripa's description of *Lussuria* in his *Iconologia* (1593): "a Faun with a crown of *eruca* [the modern term is *rugetta*, a delicious salad leaf] and a bunch of grapes in his hand to suggest libidinousness and the *eruca* to invite and urge acts of Venus." The eternally green ivy, substituted for *eruca*, is one of Bacchus's traditional attributes and suggests that the type is timeless if the boy himself is not. Ripa's alternative description of *Lussuria* as a "young woman with curly hair artificially styled . . . and almost nude" corresponds almost as well, apart from the change of sex, which may have been deliberately provocative. Such liberties with a textual source would have come naturally to the young Caravaggio. Probably the image is a composite, a kind of masquerade costume-portrait in which he has wittily transmuted his own carnality into a kind of living symbol.

The pose may have been based on the figure in Raphael's *Parnassus* that has been tentatively identified as Michelangelo Buonarroti (fig. 65). Perhaps Caravaggio fancied himself as the reincarnation of the young Michelangelo, his namesake, who at almost the same age had carved the tipsy, sensual *Bacchus,* and with whom he shared not only an almost pagan appreciation of sense experience but also a similar inclination toward homosexuality. Later in his career, Caravaggio incurred formal debts to Michelangelo and Raphael; in his youth, so naive an identification of himself with the older masters would be in keeping both with his personality and with his situation as an unknown young painter attempting to establish himself in Rome.

The image itself is more contrived and self-conscious than the *Boy with a Basket of Fruit* (colorplate 1), perhaps signs of this developing professional awareness. And it is less innocent. The model—and by extension the painter—has experienced enough to sense his own power and to be confident of it.

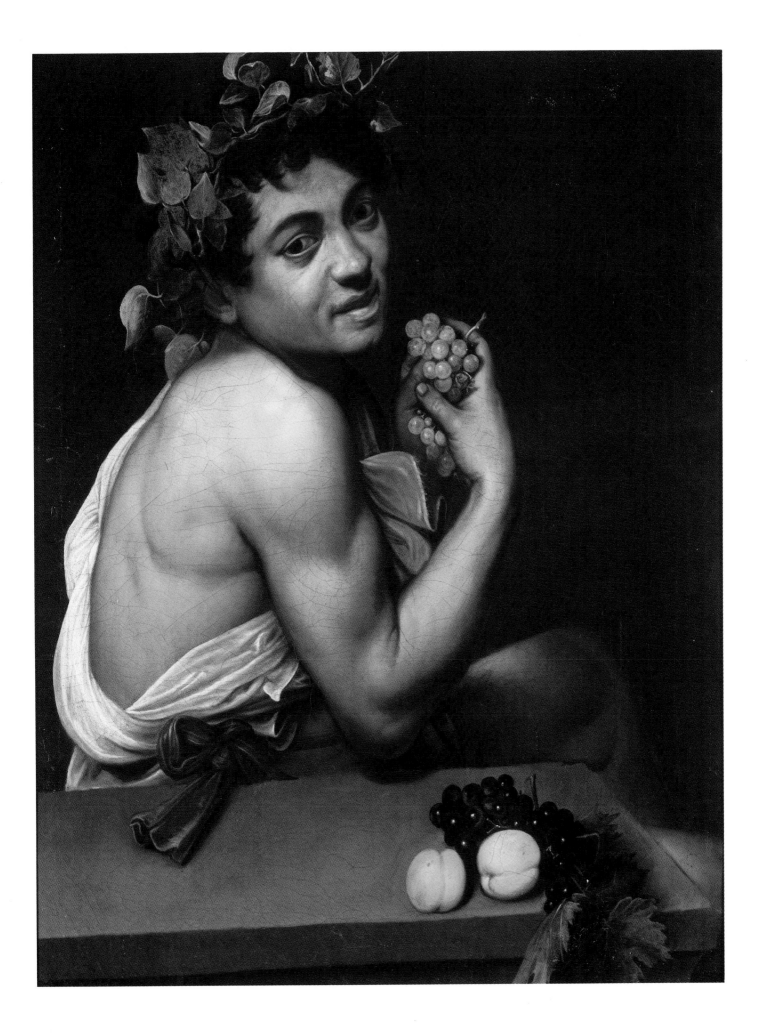

THE FORTUNE-TELLER ("LA BUONA VENTURA")

c. 1594

Oil on canvas, 39 × 52 3/8"

Louvre, Paris

According to Mancini, Caravaggio painted this picture while he was staying with Monsignor Petrignani—and sold it cheap—for eight *scudi*. When Mancini wrote (c. 1620), it belonged to Alessandro Vittrice, but by 1657 Scanelli had seen it in Prince Camillo Pamphili's collection. The prince sent it as a present to Louis XIV when Bernini visited Paris in 1665. Damaged *en route,* it was received with no great enthusiasm. By 1683 it was in Versailles, where it remained until the French Revolution, when it was transferred to the Louvre.

A variant-copy in the Capitoline Museum in Rome is probably the version that belonged to Cardinal del Monte, which after his death was acquired by Cardinal Pio. His eighteenth-century heirs sold it to Pope Benedict XIV, who added it to the Capitoline collection in 1749.

Mancini described the action as "a gypsy girl . . . telling a youngster's fortune. . . . [She] demonstrates her roguishness by faking a smile as she removes a ring from [his] finger. . . . he, by his naiveté and libidinousness, unaware that he is being robbed, smiles at her." The theft is barely visible; it does not appear in the other version. Although her neatness and her well-scrubbed look may be less than authentic, the girl's voluminous cloak tied over one shoulder and her linen turban and blouse are historically correct. They were first described in France in 1421, and gypsies continued to wear them until the end of the seventeenth century. Fortune-telling was also a customary gypsy trade, although raffish, as is made obvious by her suggestive caress of the mount of Venus on the boy's palm.

A recent proposal to pair the painting with the contemporary *Cardsharps* ("*I Bari*") as an incident in the adventures of the prodigal son makes sense (fig. 24). The moralistic, nominally Christian theme would have appealed to Cardinal del Monte, particularly in so lighthearted a form. The artist apparently intended to present more than a contemporary anecdote. The picture owes its origin to the satirical theater, as is suggested by an engraving from the *Commedia dell'Arte,* in a collection of late-sixteenth-century prints, the *Receuil Fossand* (National Museum, Stockholm). There are three figures in the engraving and they are full-length, but otherwise Caravaggio's composition follows it closely. Evidently the youth, with his shining morning face, is a willing dupe, defrauded no less by his own vanity in wanting to know the future and by his gullibility and erotic responsiveness than by the gypsy's guile. Nor does the gypsy escape the artist's mockery. Her pretty little face is sly and complacent. Thus what might have been merely a condescending venture into picaresque triviality is transformed into an elegant satire of human folly.

With his usual hyperbole, Caravaggio's friend Gaspare Murtola asked rhetorically in a 1603 madrigal on the painting: Who is the more deceptive, the gypsy or the artist? Caravaggio was no less seductive with his brush than she with her sweet talk and nimble fingers. It is a charming picture, but the space is somewhat ambiguous, as if Caravaggio had not yet solved the riddle of representing three-dimensional forms on a flat surface. And there are a few lapses in verisimilitude—in the doublet, for example, and in the hilt of the boy's rapier. The system of light is the most complex that Caravaggio had yet attempted. The source, a window to the left reflected in the hilt of the rapier, illuminates the whole space and much of the back wall. The streak of shadow between the two streams of light suggests a curtain half-drawn above a sash. But this background illumination has been adjusted to contrast with the figures' forms. It also casts the gypsy's face a little mysteriously into shadow and brings the boy's innocence into full light. Most of all, the light is silvery and lyrical, radiant as the youth and as pretty and transparent.

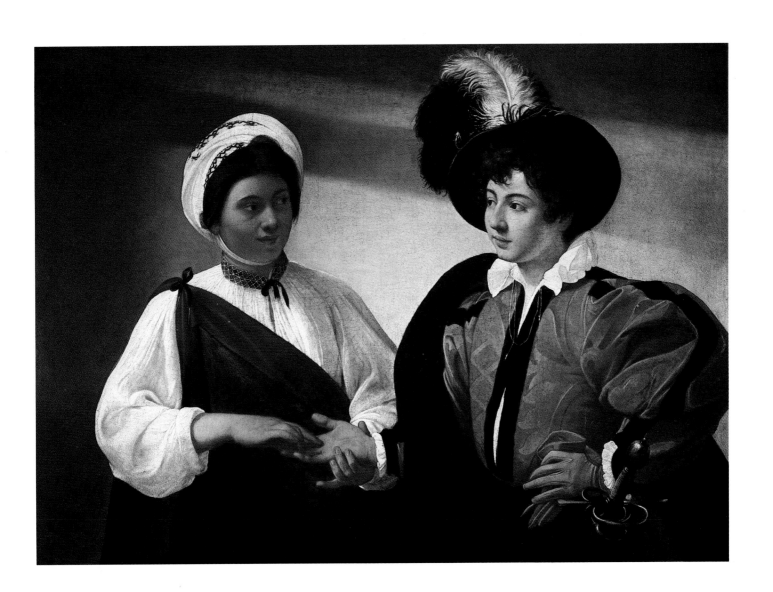

THE MUSICIANS

1595–96

Oil on canvas, 36 1/4 × 46 5/8"

The Metropolitan Museum of Art, New York City. Rogers Fund, 1952

Remains of an old inscription appear on the lower left: [MIC] HELANG DA CARAVGIO. This work, painted for Cardinal del Monte, was listed in the 1627 inventory of his estate. It next appeared at Christie's in 1834; it then passed unrecognized through a series of English private collections until 1953, when the Metropolitan Museum bought it.

In an ill-advised cleaning before the Metropolitan acquired the painting, a quiver of arrows and a pair of wings, mistakenly believed to be later additions, were removed from the boy in the left background (recently uncovered and restored). Early copies (see fig. 23) reveal that they were by Caravaggio's own hand and that the canvas had been cut down about two inches on the left side and slightly on the top and bottom.

This garland of youths was the first picture mentioned by Baglione among works that Caravaggio painted in Cardinal del Monte's household. Unreliable as Baglione's chronology is, the implication that it marked Caravaggio's debut as the cardinal's *protégé* is reasonable. Close in theme and style to the pre–Del Monte paintings, the four-figure composition is more ambitious, as might be expected of a young painter in a secure position for the first time. The subject matter is in accord with the cardinal's passion for music, his reported fondness for *beaux garçons,* and the pleasure he found in entertainments combining both. Intimate concerts had been standard pastimes since the Renaissance and were often painted, although usually the company was mixed.

Clearly Caravaggio's painting reflects his own environment. It is an intimate scene, the costumes casual, the grouping informal. The musicians are tuning up, as if about to begin. Two of them look out at the spectator expectantly, as if waiting for him to signal them to start, or even to pick up the violin and join them. Probably they are members of Caravaggio's circle of friends: the central figure appears to have been the model for *The Lute Player* (colorplate 5), the *Bacchus* (colorplate 10), and the *Boy Bitten by a Lizard* (colorplate 9); the Cupid, who has been identified as Mario Minniti, may well have been the model for the *Boy Peeling Fruit* and the angel supporting Saint Francis (colorplate 6; he might also be the boy in the right foreground of *The Musicians*); and the shawm player seems to be another self-portrait of the artist, much idealized. It would be naive, however, to accept this picture literally as a slice of Caravaggio's life, even in Cardinal del Monte's pampered establishment. The boys come from a discreetly erotic dreamworld, their costumes *all'antica* and their faces too pretty, unblemished, and regular.

Vasari described love as "always in company with music." If we could identify the music, it might convey the message more explicitly. One of the partbooks is alto with the initial B, the second tenor with the initial P, and the third shows neither clef nor initial. But there are no words, and at least one music historian has doubted that the scores are significant to the painting's meaning. Even without such a specific clue from the scores, the combination of the grapes, the Cupid, and the harmony of music, both the upper (the lute) and the lower (the shawm) orders, makes clear the pleasures that await only our joining in.

An allegorical interpretation of the picture as *concordia discors* has been proposed: the Cupid representing intoxication, the shawm player irrational experience, the boy with the music reason discovering harmony; and the central figure creating a harmonious conjunction of these three aspects of human experience. Whether so specific an interpretation is justified or not, the basic idea seems correct. Each of the figures is at the moment self-contained and detached from the others; but the lute player has only to start the music to bring them together.

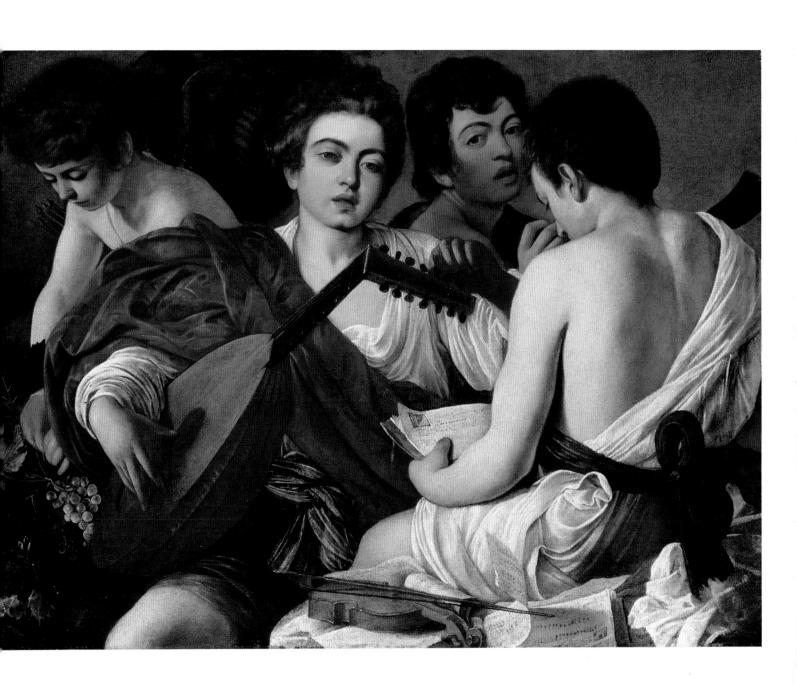

THE LUTE PLAYER

1595–96

Oil on canvas, 37 × 46 7/8"

The Hermitage, Leningrad

Another Del Monte painting, mentioned by Bellori and in the 1627 inventory, *The Lute Player* was sold to Marchese Giustiniani, in whose inventory of 1638 it appeared. In the Giustiniani sale in Paris during 1808, it was acquired by Denon Vivant for the Hermitage.

The same boy, in much the same pose, is the central figure in *The Musicians* (colorplate 4). He has now come out into the open, for we can read the first line of his music: "*Voi sapete ch'io v'amo . . .*" (You know that I love you . . .), from a madrigal by the famous sixteenth-century French composer Jacques Arcadelt, whose music was certainly familiar to Cardinal del Monte. The lute is a tenor, and the score is open at the tenor part. Could the closed score, marked Bassus, await the missing lover? Does the musician's wistful expression suggest that the lover is gone for good, that physical love is no more endurable than the freshness of the flowers, and that his youth and beauty are as fleeting as the sound of his music and as illusory as the reflection in the carafe? Does the closed score also indicate that love is done with, and that the musician is left in solitude? Is the whole picture not a *Vanitas* theme, a melancholic lament for the impermanence of the things and experiences of this temporal, physical world?

The androgyny of the lute player confused later writers and critics, including Bellori, who described the model as a woman in a blouse. Baglione correctly identified the model as male and admired the still life for the freshness of the bloom on the flowers and for the reflection of the window in the carafe. He added that Caravaggio said it was the most beautiful picture he had ever painted.

Caravaggio painted at least one other picture of a model with a floral still life, the *Boy Bitten by a Lizard* (colorplate 9). But *The Lute Player* is the only such picture that survives in a certainly autograph version. Like so many of Caravaggio's paintings, the composition—a horizontal which balances the lute player and the bouquet—is unique. We already know the boy and his pose, the lute, the violin, and the scores from *The Musicians*, the angled table from *The Little Bacchus* (colorplate 2), and the pattern of contrasting light, dark, and color from the whole series of youthful works. But Caravaggio painted only two other horizontal single-figure compositions, the Borghese and Maltese *Saint Jeromes*, both much later in his career and both different thematically. His bouquet in the *Boy Bitten by a Lizard* is much less opulent and is subordinate to the figure. In contrast, this bunch of flowers is almost antiphonal in its relation to the figure. It does not quite crowd the musician out of the picture but it is large enough in scale and so vivid in color and animate in detail as to demand attention less as an accessory than as a counterpart to the figure.

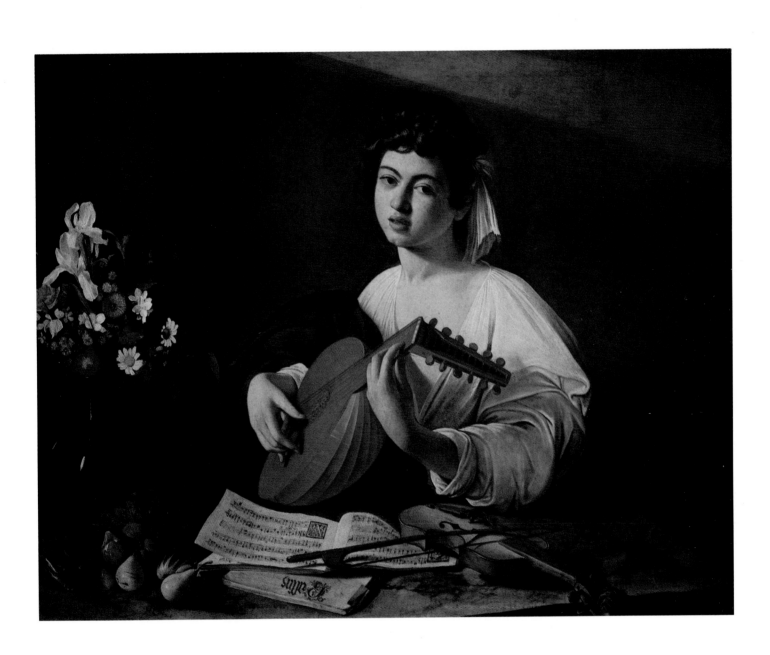

THE ECSTASY OF SAINT FRANCIS

c. 1596

Oil on canvas, 36 3/8 × 50 5/8"

Wadsworth Atheneum, Hartford, Connecticut. The Ella Gallup Sumner and Mary Catlin Sumner Collection

In the inventory of Cardinal del Monte's estate in 1627, and sold the following year, this painting then disappeared until 1938, when it reappeared in a private collection in Trieste. Since 1939 it has been in Hartford, Connecticut. Another version, mentioned in Ottavio Costa's will of 1606, may be the copy in the Civic Museum in Udine.

The picture represents both the ecstasy of Saint Francis and his stigmatization, which took place before dawn while he was in prayer on the heights of Mount Alverna in Umbria. He had a vision of a radiant six-winged seraph enshrining the figure of the crucified Christ. As the vision faded, Francis experienced metaphorical death in this world and rebirth in Christ through Divine Love, symbolized by the angel, who is supporting him figuratively as well as literally. At that moment, the stigmata appeared, as the bodily manifestation of Saint Francis's spiritual transformation. The wound on his right breast is evident; apparently a wound once on his right hand was at some time painted out.

Caravaggio painted Francis's eyes almost closed and completely unseeing, and did not show the seraph. Thus, although the vision is manifest by the angel's presence, by the saint's swooning pose, and by the light falling on them from an inexplicable source above, it is not physical but spiritual. Only Francis sees it; his ecstatic experience is private, taking place within his mind rather than as a public display. Nonetheless, in the background sky are streaks of light visible to a group of shepherds gathered around a campfire. They correspond to a passage in the standard popular work on the saint, *The Little Flowers of Saint Francis*, first published in 1477, in which the mountain is described as miraculously illuminated by divine light during the vision.

The stigmata makes clear the saint's identification with Christ, his imitation of Christ. This theme is also implied by the shepherds' wonderment, recalling the Annunciation to the Shepherds at the time of Christ's birth, and by the poses of the two principal figures. They may be derived from earlier pictures of the dead Christ supported by an angel or by some other sacred figure—like Christ and the Virgin Mary in Correggio's *Deposition* (National Gallery, Parma). An analogy to Christ on the Mount of Olives may also have been intended.

This manner of representing Saint Francis's stigmatization, in both its mystical and its personal aspects, seems to have been invented in this picture. It shows a remarkable similarity to the thought of Saint Francis de Sales (1567–1622), who did not visit Rome until 1605, or publish his *Traité de l'Amour de Dieu* until 1616. However, through Cardinal del Monte's circle, Caravaggio must have had access to some of De Sales's sources.

The picture was probably painted for Cardinal del Monte. His given name—Francesco (Francis)—may even have determined the choice of subject for his new young *protégé*'s first religious painting. It is also Caravaggio's first known nocturnal work. And it might be his first angel, inspired by a drawing by Peterzano in the Castello Sforzesco in Milan (fig. 61). The model for the angel seems a year or two older than the Cupid in Cardinal del Monte's *Musicians* (colorplate 4). Probably, then, the picture was painted in late 1596, a year or so after Caravaggio went to live in the Palazzo Madama. It would also seem to be his first painted response to the influence of Roman religious circles, clearly anticipatory of the second *Conversion of Saint Paul* (colorplate 20) in the characterization of the saint's vision as within his mind. It also anticipates his use of divine light as illuminating the darkness of mankind's world.

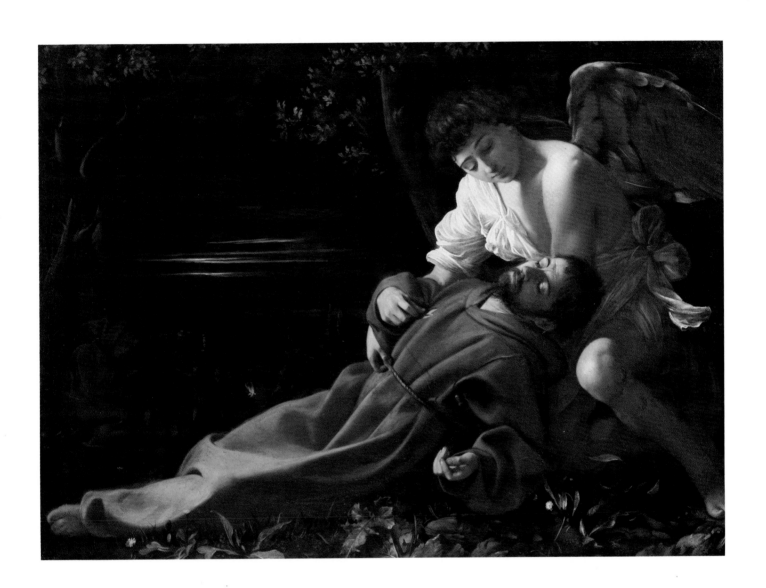

PENITENT MARY MAGDALENE

c. 1596–97

Oil on canvas, 41 3/4 × 38 1/4″

Galleria Doria-Pamphili, Rome

Bellori liked the "pure . . . and true" colors of this painting and its simplicity, but he felt it was unconvincing as a religious work, seeing it as merely a representation of a woman drying her hair, with the carafe of precious oil and the few pearls having been added to establish her identity as Mary Magdalene. It is a pretty picture, but it is in substance Christian, the poor woman tearfully repentant and ashamed of her past as a harlot, symbolized by the overrich clothing and the jewels she has discarded. The pearls, born of the sea like Venus, are a symbol of love, perhaps not only the sensual love she has cast off but also the Christian love she has taken up. The pose seems derived, appropriately, from a print of another prostitute-saint, Thais, by Parmigianino.

The painting's religious import is reinforced, rather than compromised, by the contrast between its charm as genre and its spiritual meaning. Mary's rejection of the sensual world for the world of the spirit and her hope of redemption through the forgiveness of sin are made compelling by her representation as an ordinary woman rather than as sanctified. Because she is recognizably human, a remorseful sinner, her experience becomes accessible to other humans. Thus what Bellori saw as frivolous secularity is instead an effective, if deceptive, means of developing universal human appeal. From this point of view, the painting is characteristic of the Counter-Reformation, conveying a basic Christian message through appeal to the senses.

The painting is different from Caravaggio's other youthful works in its suppression of most highlights, particularly on the flesh and the drapery. Past restoration may have reduced the highlights somewhat, but the general effect is of an intentional utilization of softer light, modified by atmosphere. The diffusion of light is particularly evident in the obscurity of the background line separating the planes of the floor and the wall, the first known instance of Caravaggio's defining the volumes of a room so completely.

The skillfully painted drapery guarantees a date after *The Musicians* (colorplate 4), as do the more complex space and light effects. It must be a Del Monte picture. It is close to the *Rest on the Flight to Egypt* (colorplate 8); the model (who has literally let her hair down) is probably the same as that for the Virgin: her pose is similar, as is the motif of the drapery across her knees trailing off to the right. And her humility is hardly less. Perhaps the picture was a rehearsal for the larger and more ambitious *Rest*. But the exceptional quality of the light might suggest that it was experimental. The Magdalene's isolated self-containment, reminiscent of North Italian prototypes, and her loneliness are intensely expressive, particularly in contrast to the gay life she has just left. Whether before, contemporaneous with, or after the *Rest*, the picture is self-sufficient.

By 1657 Prince Camillo Pamphili owned the painting (Scanelli). Why Cardinal del Monte did not keep it and the *Rest* with his other religious paintings by Caravaggio is difficult to imagine. Was he short of money? Or were these two paintings too gentle for his taste? Or was he, like Bellori, so short-sighted as to see the *Magdalene* only as an attractive genre painting?

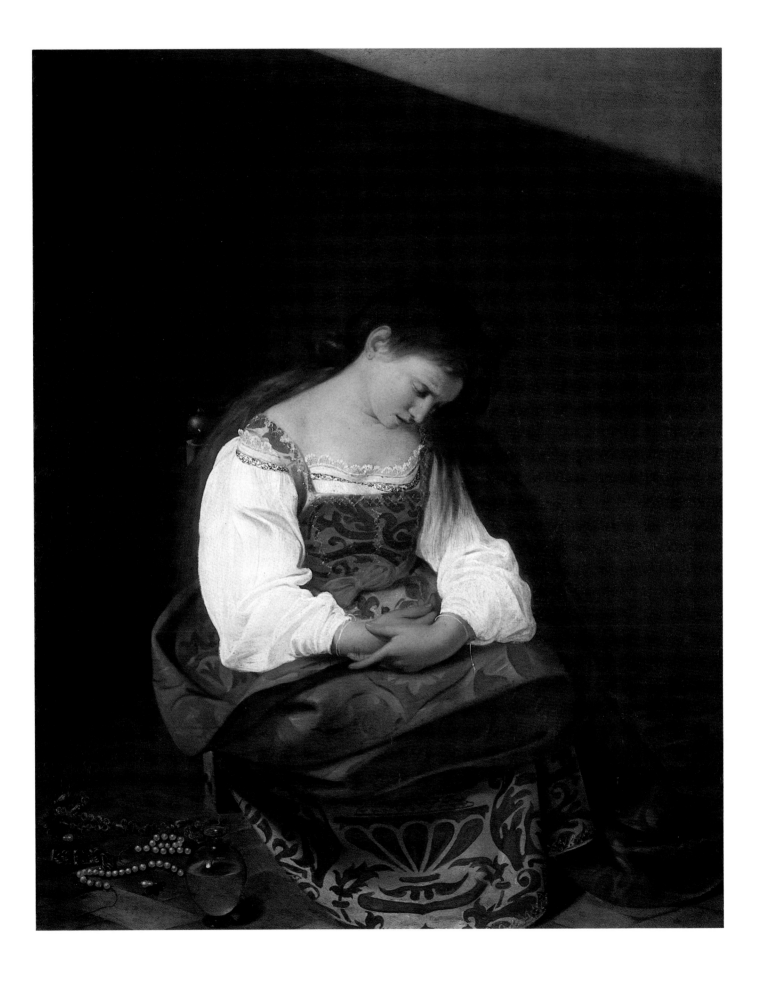

REST ON THE FLIGHT TO EGYPT

c. 1596–97

Oil on canvas, 51 1/4 × 63″

Galleria Doria-Pamphili, Rome

Following an old North Italian tradition, Caravaggio conceived the subject as a kind of *fête champêtre*, a musical picnic. Set in a verdant and well-watered dell on the Lombard plain, it is as lyrical as comparable works by Giorgione and his successors. But the deserted and untilled landscape is almost as different from Giorgione's well-tended park-like settings as it is from the harsh wastes of the Sinai Desert. Caravaggio's Madonna and Child and dumpy old Saint Joseph are at home in their rural pastoral setting. Nicely dressed as they are, they are humble: the Virgin is seated on the ground; Saint Joseph rests on a sack-like saddlebag, and the infant, an ordinary pretty sleeping baby, is without even a halo to hint of His divinity. If the angel were less gentle, he would seem an intruder. Perhaps he is a kind of Orpheus, charming even the donkey with his music. Its melody seems as much an emanation of nature as the other sounds, the rustle of the leaves of the Lombardy poplars in the light breeze and the murmur of the water.

Despite the placidity of its mood, this is a complicated picture. The Holy Family sits in a row, countered by the projection of the angel's wings and by the recession of space into the distance. The brightly colored complex drapery patterns and the luxuriant foliage would give the picture a patchwork effect, like a kind of illusionistic Douanier Rousseau, had not Caravaggio been so skillful in subordinating detail to the whole. As it is, the foliage forms a kind of lacy border to the irregular two-dimensional, hexagonal block of figures. This richness of detail, more than any other single feature of the painting, suggests the possibility of a considerably later date than has been supposed; only in the London *Supper at Emmaus* (colorplate 18) did Caravaggio allow his love of detail such free, not to say extravagant, play.

Although his contemporaries often represented the *Rest* as a night scene, Caravaggio chose to depict it in daylight, with neither the drama nor the contrast of light and dark of his later pictures. It may therefore be simultaneously the last painting of his North Italian youth and one of the first of his Roman maturity, with the gentle lyricism of the former and at least the potential grandeur of the latter. The Madonna recalls Moretto but the arrangement of the Holy Family seems to derive from a drawing by D'Arpino (fig. 22). The angel was probably inspired by the similar central figure of Annibale Carracci's *Choice of Hercules* of 1595, so the picture must have been painted later. It was certainly done in the Palazzo Madama, although apparently not for the Del Monte collection. Prince Pamphili owned it by 1672 (Bellori).

The painting is appealing and even slightly sentimental. Despite the epicene angel, it is without the psychological problems of Caravaggio's pictures of boys, or their ambiguity of meaning. The assurance of conception and execution demonstrates Caravaggio's full mastery of the art of painting.

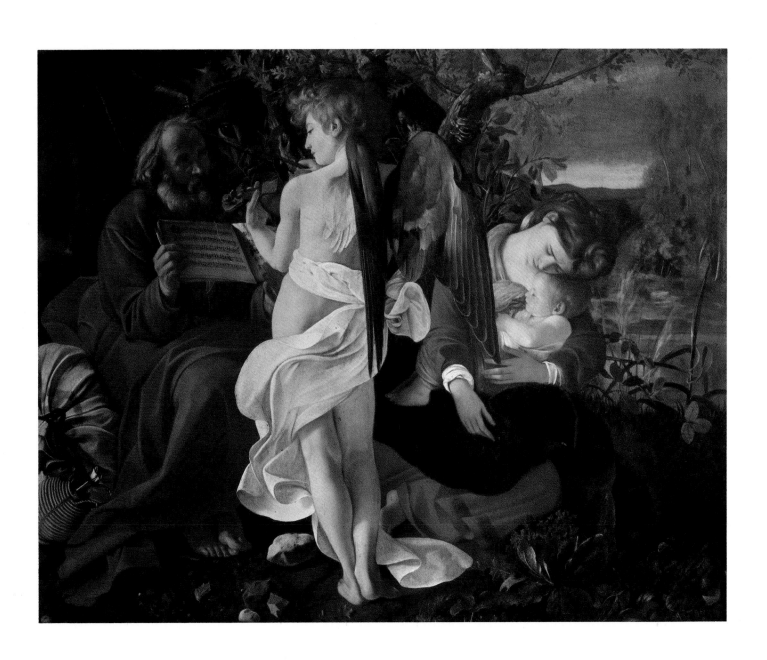

BOY BITTEN BY A LIZARD

1596–97

Oil on canvas, 27 1/2 × 22 3/8"

The National Gallery, London

Mancini described this subject as having been painted while Caravaggio was staying with Monsignor Pucci and said the young artist sold it for the miserable sum of fifteen *giuli*. This date is certainly too early. Sandrart implied it to be slightly later, when Caravaggio was working for D'Arpino. But the sharp contrasts between light and dark and the violence of the action require it to be later still, during Caravaggio's activity for Cardinal del Monte. The filmy drapery must place it with *The Musicians* (colorplate 4) and before the *Bacchus* (colorplate 10). But the light, the action, and the sense of disenchantment anticipate the paintings of the last years of the century. Presumably, therefore, it represents a glance forward in time. Perhaps it was motivated by a disappointment in love that destroyed the young Caravaggio's euphoria but had not yet completely disillusioned him, although readying him for *Bacchus*'s cynicism.

Of the three known versions of the subject, this one is the best; despite some damage and repainting, it does convey the appearance of Caravaggio's original image. The reflection in the carafe corresponds most precisely to Bellori's description of the *Carafe of Flowers*. It is even possible that it stood in the same relation to this painting as Cardinal Borromeo's *Basket of Fruit* (colorplate 17) does to the London *Emmaus* (colorplate 18), and that it transformed this detail in a figure painting into a picture that was complete in itself—or vice versa.

The reflection is the most explicit in Caravaggio's *oeuvre*. Probably it can be accepted as depicting the window in his studio at the Palazzo Madama that served as the principal source of daylight for his Del Monte pictures.

It seems very likely that this picture is allegorical. Perhaps it is a successor to *The Lute Player* emblematically as well as chronologically. The lizard obviously had an unpleasant connotation; some old sources say death, others lust. This second meaning corresponds neatly with the paired cherries, symbolic of love, and the roses, which, among other meanings, can refer to venereal disease. Both are certainly symbols of venery and would be in keeping with the mock-heroic character of the whole painting, as warning of its pitfalls.

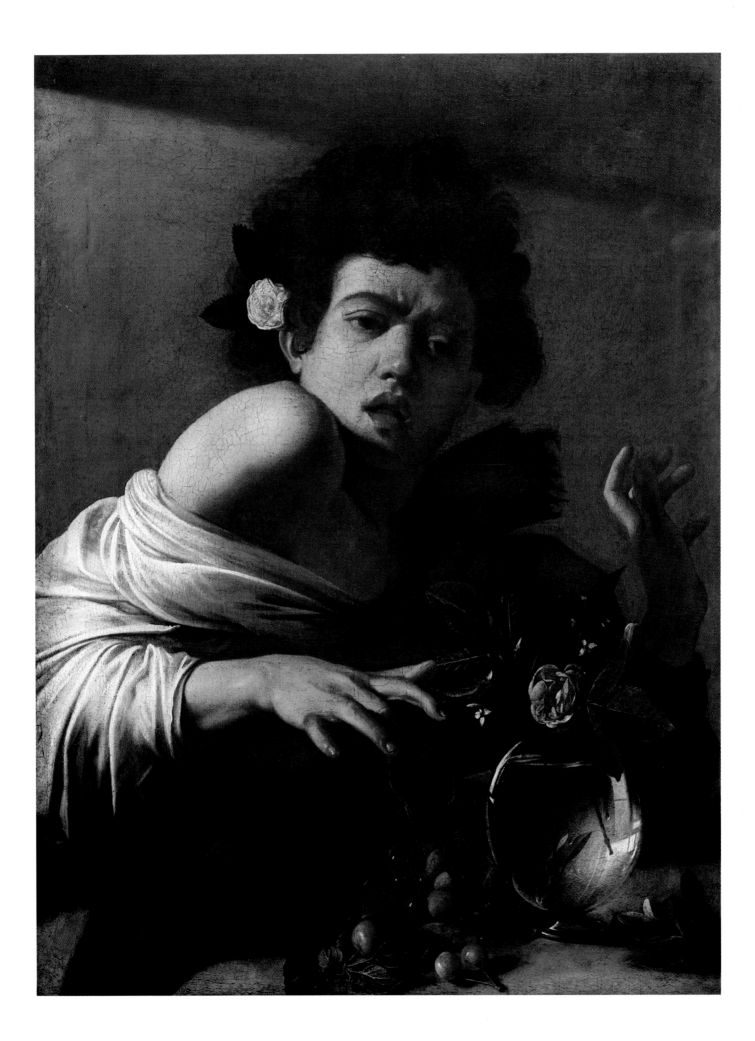

BACCHUS

c. 1597

Oil on canvas, 37 3/8 × 33 1/2"

Uffizi, Florence

Despite recent scholarly efforts to establish the *Bacchus* as an allegory—of the sense of taste, or even of Christ—the painting remains sufficient and convincing as simply the portrayal of a boy dressed as the ancient god of wine. It is less a satire than a kind of living symbolism. The same model served for the *Boy Bitten by a Lizard* (colorplate 9), as the central figure in *The Musicians* (colorplate 4), and perhaps for *The Lute Player* (colorplate 5).

It is Caravaggio's first obviously classical work. The boy is a muscular ephebe, lolling on a *lectus*, an ancient couch, and dressed not in the flimsy shirt of a contemporary musician but in heavier stuff, reminiscent of the carved drapery in ancient Roman sculpture. His hair, surely a wig, is crowned with a wreath of black and white grapes and their leaves, and he offers the viewer a glass kylix of red wine, the cup of pleasure. Caravaggio's inspiration was one of the many surviving statues of the Emperor Hadrian's beloved, Antinous, who was often represented as Bacchus; perhaps it was the full-length statue of the god that belonged to the Marchese Giustiniani, and was engraved about 1630. The pose seems derived from a frescoed *Bacchus* painted by Federico Zuccaro during 1584–85 in a lunette in the studio of his house in Florence (fig. 14).

The objects on the table are palpable under natural light which, however, casts no shadow on the background. The illusion is as seductive as the boy himself. He offers not only wine but himself as well: his right hand toys with his sash, which barely holds his drapery together. The image is a kind of imposture: the pose and costume, the affected coiffure, plucked eyebrows, pudgy hand, and plump hairless body are betrayed by the disturbingly muscular arm and the sullen provocative expression. Berenson saw him as "an Indian god, destructive and pitiless."

Someone may have dictated to Caravaggio devices to transfigure the paganism of the image into concealed Christian symbolism. Knowledge of some such signification may have made the picture acceptable to connoisseurs. But what Caravaggio characterized was a body dedicated to sensuality rather than a soul infected with Christianity. The sly, dreamy eyes speculate on carnal things and promise gratification of the senses, not of the spirit, as "love cools without wine and fruit." Yet the possibility of an underlying moral, bizarre as it may seem and contradicted by appearances, cannot be totally ignored. The touches of corruption in the still life—the wormhole that has spoiled the apple, the pomegranate that has burst from overripeness—hint again of the *Vanitas* theme, that the boy is triumphant only in his youth, which will vanish as quickly as the bubbles in the carafe of freshly poured wine.

Although it has no known history before it was found in the storerooms of the Uffizi in 1917, the *Bacchus* must have been painted while Caravaggio was under Cardinal del Monte's protection. It is the climax, the most assured and the most virtuosic of the series of pictures of boys at the onset of his Roman career. It could well be contemporaneous with the ceiling of the Villa Ludovisi of about 1597. It might even be later; the elaboration of the still life and the opening up of pictorial space anticipate the London *Supper at Emmaus* (colorplate 18). Caravaggio evidently had not lost any of the skill and sensitivity he had acquired in Lombardy; but he has now fused them with Roman monumentality.

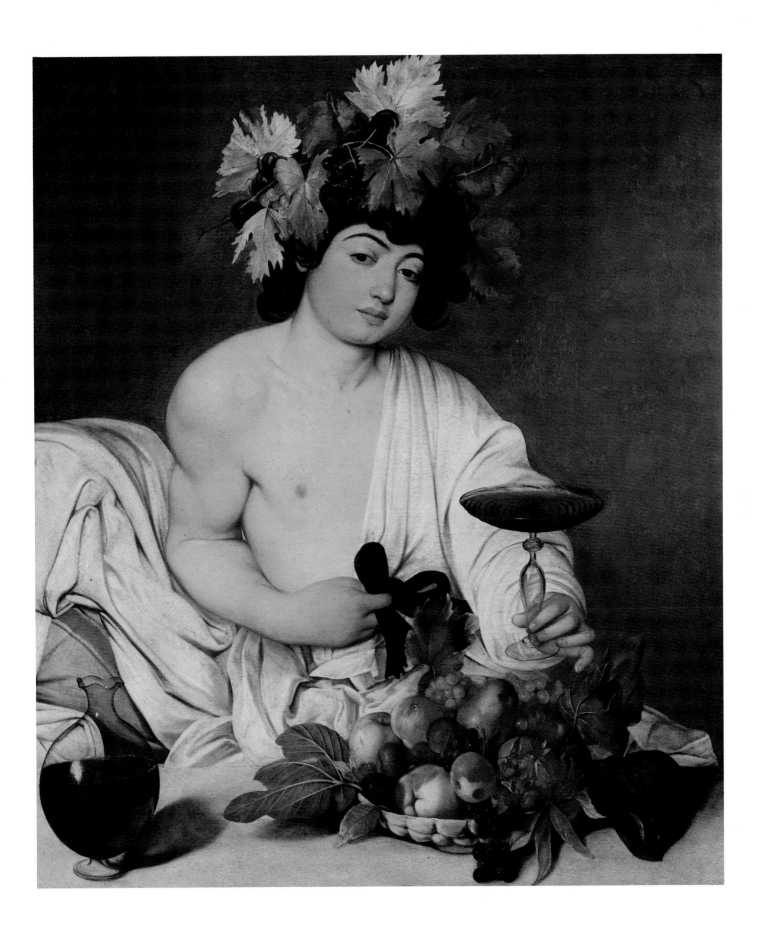

JUPITER, NEPTUNE, AND PLUTO
1597

Oil on stucco, about 9' 9" × 5' 11"

Villa Ludovisi, Rome

Cardinal del Monte bought the villa on November 26, 1596, and occupied it a month later. Probably Caravaggio painted the ceiling during the following months. The cardinal sold the villa to the Ludovisi family in 1621, and it was remodeled and redecorated, in part by Guercino, soon afterward.

The only seventeenth-century reference to this painting is Bellori's rather uncertain description:

> The *Jove, Neptune and Pluto* . . . is still believed by some to be by his [Caravaggio's] hand; the cardinal, who was interested in chemical medicine, had [Caravaggio] decorate the study of his laboratory, using these gods to symbolize the elements with a globe of the world in their midst. It is said that Caravaggio, hearing himself criticized for not understanding either planes or perspective, justified himself by arranging the figures to be seen from below, so that they would compare with the most difficult foreshortenings . . . These gods . . . are painted in oil on the vault, Caravaggio never having touched brush to fresco.

The painting was ignored until 1969, when an Italian scholar rediscovered it, and critical opinion of it is still divided.

Cardinal del Monte's principal laboratory was in the Palazzo Madama. This room in the villa was probably his private study, where he might have been more willing to permit his *protégé* to attempt his first—and, as it turned out, only—ceiling decoration. The telltale outlines incised around the figures betray their origin in the fresco technique. Perhaps the attempt to paint in oil on stucco was Del Monte's idea, inspired by Leonardo da Vinci's efforts in *The Last Supper* in Milan. Solving the technical problems would have appealed to the cardinal's interest in chemistry, and, in fact, despite some losses the ceiling has survived three centuries of neglect surprisingly well.

The three gods, Chronus's sons, bear a family resemblance to the Uffizi *Bacchus* (colorplate 10). Caravaggio was clever enough to have created this likeness consciously. It is no less convincing stylistically: the compact masculinity of the figures is defined by the same unbroken outlines and the same anatomical generalizations as in the *Bacchus*. Neptune is easily recognizable as Bacchus's bearded older brother, no less for his plump, rather effete hand than for his distinctive nose and arched eyebrows. The bits of white drapery scattered over the ceiling might literally have been cut from the same bolt of cloth as the white stuffs in the *Bacchus* and *The Musicians;* certainly they fall into the same patterns of convoluted folds.

The perspective effects, lacking any architectural point of reference within the painting, are daring but not unexpected in a showpiece by a cocky young artist. Perhaps Caravaggio was helped by the cardinal's brother Guidobaldo, who wrote a distinguished treatise on perspective. He surely made use of prints of earlier sixteenth-century perspective ceilings, notably Giulio Romano's in the Palazzo del Tè, Mantua.

The cardinal himself, or some member of his circle, must have worked out the iconography, based on Paracelsus, the most influential sixteenth-century alchemist, whose portrait hung in the cardinal's laboratory. He believed all natural things to be derived from a triad of elements: sulphur-air (Jupiter), mercury-water (Neptune), and salt-earth (Pluto). In the painting, Jupiter, floating on top between his two brothers, is manipulating a celestial globe containing the earth, the sun, and the stars, in order to achieve the astrological conditions propitious for the processes that Paracelsus called the Great Work, whereby the three elements could be transformed into the philosopher's stone, that is, the elixir of life. The philosophical implication is that by mastering the elements and therefore the material world, man might also control his own spirit, surely an appropriate sentiment for the private study of a learned sophisticate like Del Monte.

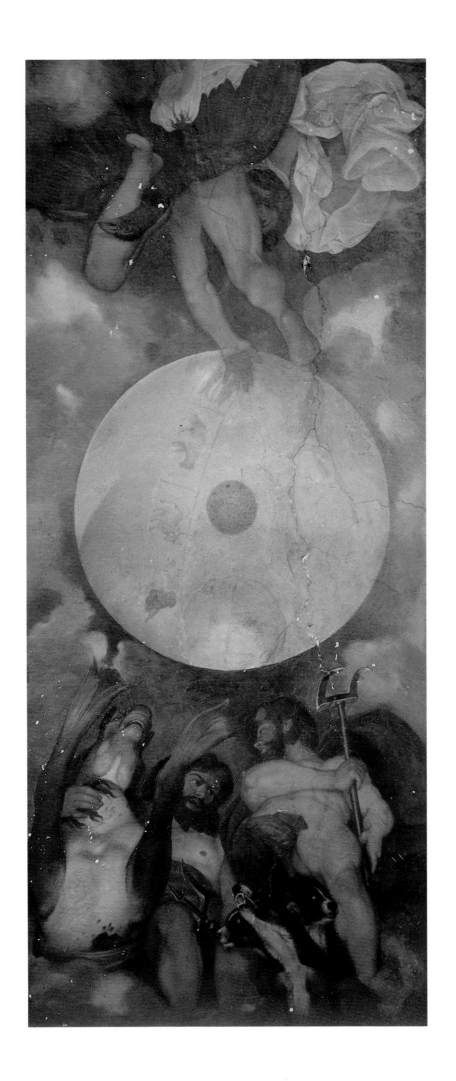

JUDITH BEHEADING HOLOFERNES

c. 1598

Oil on canvas, 56 3/4 × 76 3/4″

Galleria Nazionale dell'Arte Antica, Rome

According to Baglione, this work was painted for Ottavio Costa. Mentioned in his will of 1632 and in his estate inventory (1639), the painting was soon acquired by the first of a succession of noble Roman families, from whom it passed to the National Gallery in 1970.

It might serve as an emblem for "women's lib": the *macho* oppressor destroyed by a virtuous resolute woman, whom he had intended to victimize in sexual exploitation. Caravaggio was certainly aware of Judith's traditional identity as a symbol of triumph over tyranny; but he presented the subject primarily as a melodrama, choosing the relatively rarely represented climactic moment of the actual beheading of Holofernes. Judith, young, beautiful, and physically weak, draws back distastefully as she seizes Holofernes's hair and cleaves through his neck with his own sword. Holofernes, on his bed, powerful but drunk, nude, and bellowing helplessly, has frozen in the futile struggle of his last instant of consciousness. The bloodthirsty old servant, popeyed as she strains forward, clutches the bag in readiness for the disembodied head. It is a ghastly image, with primary interest in the protagonists' states of mind: the old woman's grim satisfaction, Holofernes's shock, and Judith's sense of determination. Caravaggio intensifies the body language not only in the poses, gestures, and facial expressions but also in the clenched hands. Drama has displaced the charm of his earlier epicurean paintings, as if the world had ceased to be his oyster and become a battlefield.

His manner of painting has changed correspondingly. The *Judith,* his first picture of serious violent action, announces his discovery of the dark interior that was to characterize the rest of his *oeuvre.* The light still comes from the left. It is now an artificial flash, fracturing the opacity of the interior. It turns Judith into a brilliant central pillar, and it shatters Holofernes's writhing body, thus contrasting her mastery of the situation with his defeat. However, having arrived at this sensational moment, they cannot escape it. For the sharp definition of their contours has paralyzed them, and the frieze-like composition imprisons them. They are removed from the time and three-dimensional space that are indispensable to sequential action. The picture recalls a visit to a waxworks; the figures are immutable, and continuity has ceased eternally for them. Perhaps this petrification is the fault of the apparent source of the composition, a *Judith* fresco from the school of Daniele da Volterra on the Piazza Navona facade of the Palazzo Massimo alla Colonna (fig. 31).

If the figures have become static, they continue to be made of convincingly solid flesh, displacing space. But the voids around them are at least as black and two-dimensional as they are empty and three-dimensional. The picture resembles a photograph taken with a wide-angle lens, unfolding panoramically rather than penetrating depth within a single frame of vision. The starting point, strangely enough, is the least important figure, the servant, whose precisely profiled head—in relief rather than fully rounded—implies a viewpoint from in front of the right edge of the painting rather than from the center. This peculiarity was probably the result of Caravaggio's having not yet fully developed the technique of rendering on a two-dimensional surface the effect of vigorous action within fully convincing three-dimensional space. Or conceivably the painting was designed to be seen from the right, and he was already experimenting with anamorphic composition.

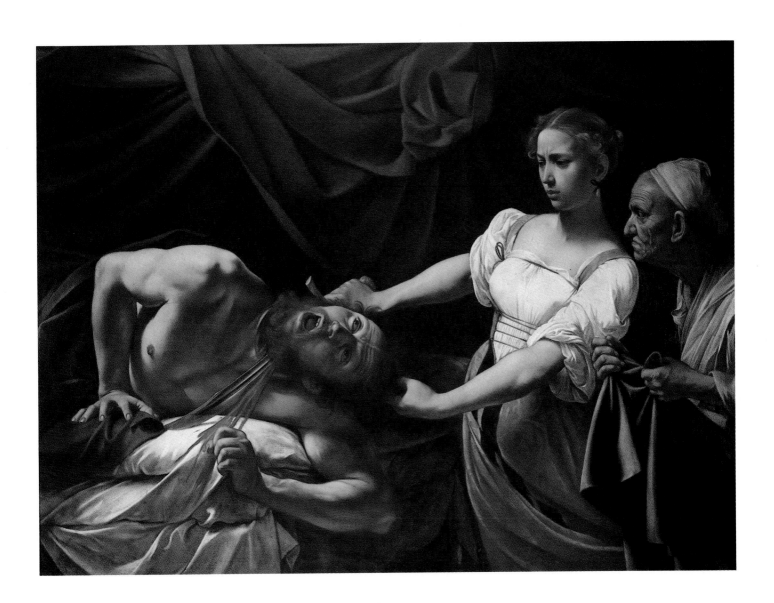

THE CALLING OF SAINT MATTHEW
1599–1600

Oil on canvas, 10' 7 1/2" × 11' 2"
Contarelli Chapel, Church of San Luigi dei Francesi, Rome

The subject traditionally was represented either indoors or out; sometimes Saint Matthew is shown inside a building, with Christ outside (following the Biblical text) summoning him through a window. Both before and after Caravaggio the subject was often used as a pretext for anecdotal genre paintings. Caravaggio may well have been familiar with earlier Netherlandish paintings of money lenders or of gamblers seated around a table like Saint Matthew and his associates.

Caravaggio represented the event as a nearly silent, dramatic narrative. The sequence of actions before and after this moment can be easily and convincingly re-created. The tax-gatherer Levi (Saint Matthew's name before he became the apostle) was seated at a table with his four assistants, counting the day's proceeds, the group lighted from a source at the upper right of the painting. Christ, His eyes veiled, with His halo the only hint of divinity, enters with Saint Peter. A gesture of His right hand, all the more powerful and compelling because of its languor, summons Levi. Surprised by the intrusion and perhaps dazzled by the sudden light from the just-opened door, Levi draws back and gestures toward himself with his left hand as if to say, "Who, me?", his right hand remaining on the coin he had been counting before Christ's entrance.

The two figures on the left, derived from a 1545 Hans Holbein print representing gamblers unaware of the appearance of Death (fig. 25), are so concerned with counting the money that they do not even notice Christ's arrival; symbolically their inattention to Christ deprives them of the opportunity He offers for eternal life, and condemns them to death. The two boys in the center do respond, the younger one drawing back against Levi as if seeking his protection, the swaggering older one, who is armed, leaning forward a little menacingly. Saint Peter gestures firmly with his hand to calm his potential resistance. The dramatic point of the picture is that for this moment, no one does anything. Christ's appearance is so unexpected and His gesture so commanding as to suspend action for a shocked instant, before reaction can take place. In another second, Levi will rise up and follow Christ—in fact, Christ's feet are already turned as if to leave the room. The particular power of the picture is in this cessation of action. It utilizes the fundamentally static medium of painting to convey characteristic human indecision after a challenge or command and before reaction.

The picture is divided into two parts. The standing figures on the right form a vertical rectangle; those gathered around the table on the left a horizontal block. The costumes reinforce the contrast. Levi and his subordinates, who are involved in affairs of this world, are dressed in a contemporary mode, while the barefoot Christ and Saint Peter, who summon Levi to another life and world, appear in timeless cloaks. The two groups are also separated by a void, bridged literally and symbolically by Christ's hand. This hand, like Adam's in Michelangelo's *Creation,* unifies the two parts formally and psychologically. Underlying the shallow stage-like space of the picture is a grid pattern of verticals and horizontals, which knit it together structurally.

The light has been no less carefully manipulated: the visible window covered with oilskin, very likely to provide diffused light in the painter's studio; the upper light, to illuminate Saint Matthew's face and the seated group; and the light behind Christ and Saint Peter, introduced only with them. It may be that this third source of light is intended as miraculous. Otherwise, why does Saint Peter cast no shadow on the defensive youth facing him?

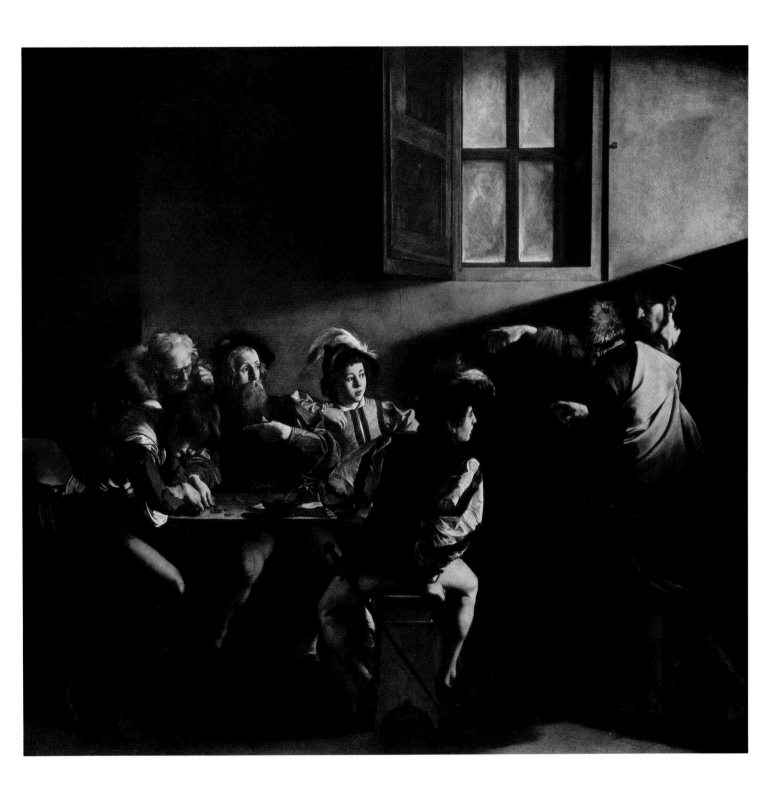

THE MARTYRDOM OF SAINT MATTHEW
1599–1600

Oil on canvas, 10′ 7 1/2″ × 11′ 3″

Contarelli Chapel, Church of San Luigi dei Francesi, Rome

Saint Matthew's history continues with his death. The king of Ethiopia, Hirticus, wished to marry his niece Iphigenia, the abbess of a convent, whose resurrection by Saint Matthew and conversion to Christianity provided the subject for D'Arpino's fresco in the vault. When Saint Matthew forbade the marriage, Hirticus had him killed.

The scene takes place in the foreground of a vast, dark interior, where nearly nude converts to the left and right of a pool await baptism. An altar is in the background. Muziano had painted the subject a few years earlier in the Roman church of Santa Maria Aracoeli, but it was not very often represented. Caravaggio must have been familiar with Muziano's painting and perhaps with a now-lost drawing for the scene made by the Cavaliere d'Arpino while he was still under contract to do the lateral paintings. Caravaggio seems to have been most influenced, however, by more distant works: Titian's famous painting (destroyed by fire in 1867) of *The Death of Saint Peter Martyr* in the church of Santi Giovanni e Paolo in Venice, of which there were many prints in circulation by the end of the sixteenth century (fig. 11); Marcantonio Raimondi's engraving after Raphael's *Massacre of the Innocents;* and comparable derivative works.

From these sources, all appropriate to a scene of Christian martyrdom, Caravaggio took various poses. He focused on the executioner in the center, at the critical moment when he seizes the supine, helpless Saint Matthew. While Matthew raises his right hand beseechingly toward the executioner, the angel hands down the martyr's palm and the other figures scatter in dismay. We see only fragments of these fleeing figures; light falls jaggedly on them like a strobe, emphasizing their confusion. This outburst of action contrasts with the inaction of the *Calling;* the movements of those figures seem to be momentarily suspended, while these appear to be congealed in their poses. The pause in the movement of the figures in the *Calling* is a part of the narrative and contributes to its authenticity; these men in flight, on the other hand, have been portrayed in an instant of continuing action. The executioner and the saint might pause, just before the fatal blow is struck; but the fleeing figures are in precarious, unsustainable poses, so that the effect is artificial, as if the instant of the outburst of response had been quick-frozen.

The confusion of movement and the almost jigsaw pattern of sharply contrasting lights and darks are stabilized by the horizontals of the steps and the altar and by the dim architectural background verticals. Less evident than in the *Calling* but faintly discernible is an underlying grid composition underpinning the jumble of actions around the central figure. The harshness of the act of assassination is modified by the graceful S-curve connecting the body of the angel through his arm and the palm branch to Saint Matthew's arms. The juxtaposition of the saint's right hand, the executioner's left hand, and the martyr's palm over the Maltese cross on the altarpiece cannot have been accidental; their proximity provides a focus for the meaning of the painting. Perhaps the single candle burning on the altar is symbolic, representing the all-seeing eye of God, ever present and aware of His martyr's sacrifice; it may also refer to the fugitiveness of human life.

The most distant figure is a self-portrait of Caravaggio (fig. 38); it provides a very specific reference point for the viewer, as if Caravaggio were participating in the tragedy, and thus making it contemporary. He looks out at the martyrdom, as if to involve the spectator in it.

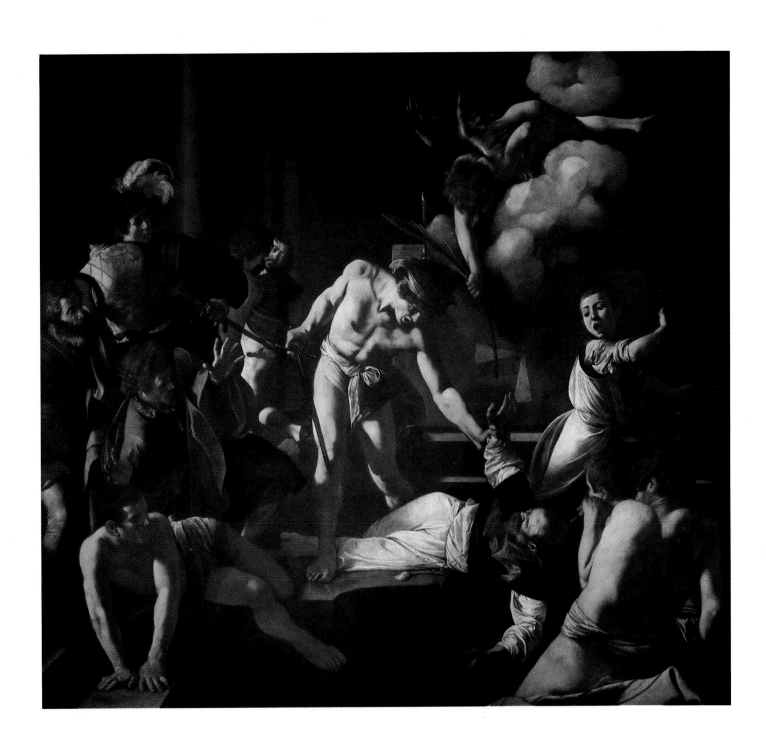

THE INSPIRATION OF SAINT MATTHEW
1602

Oil on canvas, 9' 8 1/2'' × 6' 2 1/2''
Contarelli Chapel, Church of San Luigi dei Francesi, Rome

This painting, Caravaggio's second version of the subject, was the last in the series, although it is over the high altar and therefore central in location as well as meaning. Unlike the lateral canvases, it is visible from all points in the chapel, a constant reminder of the importance of the Gospel. The angelic messenger is evidently dictating to the saint, ticking off points on the fingers of his left hand. The reading of the text of the Gospel demonstrates that he has reached the second part of the introduction, that is, Christ's genealogy and hence His continuity with the past.

Saint Matthew appears to have been portrayed from the same model as in the *Martyrdom,* and, appropriately enough, to be older than he was in the *Calling.* Despite his dignity, his noble, bearded face and bald head, and his robes reminiscent of an ancient philosopher's, he is in a very unsettled pose, not having had time to sit down, and with the bench under his knee tipping a little whimsically over the edge of a ledge. Obviously he is writing on the inspiration of the moment, coached by the angel. His role as a divine instrument is also implied by his name, which was believed to derive from the words "*manus*" (hand) and "*theos*" (god).

Cardinal Contarelli originally intended that the two figures be placed side by side, as they were in the first version (fig. 53). By changing this scheme for the traditional arrangement of the angel's flying in, Caravaggio emphasized the divinity of Matthew's inspiration and thus the authority of his Gospel. No doubt Caravaggio referred to some of the numerous sixteenth-century prototypes for the composition. Perhaps he had access to Taddeo Zuccaro's drawing of *The Flight to Egypt* (now in the Louvre), where the poses and some of the gestures of Joseph and the angel, and the relation between them, are similar (fig. 67). Or he may have been influenced by one of the many Venetian prototypes, of which the closest seems to be the reversed composition of *The Inspiration of Saint John the Evangelist* that Francesco Bassano had painted a few years earlier (fig. 10).

The ledge beneath the bench precisely defines the saint's spatial position in relation to the altar and to the whole chapel. But the placement of the angel is ambiguous. He must be not only above Matthew but also in front of him, judging from the saint's direction of regard. But in the whole context he is difficult to place, as if, like the blank, amorphous background, he were out of time and place. Nonetheless, he is fully corporeal and probably was inspired by actors in the contemporary theater, who were flown across the stage on wires.

Of the three paintings in the chapel, this shows the most use of the grooves that are incised in some of Caravaggio's paintings. Perhaps Caravaggio had been experimenting with this method of preparation in the two lateral canvases and perfected it only in this, the last. The contours of the painted image as we now see it do not correspond exactly with these grooves, so it is possible that Caravaggio first conceived of the bodies undraped, incised these contours in the wet priming, and then painted the drapery over them as if he were actually clothing nudes.

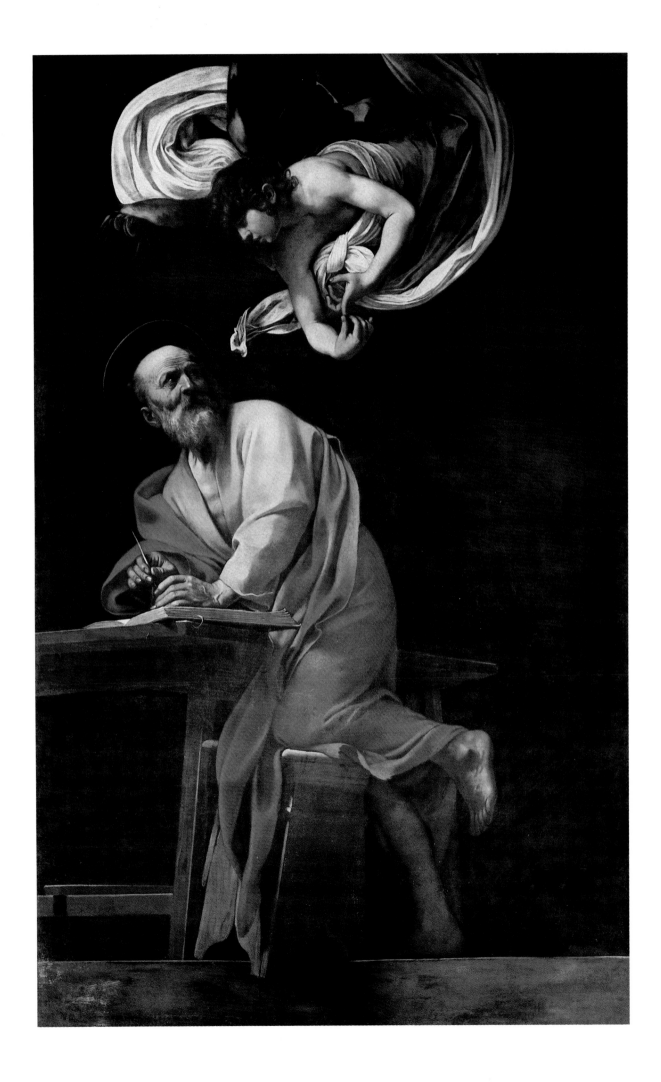

MEDUSA

1600–1601

Oil on canvas, mounted on a convex poplar-wood shield,
23 5/8 × 21 5/8"; the circumference is about six inches deeper than the center
Uffizi, Florence

A parade shield for ceremonial use, this painting was probably commissioned by Cardinal del Monte as a gift to Ferdinand I, grand duke of Tuscany, and sent to Florence in 1601 with an embassy from the shah of Persia, Abbas the Great. In the Medici armory it was placed in the hand of a lifesize equestrian figure, one of a pair mounted on wooden horses as if ready for a tournament. Clothed in a Persian coat of mail of glittering gold-and-gray scales forming peacock eyes, and armed with an arrow and a scimitar, the horseman was the focal point of the display of arms in a large gallery. So the painting, rather than being self-sufficient, was reduced to a piece of the rider's equipment. Until the armory was disassembled during the 1770s, it remained there; by 1908 it was in the Uffizi. Originally the back was fitted with velvet, silk, and leather, of which fragments remain.

Little wonder that Medusa looks terror-stricken—like Holofernes, at this moment she is literally losing her head. The motif was often cast at the center of sixteenth-century shields, and it inspired another memorable painting, by Leonardo da Vinci, now lost but described by Vasari as "queer and bizarre" rather than horrifying, a description that also fits Caravaggio's painting. That Caravaggio might by himself have conceived of making so artificial an object seems unlikely, even at a time when he was interested in violence and the macabre. It was probably painted specifically for the equestrian figure, as the downward regard of the head implies.

Ripa, in his *Iconologia* (1593), said that Medusa symbolized the triumph of reason over the senses for the sake of *virtù*, and Marino, who could have seen the picture in Rome in 1600 or in Florence in 1601, wrote flatteringly that Caravaggio's *Medusa* symbolized the duke's valor in overcoming his enemies. Caravaggio made it sensational, within its limitations and perhaps his own. It is as reverberating as it is gory. Most effective, however, is the extraordinary *trompe l'oeil*, whereby the convex surface of the shield appears concave, with the head suspended in front of it, projecting out into real space (fig. 32), so that the blood may drip onto the floor below and the fetid breath that the true Medusa would exhale (but not this play-acting scared boy) may offend the viewer's sensibility.

The legendary Medusa was a woman; Caravaggio's is a boy. She was a terrifying creature whose glance turned men to stone; this face is more frightened than frightening. Caravaggio had painted other contemporary boys as mythical beings, and would again. Yet *Medusa* is unconvincing; it never quite escapes identification as one of his familiar models grimacing through a fancy amusement-park peephole embroidered with snakes and blood.

Perhaps science-fiction's green men from Mars and Dali's deformations of the human figure have jaded the modern capacity for horror. Somehow, to twentieth-century eyes at least, Medusa seems to have defeated Caravaggio. Was the theme so exotic, so alien to his mentality as to deprive him of his usual ability to give authenticity to his images, or did it seem so bizarre as to turn him playful or ironic? Certainly the face is horrified. But the boy's panic is hyperbolic and thus a little ridiculous. Perhaps the most important meaning in the image is its revelation of Caravaggio himself, less in the attempt to transform a real boy into an ancient fantasy than in the sense that the chief horror emanates from within. In this aspect, it surely anticipates the shocking self-portrait as Goliath (see colorplate 35).

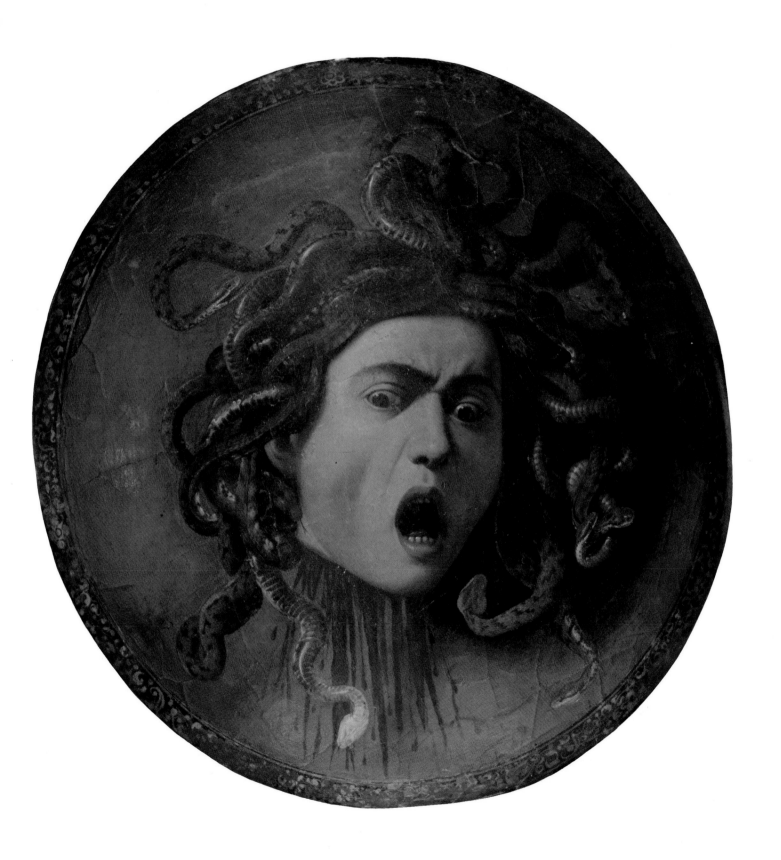

BASKET OF FRUIT

c. 1600–1601

Oil on canvas, 18 1/8 × 25 3/8"

Ambrosiana, Milan

The canvas was originally longer, although of the same height. X-rays reveal the right end of a frieze of *putti* and garlands by another artist, possibly Caravaggio's friend Prosperino delle Grottesche, underneath this image (fig. 21). Caravaggio cut this end of the frieze off, turned the canvas upside down, primed it, painted the still life on it, and then added the background.

This is Caravaggio's only independent still life that survives and has been identified securely. Four other still lifes from his hand are extant but they are only details in figure paintings. None of his paintings of fruit includes exactly the same varieties, or in quite the same arrangement. But they are remarkably similar stylistically, even though they may span as many as eight crucial years beginning about 1593.

Sensitive and respectful rendering of fruit, crystal, linen, and the like was traditional among North Italians, but not until about the time of Caravaggio's birth did a few Lombard artists begin to paint still life unrelated to figures. Caravaggio followed their example. His accomplishment as a still-life painter was recognized and became partly responsible for the popularization of the genre among Italian painters during his lifetime and after.

He dignified the subject. The *Basket of Fruit* is like a *haiku:* unpretentious, but striking and intensely concentrated. The components are presented forthrightly, without any evident mannerism. Asymmetrical and seemingly piled up casually, they have in fact been arranged as carefully as an architectural construction. The low horizon line causes the basket to loom up, confirming the monumental effect. Each organic element reveals its proper form and obeys nature's laws: the still-fresh dewdrops, the characteristic shapes of the different kinds of leaves, the apple's color modulation, the pearl-like grapes, the figs' striated skins, the woven rhythm of the straw fabric of the basket, even its loose strand. Each is specific, and yet each is transmuted to universality. The leaves summarize the life cycle: still reaching toward the sun on the upper left, drooping on the lower left, and withering and dying on the right. No wonder one writer has seen a reflection on life and death in the picture.

The first documentary reference to the painting is in a codicil of 1607 to Cardinal Federico Borromeo's will, bequeathing it to the Ambrosiana, where it has been since he founded the gallery in 1618. Probably it was painted contemporaneously with the London *Emmaus* (colorplate 18), where the still life includes similar fruit and leaves, arranged in the same basket, which is also perched precariously on the table edge. Except for 1595–97, when he was in Milan, Borromeo lived in Rome from 1586 until 1601, during 1599 in the Palazzo Giustiniani. He must have been thoroughly familiar with Caravaggio's work and may have been given the painting by Del Monte; or he may have ordered it from the artist himself. The subject might seem a peculiar choice for a high clergyman famed for his propagation of Counter-Reformation religious art, but he was a passionate collector of still life. Perhaps he saw it generally as the fruit of Adam's labors and specifically recognized in the painting's dignity something of his friend Saint Philip Neri's veneration of the humble. Perhaps his personal austerity did not exclude appreciation of the fruit, as well as the lilies, of the field. And perhaps he discovered in it those qualities that made its companion basket of fruit worthy of inclusion in the *Supper at Emmaus.*

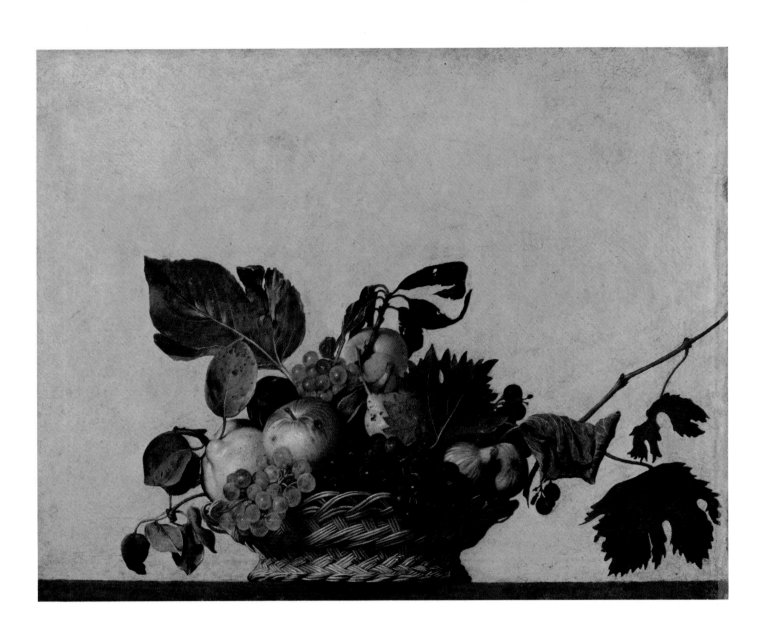

SUPPER AT EMMAUS

c. 1600–1601

Oil on canvas, 54 3/4 × 76 3/4"

The National Gallery, London

This painting was in the Borghese Gallery in Rome by 1650 (Manilli), but it cannot have been painted for Cardinal Scipione Borghese because he did not arrive in Rome until 1605. In 1801, Prince Camillo Borghese sold it, and by 1831 it belonged to an English collector, who gave it to the National Gallery in London eight years later.

Perhaps nowhere in Caravaggio's *oeuvre* is his debt to Moretto da Brescia more evident, in the frangible glass, the complex but convincing topography of the draperies, the broad range of colors and brilliant illumination, and the masterful illusionistic detail (see fig.3). But the thirty-year-old Caravaggio was as brash in displaying his skills as Moretto was sophisticated, detached, and understated.

Caravaggio used the standard Venetian central type of composition, derived from Titian and Veronese, and including a servant as well as Christ, the apostle Peter, and Cleophas. It may not be the most loaded board in the history of the subject, but rarely before were the pilgrims so well fed. It is surely Caravaggio's most complex and opulent, not to say extravagant, still life. Bellori was dismayed that the fruit is autumnal when the event took place in the spring. But we may suspect a double meaning in the objects, not only in the eucharistic grapes, wine, and water, but also in the apples, symbolic of the fall of man, and in the bursting pomegranate, symbolic of the crown of thorns. Perhaps Caravaggio included the Ushak rug to suggest the Near Eastern locale of the event, but such rugs were a commonplace in North Italian painting of the sixteenth century, as was the luxurious white tablecloth covering it.

Although the painting must have been done after the lateral canvases in the Contarelli Chapel, the light system is reminiscent of Caravaggio's brighter, earlier paintings. The source of illumination is, as usual, from the left. While the room is basically well-lit, the illumination is not without ambiguity. Most notably, the innkeeper casts his shadow on the wall, but not on Christ. Thus, Christ's face seems to be illuminated by an inner light, emphasized by contrast with the shadow behind His head. His radiance removes Him subtly but irresistibly from the quotidian setting.

Caravaggio chose to represent the moment of the blessing of the bread, when the apostles recognize Christ as the resurrected Redeemer. Following Saint Mark's comment that He appeared "in another likeness," He is clean-shaven, rather than bearded, as was more usual. The innkeeper's self-assured stance and facial expression and the fact that he has kept his hat on indicate that he does not realize he is in the presence of the Lord. The rhetorical gestures of the two apostles, however, mark the moment as one of recognition. The gesture of Christ's right hand, derived from Michelangelo's *Last Judgment*, has led one scholar to suggest that Peter's extended arms are intended to symbolize the Crucifixion.

Like the first *Conversion of Saint Paul*, this is an intricate picture, a little self-conscious and contrived. The artist seems to be deliberately displaying all of his skills, his ability not only to conceive and carry out a dramatic composition with subtle theological implications, but also—in such details as the beautiful reflected light on Cleophas's face, Christ's left hand, and the lusterware bowl—his technical virtuosity.

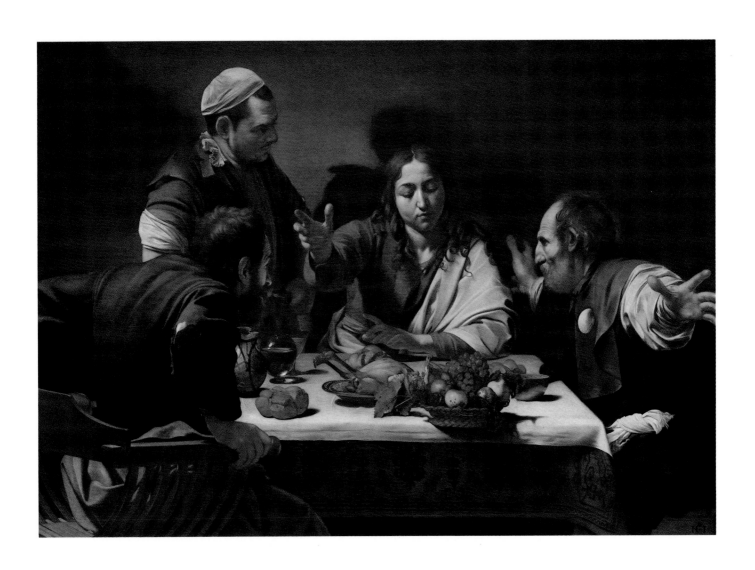

THE CRUCIFIXION OF SAINT PETER
1600–1601

Oil on canvas, 90 1/2 × 70″

Cerasi Chapel, Santa Maria del Popolo, Rome

Saint Peter, already nailed to the half-raised cross, provides the focus of the composition. Following the tradition that he chose to be crucified upside down so as not to rival Christ, the cross is being elevated with his feet above his head. This position permits him to turn his head to look out of the picture, not toward the worshiper, as in Michelangelo's Pauline Chapel fresco, but toward the crucifix on the chapel altar, as a source of reassurance to him and as his testimony of faith. The emphasis of the picture is on this faith. There is no bloodshed or sense of pain; the artist has eschewed sensationalism for understated drama. The executioners—the one in the lower left corner derives from Jacopo Bassano—are characterized as efficient anonymous mechanical forces, coarse but without the rancor of those in *The Flagellation* (colorplate 34). The only one of their faces that is at all visible is hidden in shadow and is expressionless. Saint Peter is depicted as a husky old man, hardly worn by age, not panic-stricken as in his denial of Christ or in the *Quo Vadis Domini?* in the ceiling fresco overhead, but calm, stern, resolute, a rock of faith on which the Church could be founded and would be secure. His position of helplessness and his acceptance of his martyrdom contrast with the executioners straining at their task. But they are merely the apparent operative force, for they have significance only in relation to him, as the means through which he can witness Christ and go to the better life.

This message is conveyed with great economy of means. The mechanics of elevating the cross have been carefully calculated so as to be convincing. But the absence of spectators transmutes the crucifixion from an historical event to a personal ordeal. Presumably Caravaggio made use of his newly developed nocturnal light less as a stylistic mannerism than to emphasize this intimacy. The figures are set relief-like against the dark wall. They are ponderous, deliberate, and dignified; their monumental massiveness reinforces the import of the martyrdom.

Caravaggio did respond to Michelangelo's new formulation of the subject in terms of excited action, the *raising* of the cross. He presented it as a conceivable contemporary event, with models who look as though they might have been brought in from the Tor di Nona prison, or more likely from the farm. But he restored to the subject something of the traditional symbolic meaning of such *quattrocento* representations as Masaccio's (Staatliche Museen, Berlin-Dahlem). There the cross has already been elevated, and the saint is stabilized as an emblem of Christian determination, resignation, sacrifice, and heroism. Because Caravaggio rendered the actual process of raising the cross so convincingly, however, and because the swastika form of the composition and its subtle effect of diagonal recession are so animate, the image is neither static nor abstract. Rather, Caravaggio has created it as a living witness of faith, and of the eternal triumph of its power over that of the secular world.

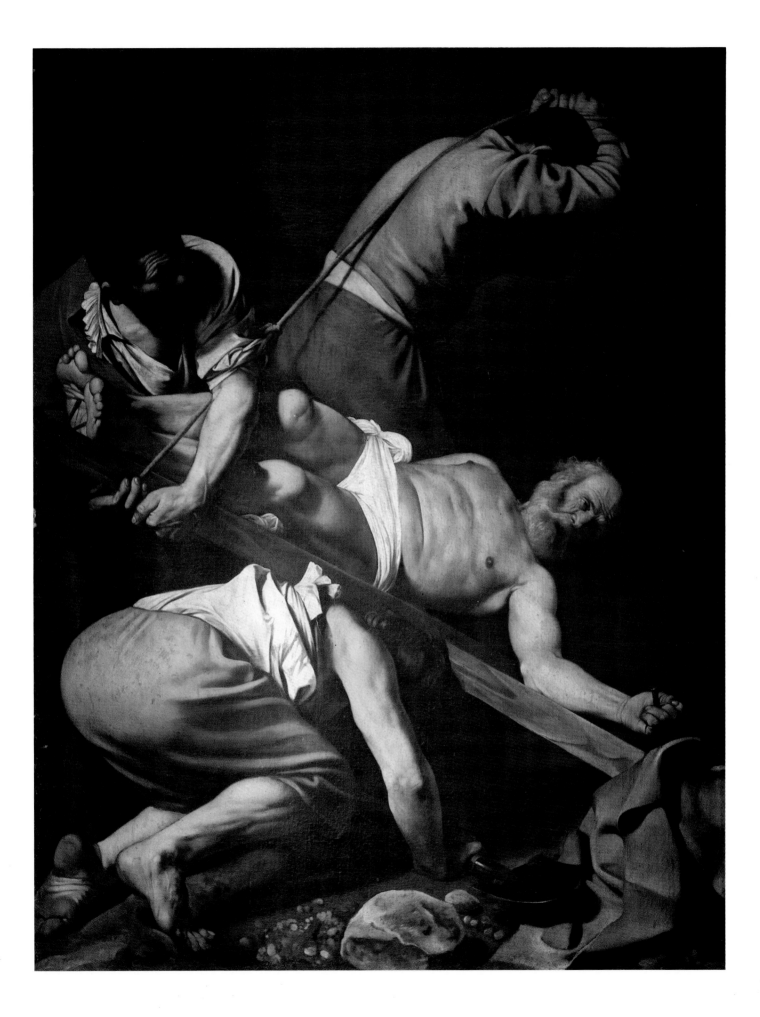

THE CONVERSION OF SAINT PAUL

1600–1601

Oil on canvas, 90 1/2 × 70''

Cerasi Chapel, Santa Maria del Popolo, Rome

Conceived as a companion to *The Crucifixion of Saint Peter* on the facing wall of the chapel, this painting is no less severely concentrated. The figures are as large and as compressed, the colors are similar earth tones, and its protagonist is as helpless and also is undergoing a transition from one life to another, from state-serving to God-serving. Yet the composition, the effect, and the signification of the painting are quite different. The vision is described by Saint Paul in Acts 22:5–11.

Caravaggio has made use of a number of psychological devices, enticing the viewer to identify with the saint's experience. Saul's pose, supine on the ground with his head seen from a three-quarter view above and his body extended into depth on a forty-five-degree diagonal, is tantalizing. It compels the viewer to crane his neck and turn his head to meet the fallen soldier's eyes. The impulse is frustrated, but the desire produces an exceptional sense of union with the image. Furthermore, the parabolic frame-within-a-frame formed by the raised arms transforms the recessive diagonal of the body into a vacuum, drawing us into the core of the picture and vicarious participation in the event. Finally, the heavy mass of the horse filling the top half of the painting bears down as oppressively on the viewer as does the divine light on Saul.

It is inconceivable that this farm horse could have been so high-spirited as to throw a muscular young soldier like Saul. Yet he lies powerless, his eyes closed, his arms raised supplicatingly in an *orant* gesture. So he must have been struck down. The explanation is provided by the supernatural light, in accord with Saint Paul's own account of his conversion, although the dark background contradicts Paul's statement that the miracle took place at high noon. If his arms were not raised, he would seem to be unconscious; as it is, he seems to be in a state of ecstasy. The image is thus transformed from a banal incident, a man's having inexplicably fallen off a plow horse, into a divine revelation. Caravaggio accentuates the corporeal reality of the sluggish horse, the ungainly heavy-handed groom, the stocky Saul, and even the rich impasto of the paint in order to intensify the effect of the supernatural light that floods this massive little world with the divine spirit. Thus, the message is not Saint Peter's power of faith, however great a witness to it Paul may thereafter have become, but the power of divine will.

Caravaggio used a variety of sources for the *Conversion*: the horse, from Dürer's *Large Horse* engraving of 1505; Saint Paul's pose, from the slave in Tintoretto's great *Miracle of Saint Mark and the Slave* of 1548 (fig. 5); and the idea of isolating the saint from his companions, from Moretto da Brescia's *Conversion* at Santa Maria presso San Celso in Milan (fig. 18) or from Parmigianino's, now in the Kunsthistorisches Museum in Vienna. The end result was too radical. No contemporary copies of the painting exist, and there is little seventeenth-century comment on it except for Bellori's criticism that it is "entirely without action." This comment gives insight into Caravaggio's contemporaries' lack of comprehension of an essential feature of his art: his representation of the significant moments of inaction (which are consistent with the static nature of painting) in order to penetrate the psychological core of events.

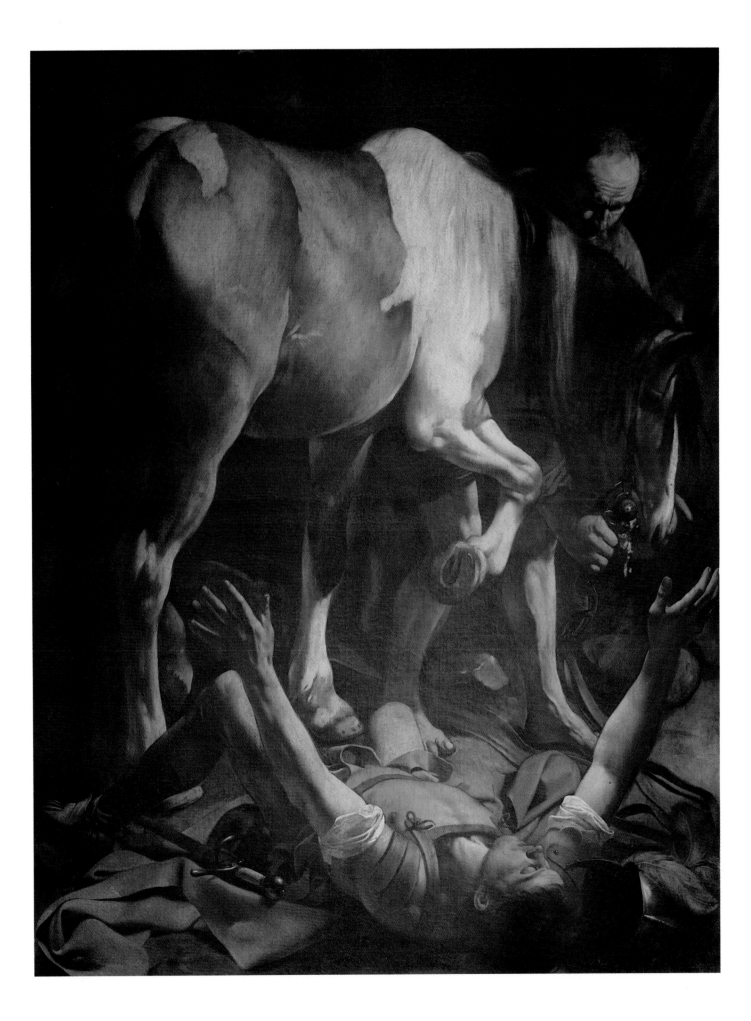

THE INCREDULITY OF SAINT THOMAS
1601–2

Oil on canvas, 42 1/8 × 57 1/2"
Neues Palais, Potsdam

Like the lost *Calling of Saints Peter and Andrew* and *The Taking of Christ* (fig. 26), this image is without any accessories or any indication of setting. It is tensely concentrated, compact within a solid Romanesque archway formed by the outline of the four figures clustered intimately together against a dark background. The focus is on Saint Thomas's right hand, firmly guided by Christ's, as the stolid doubter carefully prods the wound with his index finger. Tellingly, the hands of the other two apostles are concealed, although their curiosity is undisguised and scarcely less restrained than Thomas's. All three apostles are portrayed as rustic materialists without imagination or tact. They do not question Christ's identity but are fascinated by his wound as a tangible phenomenon, physical evidence of His existence as a man in their corporeal world, although no longer of it. Christ, who is understanding, indulgent rather than reproachful, is without a halo or any other sign of His divinity. His trim athletic torso contrasts with Thomas's burly form, and His physiognomy is more refined than the apostles'. But He comes to them as a man made of flesh and blood rather than as a disembodied spirit, so His resurrection is apprehended in their literal terms, and is all the more miraculous. The message is again one of faith; Christ's words were: "Because thou hast seen me, Thomas, thou hast believed: blessed are they that have not seen and have believed" (John 20: 29).

The motif of the hands is an old one, the device of Saint Thomas's finger perhaps inspired by a Dürer print. Surprisingly, only Malvasia, the propagandist for Bolognese painting, faulted the picture as indecorous. It was much copied, even while Caravaggio was still alive. Cardinal del Monte, Ciriaco Mattei, Prince Ludovisi, and the duke of Savoy all owned versions of it, so its lack of obvious mysticism and its psychological penetration must have struck a contemporary response.

Although the folds of Christ's robe are as fussy as Judith's and their pattern is like that in the drapery swag above her head (colorplate 12), the painting must be later, close in time to the Cerasi Chapel and the first *Inspiration of Saint Matthew* (fig. 53). The model for the bald apostle can be recognized as the soldier in the first *Conversion of Saint Paul* and as Abraham (see colorplate 24). The mannerism of Christ's coiled locks—and perhaps his physiognomy—appears also in the *Taking* and in the London *Emmaus*. And the three-quarter-length, large-scale easel format is characteristic of the private commissions Caravaggio was carrying out during the years 1598–1602. Perhaps the picture can be placed precisely during the slack months between the completion of the Cerasi Chapel paintings in November, 1601, and February, 1602, when he was commissioned the first *Inspiration of Saint Matthew*. Although Baglione says it was painted for Ciriaco Mattei, it belonged to Marchese Giustiniani by 1606. When his collection was dispersed in 1815, the king of Prussia bought it. It was in the Kaiser-Friedrich Museum until World War II and since then has been at Potsdam.

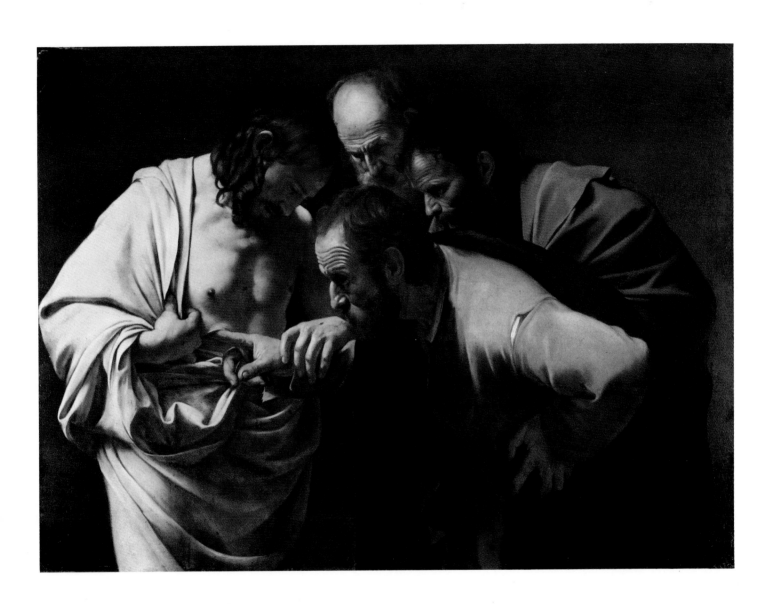

VICTORIOUS AMOR

c. 1601–2

Oil on canvas, 60 5/8 × 43 1/4"

Gemäldegalerie, Staatliche Museen, Berlin-Dahlem

This painting, commissioned by the Marchese Giustiniani, arrived in Berlin by the same route as the *Saint Thomas* (colorplate 21). It must have been completed by July, 1603, the date of the preface of Murtola's book of madrigals, including four inspired by it. It was cited in the hearing of September, 1603, as the *Earthly Love* that inspired Baglione's rival *Divine Love*. The model might be the Giovanni Battista mentioned in the hearing as Caravaggio's "*bardassa*" (catamite), of whom the artist denied all knowledge. The model also served for the Medusa and the Isaac (colorplates 16, 24). Younger than Isaac, of the second half of 1603, his age is closer to the Medusa's, of 1600–1601. So the painting may well have been done in 1601 or 1602. Caravaggio was already in contact with Giustiniani by 1600, and the painting may have been one of his first commissions, if not the first. Sandrart reports that it was so admired that it secured Caravaggio's liberation from prison, which may have been in February, 1601, when he was released by the governor of Rome, the cardinal-nephew Pietro Aldobrandini.

Sandrart also writes that the painting was kept under a green silk curtain in the Giustiniani gallery for fear that it would outclass all the other paintings. Considering the character of the image, this explanation may have been less than frank. Certainly the boy is knowing and insolent, rather than heroic or ideal. His pose seems to derive from Michelangelo's *Victory* (fig. 15), but unlike that precarious hero, he is firmly in the saddle. He is triumphant over the intellectual life: music (the old-style lute, the new Cremonese violin, and the score, with the *incipit* beginning with *V*, perhaps for Vincenzo), geometry (the T square and compass), and astronomy (the blue globe with stars), three parts of the scholastic formula of the quadrivium. He is also triumphant over the active life—of the military (the armor), of the intellectual (the book and quill), of the ruler (the crown and scepter or baton), and even of fame (the laurel wreath).

Notably absent are any symbols of the pictorial arts, which usually appear in paintings of this subject. The omission is not accidental. Love is the *friend* of the arts, and thus they escape the parody to which Caravaggio subjects the other achievements. But not all pictorial art escapes. No wonder Baglione was outraged, for through this impertinent awakened Huck Finn, the brazen Caravaggio was mocking the pompous rhetoric of his more proper contemporaries.

A recent cleaning of the painting has clarified the background by revealing the top of a low balustrade running horizontally, just behind and above the lute, from Amor's right thigh to the left edge of the painting.

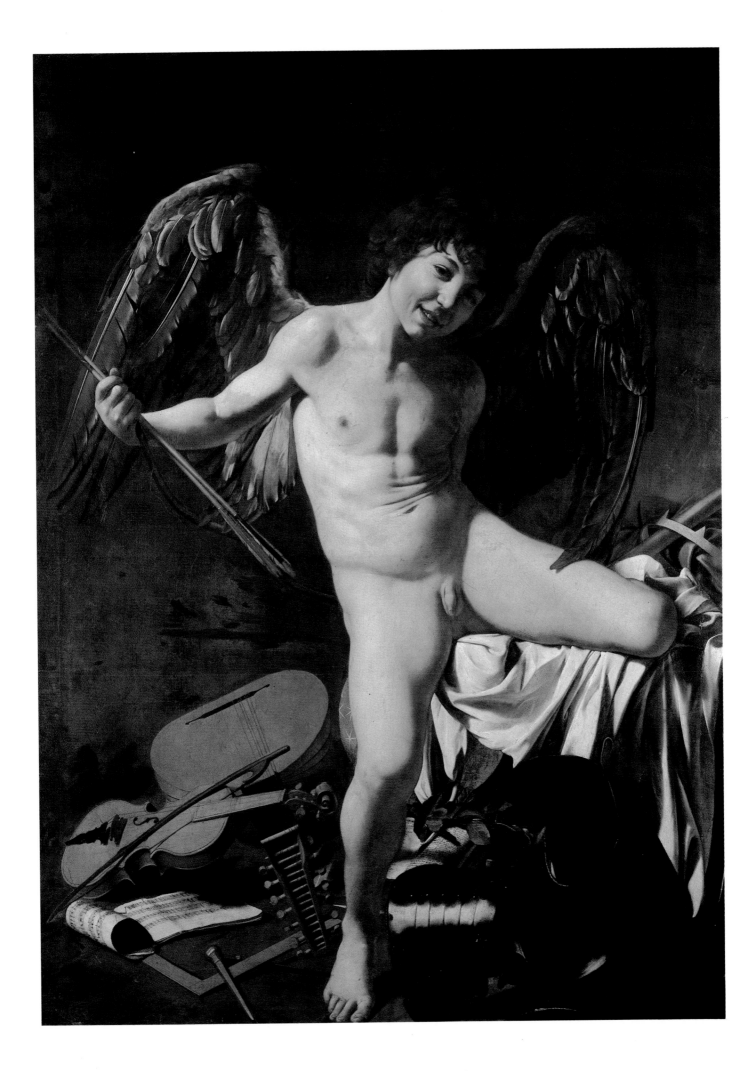

YOUTH WITH A RAM

c. 1602–3

Oil on canvas, 52 × 38 1/4"

Capitoline Gallery, Rome

Painted for Ciriaco Mattei, this canvas was left by his son Giovanni Battista to his friend and mentor, Cardinal del Monte. After the 1628 sale of the cardinal's estate, its history is much the same as the Capitoline version of *The Fortune-Teller*: acquired by Cardinal Pio, sold by his heirs to Pope Benedict XIV, and then in the Capitoline Museum, from which it disappeared during the early years of this century. It was rediscovered in the office of the mayor of Rome in the 1950s. For many years an excellent exact copy in the Doria Collection was mistaken for the original.

As early as 1620, when Celio described the subject as the mythological shepherd Phyxis, the identity of the youth has given rise to uncertainty. Soon after the painting was completed, other artists used it as a model for representations of Victorious Amor, and an eighteenth-century inventory described it simply as *A Youth with a Ram*. An attempt has recently been made to resuscitate Celio's shepherd. The Del Monte inventory of 1627, Baglione, Scanelli, and Bellori all refer to the boy as Saint John the Baptist, and their identification has generally been accepted. Saint John was often represented nearly nude, but this youth does not carry his traditional cross-staff (an omission corrected in most of the numerous copies and variants) and the horny old ram who is nuzzling him is a very different creature from his usual companion, a pretty little lamb.

The difficulty is that this youth is not acceptable as a sacred Christian figure. He is not androgynous, like the *Bacchus* (colorplate 10), but he is nearly as challenging and even more openly erotic. One has only to imagine replacing the ram with a leering old man to become aware of the picture's potential indecency. Friedlaender faced up to this ambiguity and explained it as "persiflage" directed at Michelangelo. His Sistine Chapel *ignudi* inspired the pose, probably through Cherubino Alberti's engraving of 1585. Recent scholars have searched sixteenth-century literature for means of bowdlerizing the image by translating the ram into a symbol—of the cross or of divine love—and Cardinal del Monte may have done no less. But the ram can also symbolize lasciviousness, and the boy's extraordinary pose, half-reclining with his legs spread like Leda awaiting her swan's attentions, his facial expression discreetly veiled in shadow but mocking, the caresses bestowed on his body so lovingly by the light—to say nothing of the painter's brush—all defeat propriety. He may have been accepted as Saint John, but he is a pagan little tease, uncontaminated by Christian sentiment.

When Caravaggio painted the canvas is hardly less puzzling than how he managed to pass this boy off as Christ's cousin, if he did in fact. The delicacy of the modeling, the subtle modulation of the light into shadow, and the glossy handling of the flesh are so nearly identical to Isaac's rescuing angel's (see colorplate 24) that the two canvases must have been painted at almost the same time, a little later than *Victorious Amor* (colorplate 22), who is no less bold, restless, and ironic. Caravaggio, liberated from the elegant restraint of Del Monte's refined young friends, has become cheerful, audacious, even boisterous, and so self-confident as to leave discretion behind. We may even suspect him of teasing his patron with the painting—on the principle of the emperor's new clothes.

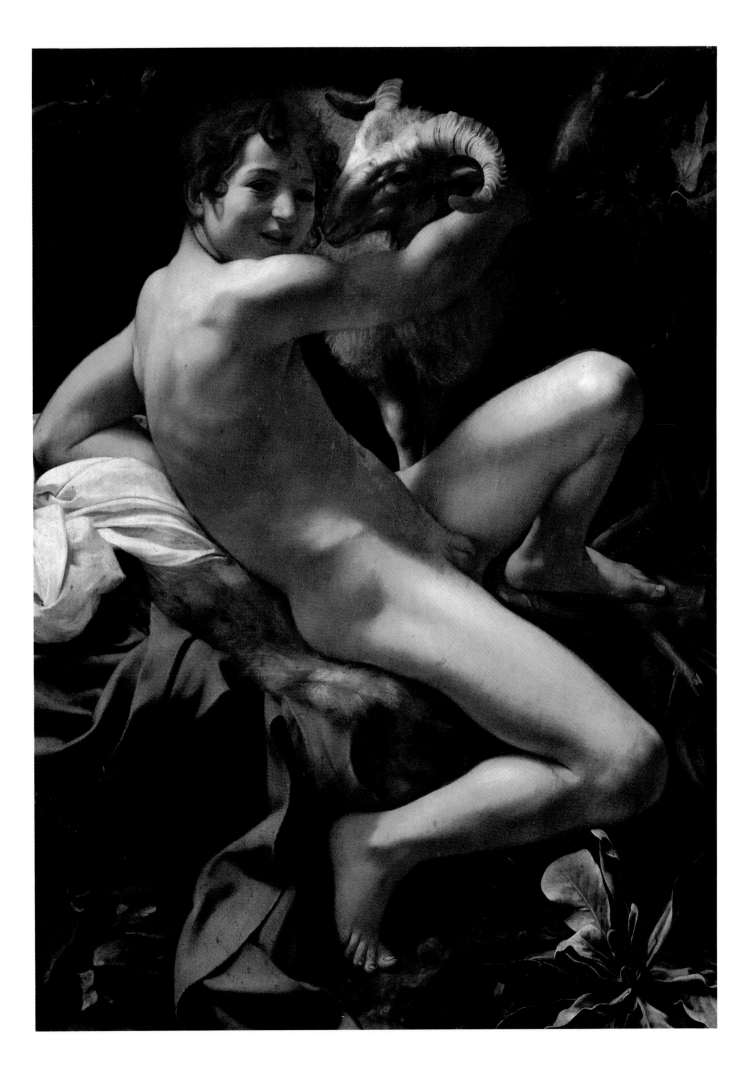

THE SACRIFICE OF ISAAC

1603

Oil on canvas, 41 × 53 1/8"

Uffizi, Florence

Although the pair of figures barely discernible in the right background may refer to the two young men who accompanied Abraham but were left at the foot of the mountain to wait while he sacrificed his son, other details do not follow the account in Genesis 22 precisely. According to the Biblical text, Abraham prepared for a burnt offering, laying Isaac bound on a pile of wood on an improvised altar. Just as Abraham was about to slay his son, an angel intervened by calling to him. A ram then unexpectedly appeared, divinely provided as a substitute sacrifice for Isaac. In Caravaggio's visualization of the subject, the angel physically materializes beside Abraham. This treatment of the subject was customary, and Caravaggio took full advantage of its potential for drama.

It is another of his favored crucial moments between one course of action and another abruptly superseding it. Abraham has laid Isaac down on the altar, drawn the knife, and is at the point of slitting his throat; the restraining angel rushes urgently to the rescue just in time. The focus of the action is on the patriarch's right hand holding the knife. The three heads are radial to it, and it joins the authoritarian figures on the left to the victims on the right. The other hands are hardly less expressive: the angel's left with its commanding gesture and Abraham's left grasping his squirming son to steady him. The concealment of Isaac's hands emphasizes his helplessness.

Monsignor Maffeo Barberini's agents paid Caravaggio for this painting and perhaps another that has not been identified, in four installments, the first in May, 1603, and the last in January, 1604. The precision of this documentation provides a key to Caravaggio's chronology and evolution. The frieze-like composition he adapted from his own *Judith* (colorplate 12), reversing the sequence of action to read from left to right. But during the five intervening years the figures have become more fully three-dimensional, and the space adequate to permit them to move freely within a single frame of reference. Abraham is the same model as the background apostle in the *Incredulity* (colorplate 21) and as the second Saint Matthew (colorplate 15). The light on the angel and the modeling of his body make him the Capitoline *Youth*'s unsullied brother (colorplate 23); without the clue of his wings, he would seem as mortal, and his nudity and his capability to interfere with the implacable Abraham would be inexplicable. The terrified Isaac is Caravaggio's naughty little friend, the Amor, no longer victorious and now a couple of years older. Parenthetically, can we read the image as a playfully sarcastic intimate threat to the boy?

Canonically the episode should take place out of doors, and it does. But the figures are in studio light, creating an apparent syntactical inconsistency. Perhaps it can be explained by Abraham's having taken the boy into a dark glade for the sacrifice, with a ray of early morning—or miraculous—light cutting through the foliage to illuminate the horror of the deed. And the landscape: Was it inspired by Caravaggio's memories of the foothills of the Alps, or can it be recognized as some Barberini possession in the Alban hills?

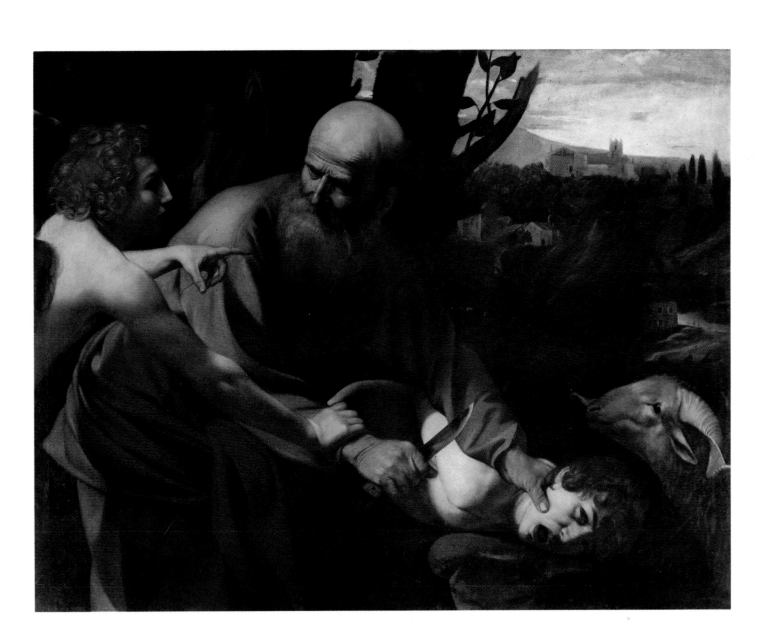

THE ENTOMBMENT
1602–4

Oil on canvas, 9' 10 1/4" × 6' 8"

Vatican Pinacoteca, Rome

By January 9, 1602, this painting had already been commissioned by an unidentified member of the Vittrice family for their chapel, the second on the right aisle in the Roman church of Santa Maria in Vallicella (the Chiesa Nuova). By September 6, 1604, it was certainly complete and probably in place. In 1797 the French took it as booty and exhibited it in the Musée Napoléon in Paris until 1815, when it was returned to Rome. It was then installed in the Vatican, where it has been since, replaced in the Chiesa Nuova by a good eighteenth-century copy.

The sole painting of Caravaggio's maturity that gained unanimous critical acclaim, it was much copied—no fewer than forty-four drawn, painted, or engraved copies are known, including one by Cézanne, who, having never visited Rome, must have made his watercolor from a photograph or a print. Perhaps the critics' approval was based on its reputable literary source—the Dominican Alberto Castellano's *Rosario della Gloriosa Vergine Maria* (1521), of which Saint Philip Neri owned a copy. Painted for a chapel that belonged to one of Saint Philip's oldest friends, in the church the saint had built for the Oratorian Order that he founded, its iconography may have been conceived by one of the distinguished scholar clerics associated with him, Cardinals Baronio, Bellarmine, or Ottavio Paravicini, who at the time of the painting's execution showed an interest in Caravaggio. The chapel was originally dedicated to the Pietà, an association preserved in the fresco in the half-dome above the altar, which was painted during 1611–12 by an occasional follower of Caravaggio, Angelo Caroselli (1575–1652).

The *Entombment* is as tragic as Michelangelo's *Pietà,* which Caravaggio must have had in mind as he painted. Two members of the grieving little group are gently bearing Christ's body into a cave-tomb barely visible in the obscurity of the left background. Much of the pathos is conveyed by the gestures: Nicodemus almost embracing Christ's legs, Saint John touching Christ's wound, the aged Virgin blessing Him and extending her arms to embrace the whole group, and most poignant of all, Christ's pendant lifeless right arm and His left hand lying on His abdomen. Mary Cleophas's upraised arms recall Saint Paul's similar gesture of acquiescence (see colorplate 20); her face, the only one except Christ's that is fully illuminated, looks up like Saint Paul's into the source of light as if seeking divine guidance.

In its fan-shaped arrangement the group is as compact and as monumental as a piece of sculpture. It is motionless, at the moment when the mourners pause just before carrying the corpse into the burial chamber. The slightly diagonal recession to the left indicates the direction of their movements and prevents the picture from becoming static, as does the sharp point of the stone tomb cover on which they hesitate. This slab of stone refers iconographically to Christ as the foundation of the Church. Its point projecting toward the picture plane, together with Nicodemus's wary glance out toward the chapel, establishes contact with the worshiper. When the priest elevated the Host in the sepulchral half-light of the chapel, the effect on the worshiper must have been a reenactment of the sacrifice there a few inches above the altar, in perfect accord with Saint Philip's ideal of Christianity as a direct, living experience for his congregation.

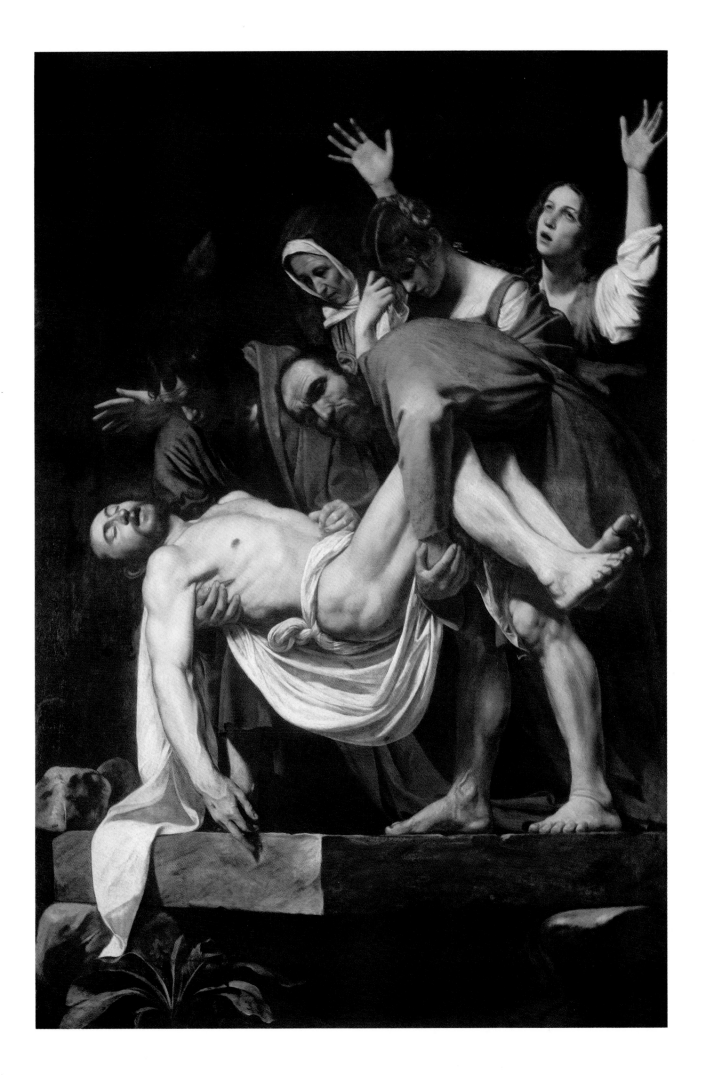

THE MADONNA OF LORETO, *or* THE MADONNA OF THE PILGRIMS
1603–4

Oil on canvas, 8′ 8 1/2″ × 4′ 11″

Cavalletti Chapel, Church of Sant'Agostino, Rome

On September 4, 1603, fulfilling a bequest of the previous year by Ermete Cavalletti, his heirs provided five hundred *scudi* for decoration of the family chapel, the first on the left aisle of the church. By the end of 1604, this painting had been installed in the chapel, where it has remained since.

The Madonna of Loreto is a simple composition—two peasants kneeling in adoration before the Madonna and Child, who is blessing them. Their staffs and the man's dirty bare feet show them to be pilgrims, perhaps a reminder of the Papal Jubilee of 1600, when 1,200,000 of the faithful visited Rome. The man is younger than the wrinkled toothless old woman; they too might be mother and son. They are worn, having presumably come a long way on foot. Scanelli sympathetically remarks on "the pure simplicity of their hearts." All four figures seem human: Christ, a chubby five-year-old; the Madonna, tall and richly dressed (the model for *The Madonna of the Snake* [colorplate 29], she can be identified as Caravaggio's friend Lena, the cause of a dispute in July and August, 1605); the peasant man, the same model as Cleophas in the London *Emmaus;* and his companion, the first of the humble anonymous old women who were to appear in Caravaggio's later paintings.

Enshrined above the altar in the apse-like chapel, the painting is like a *tableau vivant,* yet is also iconic. The Madonna stands on a step against an imposing architectural enframement, probably intended to represent the entrance to the sanctuary of the Holy House, as the patch of exposed brick to the right of the molding implies. A suggestion of the Gate of Heaven may also be intended, derived from Raphael's fresco of the prophet Isaiah, nearby in the church, with the inscription from Isaiah 26:2–6: "Open the gates to let a righteous nation in that keeps faith. . . . [The Lord] has brought low all who dwell high in a towering city . . . that the oppressed and poor may tread it underfoot."

The illumination hints of the meeting of two worlds. The shadow in front of the step appears to be cast by the picture frame, as if the peasants were lighted from the actual entrance to the church. But the Madonna's shadow on the molding indicates another, higher source. The sacred figures wear halos, and the Virgin, whose feet bear little weight, seems to float, despite the sculptural character of her form. Her pose and drapery may derive from the ancient Tusnelda statue then at the Villa Medici in Rome, but Caravaggio may have wanted to recall the statue within the shrine at Loreto that was the objective of the devout. It is a vision: a statue brought to life by the simple faith of its worshipers.

The image is Caravaggio's own invention, original but in conformity with the donor's choice of the Madonna of Loreto as patroness of his chapel. Ordinarily she is represented with the principal relic of the shrine, the house where Christ was born, floating during its miraculous transport to Loreto from Palestine. Perhaps the idea was derived from a print or from some folk legend that Caravaggio heard in Loreto, which he may have visited during December or January, 1603–4, when he is reported nearby, in Tolentino. An engraving of the marble Cumaean sibyl by G. B. della Porta in the upper range of figures at the southeast corner of the shrine of the Holy House shows the same motifs of the Virgin's crossed feet and her downward regard; published in Rome during 1567–68, the print may have suggested the pose to Caravaggio.

Despite the usual reservations about the peasants' dirty feet and rumpled clothing, seventeenth-century writers grudgingly admitted the popularity of the painting. It was much copied—even the impeccably correct Poussin made a variant drawing of it.

The Madonna of Loreto is exceptional in Caravaggio's *oeuvre,* a hieratic and votive image. But it remains true to his conception of religious experience in human terms. The Madonna and Christ are presented as a naive worshiper might imagine them—a living mother and child, exalted in position but approachable, compassionate, and responsive to the sincere devotion of the faithful. Whether consciously intended or not, the painting can also be read historically as a Counter-Reformation defense of the cult of the Virgin. Its chief message is one of hope to all Christians, however humble, whose faith is sufficient.

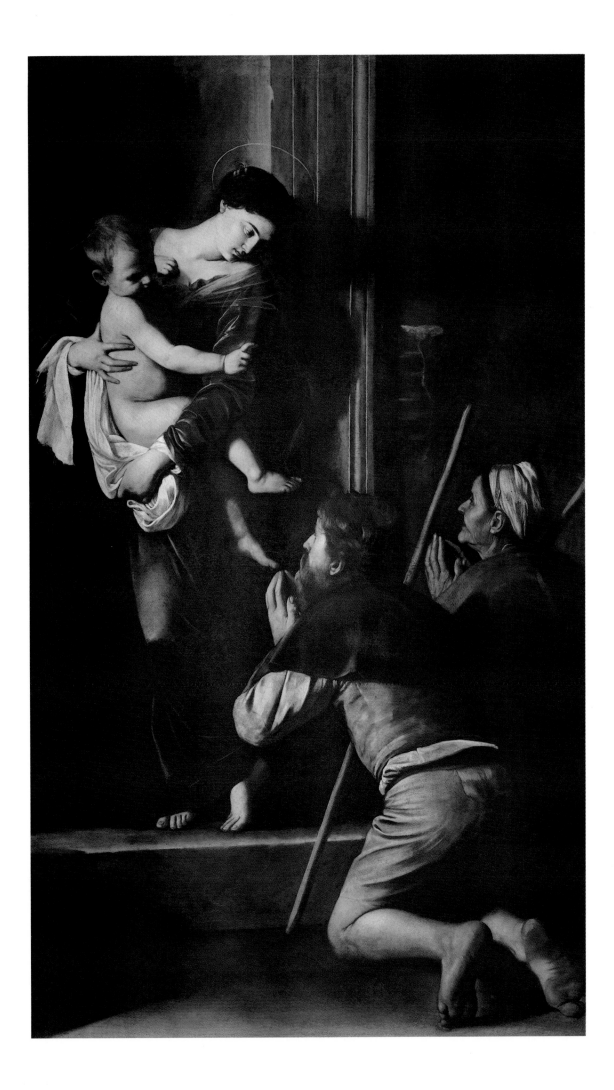

ECCE HOMO

c. 1604–5

Oil on canvas, 50 1/2 × 40 1/2"

Civic Collection, Palazzo Rosso, Genoa

Caravaggio painted this canvas in competition with two Tuscan artists, Domenico Passignano (1559–1638) and Lodovico Cardi called il Cigoli (1559–1613), whose winning canvas is now in the Palazzo Pitti, Florence. The competition was sponsored by Monsignor Massimi and must have taken place after April 3, 1604, when Cigoli arrived in Rome. Caravaggio's painting is reported to have been taken to Sicily, where there are several copies. But as early as about 1620, traces of it seem to appear in Genoa, where it was rediscovered in 1953. Perhaps Caravaggio himself took it to that city, since he is reported to have gone there in August, 1605. A few scholars believe it to be a copy after a lost original.

When the canvas was rediscovered, it was so battered that a restorer added a few inches to the top, bottom, and sides. A copy in Messina is considerably more spacious overhead, and this canvas too may well have been higher originally. Additional height would accord with the probable date shortly before *The Madonna of the Snake* (colorplate 29).

The arrangement of the figures behind a balustrade, as if Pilate were presenting Christ to us to be condemned and then crucified, is not unusual. Cigoli made use of it in his picture, as did many other artists before and after him. However, the asymmetry of Caravaggio's composition is exceptional, although not without precedent. Usually Christ is flanked by the jailer and Pilate. Caravaggio's disposition of the figures isolates Christ, a pariah, beaten, helpless, despised, and shamed as a man by the torture and mockery to which He has been subjected. His nakedness, His downcast eyes, the crown of thorns He wears, and the reed scepter that has been thrust into His hands mark His humiliation no less than Pilate's offering Him like some less-than-human object for sacrifice. The jailer seems strangely solicitous as he lifts Christ's cloak gently from His shoulders; is he perhaps sympathetic to his victim, while nonetheless doing his job? There is no ambiguity, however, about Pilate: he is a cynic, anxious by whatever means to dispose of the problem created by Christ. We should probably complete the picture by imagining ourselves as part of a snarling mob, to whom the presentation is being made.

Fifteen heretics were burned at the stake in Rome between 1595 and 1597, and the most famous, Giordano Bruno, was put to the flame in the Campo dei Fiori during 1600. Caravaggio must have recognized the inhumanity of this method of coping with dissent. His presentation of Christ may manifest this understanding; He sorrows and is shamed, not for Himself, but for man's capacity for inhumanity.

Astonishingly, and inappropriately, the inspiration for Pilate seems to be Sebastiano del Piombo's *Portrait of Andrea Doria* (fig. 66).

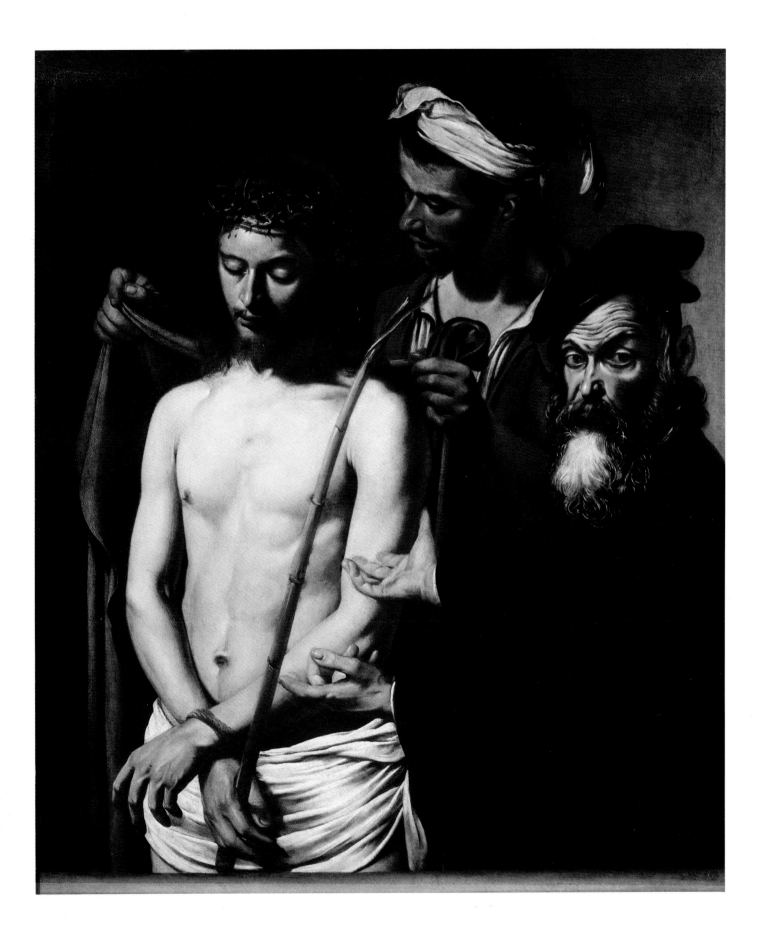

COLORPLATE 28

SAINT JOHN THE BAPTIST

c. 1605

Oil on canvas, 68 1/4 × 52"

Nelson-Atkins Museum of Art, Kansas City, Missouri. Nelson Fund

According to Baglione, this work was painted for Ottavio Costa, who had a copy made for his family chapel in Cosciente in Liguria, where it still exists. The original was mentioned in the Costa inventory of 1639 and then disappeared. It reappeared in an English private collection in 1844 and was acquired during the early 1950s by the Kansas City museum.

Cardinal Baronius is quoted as having told Pope Clement VIII, whom he confessed every night, that "it is only possible to judge the conversion of a sinner by external signs." Saint John the Baptist was a prophet, not a sinner. But Caravaggio in this, his most sober and moving devotional image of the saint, has been remarkably effective in using subtle external signs to reveal personality. It has something of Michelangelo's *terribilità;* Saint John is as downcast as the Jeremiah and his pose is a composite of prophets from the Sistine ceiling. Its tense energy underscores Saint John's singularly high-strung nature. A number of devices emphasize his nervous force: the diagonal position of the body, reiterated by the staff (which has an added crosspiece transforming it into a crucifix) and opposed by the diagonals in the shoulders and across the knees; the restless position as if he were about to spring up; the sharp contrast between the lighted areas and the broken arc of shadow disrupting the figure from the cheek to his right ankle; the twisting draperies; and the flutter of leaves in the background. And the downward regard, the deeply shadowed eyes, and the somber expression reveal the profundity of his thought. He is a young Moses, passionate, a zealot, nearly bursting with vitality, but as much a contemplative, even a melancholic, as an active man. The emphasis is on his inner life, his seriousness, his spirit; he is not a mere symbol, but a man, an extraordinary visionary. Roberto Longhi believed that Caravaggio intended to suggest the moon as the picture's light source. And perhaps this Saint John is a little mad—with the singleness of purpose of a man driven by his sense of mission.

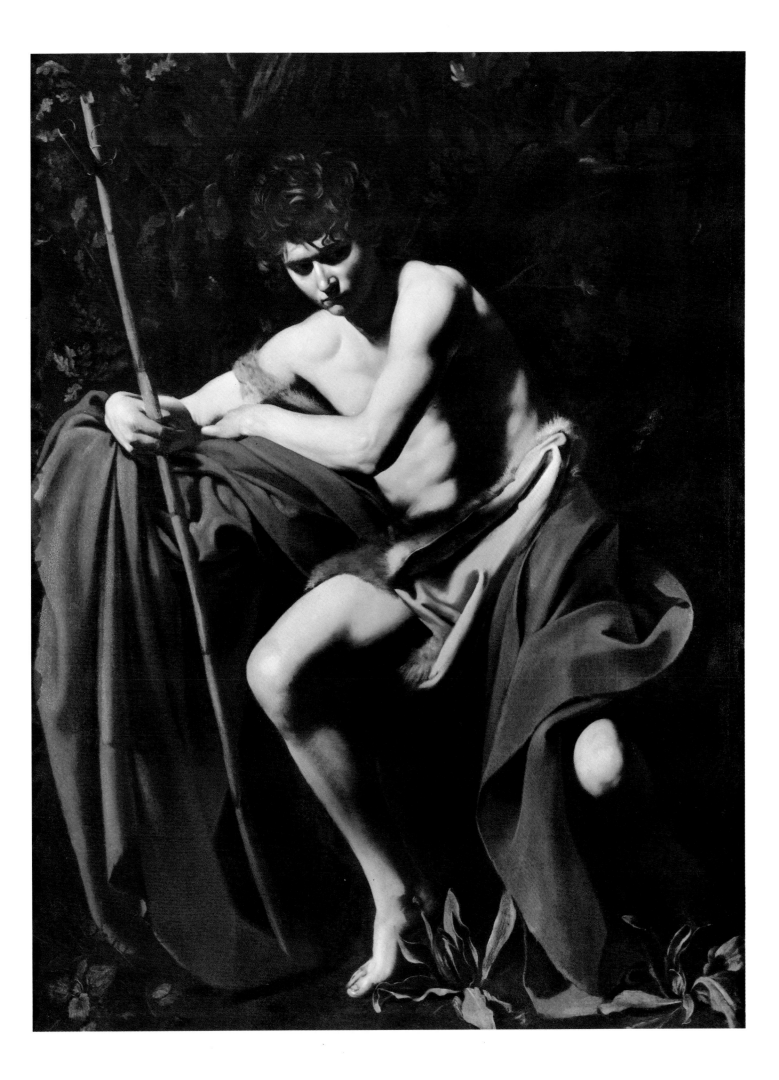

THE MADONNA OF THE SNAKE, *or* THE MADONNA OF THE GROOMS
(*Palafrenieri*)
1605–6

Oil on canvas, 9′ 7″ × 6′ 11 3/4″

Borghese Gallery, Rome

Commissioned as the altarpiece for the Confraternity of Grooms in the new Basilica of Saint Peter's then under construction, this painting was begun by autumn 1605. It was completed before April, 1606, when Caravaggio acknowledged payment—of only seventy-five *scudi*—for it. The Grooms' hopes for an altar in the new basilica were disappointed. None was assigned to them, and the painting was acquired from them by Scipione Borghese for one hundred *scudi*(!).

The subject, derived from a passage in the Old Testament, was codified by a papal bull on the rosary promulgated by Pius IV in 1569. This bull established the joint responsibility of Christ and the Virgin for crushing the serpent of original sin. Because the Roman Catholic church identified itself with the Virgin, its stamping-out of heresy is also implied. The shadowy Saint Anne is present as Mary's mother, the vessel of her immaculate conception, the source of her purity. Like *The Madonna of Loreto,* the image is a Counter-Reformation document in defense of the Roman Catholic church, directed against Protestant denial of the Immaculate Conception and of the Virgin as mediator.

This is the only surviving painting in which Caravaggio undertook so irredeemably doctrinal and artificial a subject. He translated it into human terms, to bring its theological abstraction to life. Although removed from the historic world, the three figures behave naturally, as if in the intimacy of a prosperous artisan's family. The Virgin solicitously supports Christ, represented as an obedient child frowning as he presses His foot on hers, thus trampling the serpent. Saint Anne looks on, a concerned but detached grandmother, keeping to the background.

Despite Bellori, who lamented the picture's "vileness," it maintains the dignity essential to the theme. As an altarpiece in a dark chapel it would seem as sculptural as *The Entombment* (colorplate 25). Probably Caravaggio found Roman matrons in ancient sculpture as self-assured as this Virgin and as tall and columnar as Saint Anne. And in Christ's figure, pose, and action, the infant Hercules may live again. The pictorial source is Ambrogio Figino's altarpiece of the Madonna and Child engaged in the same action, without Saint Anne, which was in the church of San Fedele in Milan (fig. 19), where Caravaggio must have seen it. In Rome he probably used an engraving of Figino's painting to refresh his memory, as is indicated by his having reversed the poses. He added Saint Anne because she was the Grooms' patroness and had been represented in their former altarpiece in old Saint Peter's.

The three figures appear together on the obverse of a medal struck in 1565 for the foundation of the Grooms' church in Rome, with the Virgin seated on her mother's lap and holding Christ on hers (fig. 64). This arrangement of the so-called Madonna *Selbdritt* follows a long tradition, of which an important example is a sculpture of 1512 by Andrea Sansovino that was within sight of *The Madonna of Loreto* in Sant'Agostino, where Caravaggio must have seen it repeatedly. Caravaggio's configuration, with all three figures standing, is rare but not without precedent. Presumably he was instructed by the confraternity to include Saint Anne and was shown the medal, but he rearranged the figures on his own initiative to make them more lifelike.

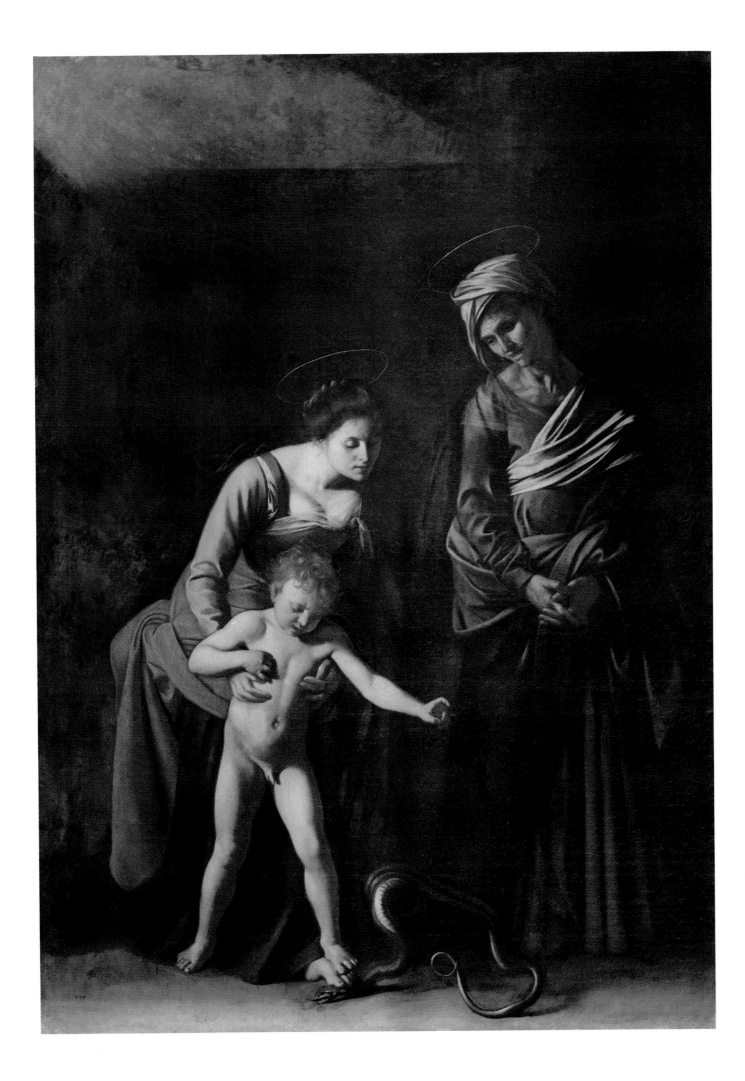

THE DEATH OF THE VIRGIN
1605–6

Oil on canvas, 12′ 1 1/2″ × 8′

Louvre, Paris

This altarpiece was painted on the commission of Laerzio Cherubini (died 1626), a pious Vatican lay bureaucrat, for his family chapel, the second on the left in the new church of Santa Maria della Scala in Trastevere in Rome. The Carmelite clergy of the church rejected it, and in April, 1607, it was purchased by the duke of Mantua on the advice of Rubens. After a week's exhibition in Rome at the request of local painters, it was shipped to Mantua. In 1627–28 it began traveling: to Charles I of England, to the banker-collector Jabach after Charles's execution, to Louis XIV, and finally in 1793 to the Louvre.

Traditionally the Transit of the Virgin, to which the chapel was dedicated, is depicted as a transcendental event—the Virgin usually makes some pious gesture, her soul is sometimes shown flying heavenward, and clouds of angels often appear. Caravaggio, freed from the burden of doctrine imposed by *The Madonna of the Snake,* presented the unrelieved sorrow of an ordinary mortal death. Mary lies on a kind of litter, a poor woman, plainly dressed and barefoot, too weak to have crossed her hands in prayer and too worn even to welcome the release of death. The same Mary Magdalene who wept in *The Entombment* huddles disconsolately beside her (see colorplate 25), and the apostles stand by, hushed and helpless. The young man kneeling must be Saint John the Beloved, and one of the grandfatherly figures Saint Peter. Otherwise, the mourners are not identifiable as specific apostles.

This anonymity consolidates them into a group of grieving friends rather than distinct personalities who might distract the viewer from concentrating on the Virgin and the inescapable fact of physical death. The focus is on her: she forms the only horizontal in the cluster of figures and is the only one who is not crowded by the rest; hers is the only body fully revealed, and her frailty and exhaustion contrast with the apostles' vitality, even though it is subdued by their grief; and only she is fully illuminated. The light, softened by the atmosphere and by the handling of the pigment, fortifies the silent solemnity of the scene.

The emotional and physical starkness of the painting is unrelieved. The room is bare, stripped not only of rhetoric but also of extraneous detail. Caravaggio allows no hint of ritual, not even the customary sacramental censer and candle, and only two touches of domesticity: the beautiful somber copper pan at the foot of the bier and the great red swag of drapery filling the space overhead.

This plainness corresponds with Oratorian teaching; Caravaggio even cast a shadow over Mary's canonically bare feet, lest the criticism of the first *Inspiration of Saint Matthew* (fig. 53) be repeated. How devastating is Mancini's description of her as a woman of the streets, and Bellori's dismissal of her sadly exhausted body as "bloated"; and how unjust. The admiration of Rubens and local painters for this masterpiece came after Caravaggio had already left Rome, too late to console him for the disappointment and humiliation of the painting's rejection. No longer displaying the sometimes brash drama of a few of his earlier church paintings, this work, with its austere dignity, large scale, numerous figures, and deeper, less compelling, space, signals the first of the monumental tragedies of his full maturity.

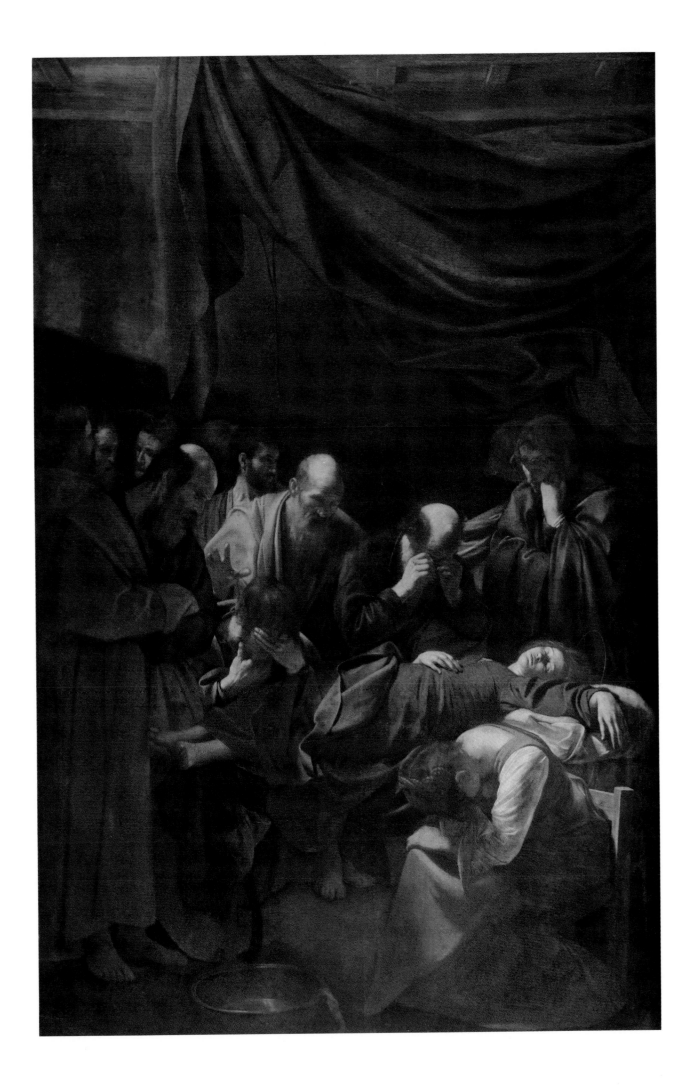

THE MADONNA OF THE ROSARY

c. 1605–7

Oil on canvas, 11' 11 1/2" × 8' 4"

Kunsthistorisches Museum, Vienna

The first documentation of this painting is a letter of September 25, 1607, from the duke of Mantua's court painter, François Pourbus, reporting from Naples that it was for sale there for four hundred ducats. The duke did not buy it. Instead the Flemish painter Louis Finson, who was in Naples from 1608 to 1612, acquired it and took it to Antwerp. There, sometime after his death in 1617, a group of painters and connoisseurs, including Rubens, bought it. By 1651 they had presented it to the Dominican church. In 1786 Emperor Joseph II took it to Vienna, where it has been ever since. Rubens's printmaker, Lucas Vorsterman, engraved it with a different donor, Antoine Triest, bishop of Ghent and Bruges.

According to Roman Catholic tradition the Madonna handed the rosary to Saint Dominic (recognizable by the star on his forehead) during a miraculous appearance in Albi. Saint Teresa of Avila described the rosary as "a chain uniting Heaven and Earth," and Caravaggio presents the subject hieratically. The Madonna, enthroned with the Child standing on her lap, points down rather imperiously to the rosaries dangling from Saint Dominic's hands. The peasants eagerly reach toward them. The hieratic stratification is made clear by the intervention of the saints—on the right Saints Thomas Aquinas and Peter Martyr balancing Saint Dominic on the left—between the Madonna and the humble but happy and polite peasants. Like them the rather austere donor kneels. His is a privileged position, his hands supporting Saint Dominic's right arm; he glances out of the picture seeking approbation. Saint Peter Martyr (the crack in his skull establishes his identity) also looks out of the picture, gesturing toward the Madonna and Child as if he were preaching, pointing out an analogy between his persecution of the Albigensian heresy and the contemporary necessity to defend the cult of the Virgin and the Rosary against heretical Protestant attack.

The composition, set in a church-like apse, is a *sacra conversazione*. Caravaggio seems to have recalled the very similar composition of Nicolo Moietta's altarpiece painted in 1521 for the church of San Bernardino in the town of Caravaggio (fig. 16). Saint Dominic is posed like Moietta's Saint Francis, the poses of the donors are similar, as are those of the two Madonnas, even in their pointing gesture. Caravaggio's hieratic structure is rather rigid, with the clerics' heads in one horizontal line and the peasants' and the donor's in another. But the painting is animated by the hand gestures and the excitement of the crowd.

Caravaggio would not have undertaken so large a painting of so artificial a subject except on commission, but it is undocumented. It must originally have been conceived for a Dominican church or patron, and carried out while Caravaggio's life was unsettled and probably when he needed money. The tight *fattura* and dry cool colors are unlike his latest Roman or his Neapolitan works; they are closer to *The Madonna of the Snake* of late 1605 (colorplate 29). This might possibly be the work reported by the agent of the duke of Modena as having been commissioned by the duke. The duke's agent quoted a price of sixty or seventy *scudi,* inadequate for so large an altarpiece, and Caravaggio may have procrastinated about finishing the painting until his flight from Rome. Perhaps he took up work on the canvas again in the Campagna, hoping that his protector there, Don Marzio Colonna, would buy it from him. Colonna, who was hard pressed financially, must have failed this expectation.

Caravaggio would have completed the painting in Naples, using the same model for the Madonna as for the London *Salome* (colorplate 33), which was certainly painted there and from a palette as neutral as that used for the saints on the right. This prolonged and interrupted process might explain the anomalies of the scale of the very large Virgin and the excessively tall saints. Probably Caravaggio sold the *Rosary* in Naples by July, 1607, when he went on to Malta. The donor portrait might be of Don Marzio, a compliment that failed to induce him to buy the picture. Or it may be the Neapolitan purchaser's.

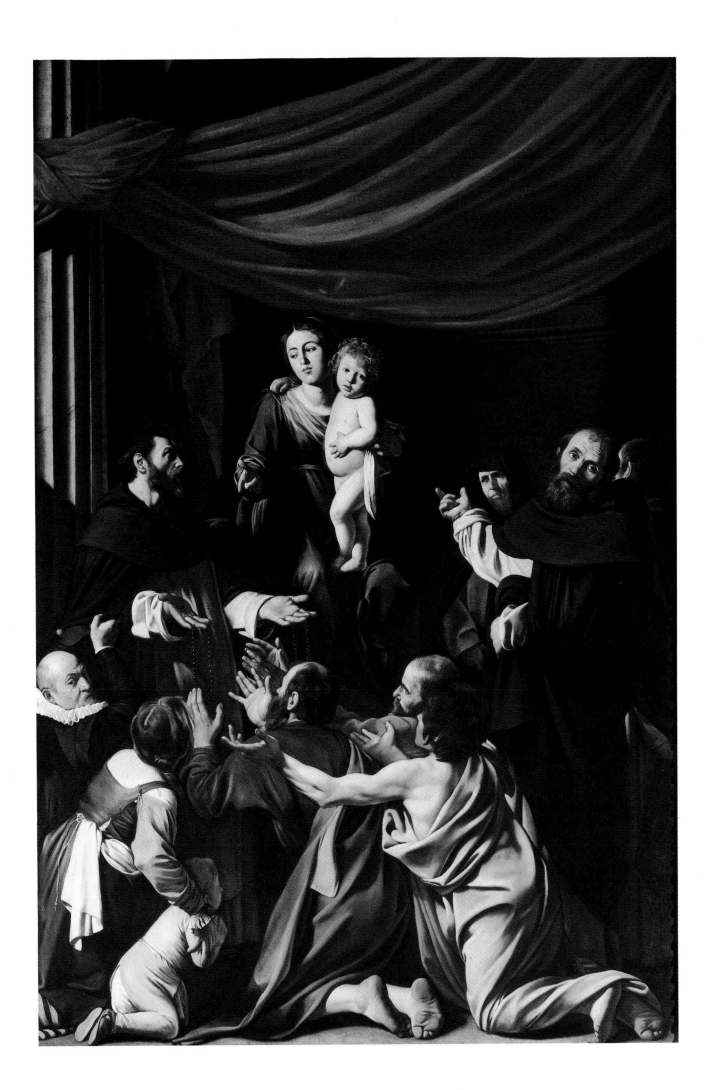

THE SEVEN ACTS OF MERCY
1606

Oil on canvas, 12' 9 1/2" × 8' 6 1/2"
Pio Monte della Misericordia, Naples

In January, 1606, Pope Paul V conceded a privileged altar to the aristocratic congregation of the Misericordia, founded in Naples five years before. Caravaggio may have been invited there for the purpose of painting the altarpiece. He carried it out rapidly, between September 23, 1606, and January 9, 1607, when he was paid four hundred ducats for it.

The requirements for the altarpiece were difficult: Caravaggio had to include both the Madonna of the Misericordia and the Acts of Mercy in a single vertical canvas. Traditionally each Act had been represented separately. The few prototypes combining all the Acts in one picture were North European and inaccessible to him, and none included the Madonna. He set the Acts described in Matthew 25: 35–36 in a little *piazza*, perhaps in front of the same Taverna del Cerriglio where three years later he was attacked. It is night, and the *padrone* is directing three men to his inn ("I was a stranger, and you welcomed me"). One is hardly visible. The second is recognizable as a pilgrim by his staff, Saint James Major's shell, and Saint Peter's crossed keys on his hat; perhaps he can be identified as Saint Roch but more likely, following the Gospel, he is Christ in disguise. The third, a young *bravo*, is Saint Martin cutting his cloak to share it with the naked beggar in the foreground ("I was naked, and you clothed me"). In the shadow behind the blade is a youth whose legs seem to be twisted ("I was sick, and you visited me"). The group of loiterers is completed by a husky man, Samson, in the desert of Lechi (Judges 15: 19), pouring water into his mouth from the jawbone of an ass ("I was thirsty, and you gave me drink"). Opposite this group, on the right, is Pero breast-feeding her aged father, Cimon, through the bars of his prison ("I was hungry, and you gave me food" and "I was in prison, and you came to me"). And in the background, a vested priest holds a torch to illuminate the hasty transport of a corpse, perhaps recalling the plagues that periodically decimated the city's population (burial of the dead, the seventh Act, not mentioned in the Gospel). Above the scene hover the Madonna and Child with two angels, as if to warrant divine acknowledgment of human charity, particularly of the protagonists in the painting, who may portray members of the confraternity.

Altogether, it is an ingenious solution to an almost insurmountably difficult pictorial problem. Caravaggio did not accomplish it without some help: Pero and Cimon had already been used in previous representations of the Acts; he based his angels on a Zuccaro composition of *The Flight to Egypt* (fig. 67); and Saint Martin's beggar recalls the famous Hellenistic *Dying Gaul*. Nor did he carry it out without some revisions: there are substantial *pentimenti* in the heavenly group and in the area around the heads of Samson and the innkeeper.

The *fattura*, particularly in the patchwork quilt of the draperies, is exceptionally summary. Seen above the flickering candlelight of the altar in the dark interior, the painting makes the church appear to have been invaded by the crowded, animated Neapolitan street squalor that must have impressed Caravaggio, newly arrived from Rome. It is no more hallucinatory than Naples itself, but a slice of the kind of life still observable outside the church in the old central-city slum of the Via dei Tribunali area. The scene is singularly appropriate to the Misericordia, dedicated to daily performance of the good works it depicts. As man struggles to do the little he can in the oppressive darkness of the world, it is an effective statement of the doctrine that deeds, like faith, are a means to salvation.

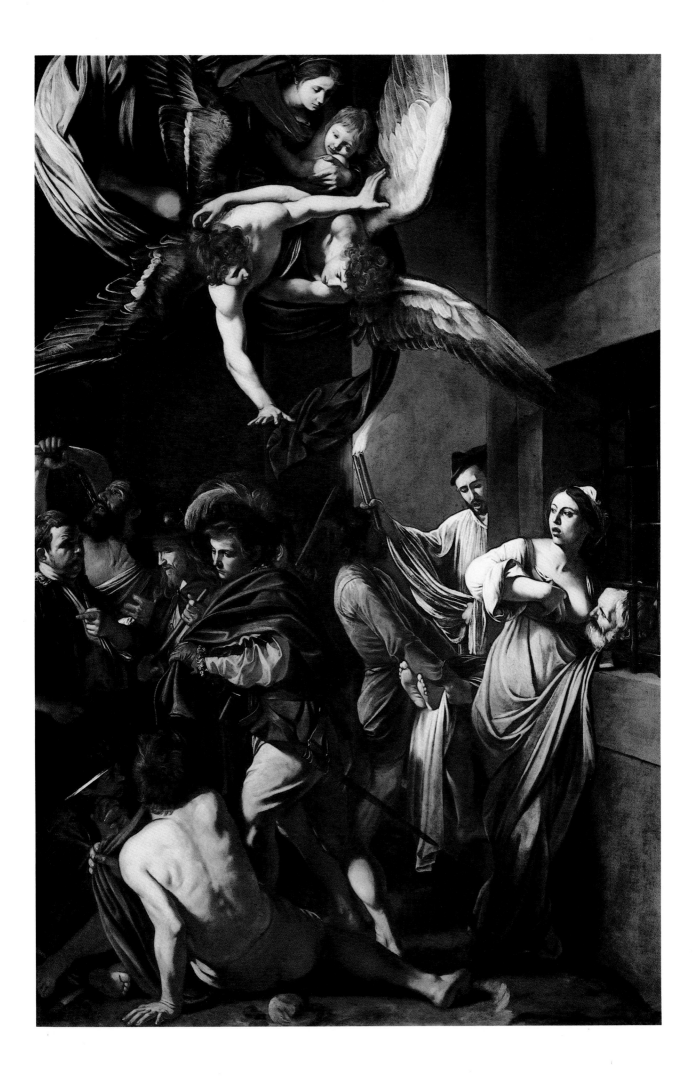

SALOME

1609–10

Oil on canvas, 35 5/8 × 65 3/4″

The National Gallery, London

Bellori mentioned a *Herodias* that Caravaggio painted for Alof de Wignancourt, no doubt as a peace offering during his second visit to Naples. Bellori's description of Saint John's head on a platter would seem to exclude this painting, although Bellori was never in Naples and probably knew of the painting only through an informant. There is no certain reference to it until 1959, when it appeared in a French private collection before entering the National Gallery in 1970. The models are familiar: Salome is the Madonna of the Rosary, and the executioner one of Christ's tormentors in *The Flagellation* (color-plates 31, 34). The draperies, which are similar to those in *The Seven Acts of Mercy* (colorplate 32), the somber black-and-white color, like the costumes of the saints in the right background of the *Rosary*, and the use of David's pose in reverse for the executioner (see colorplate 35) all correspond to Caravaggio's first stay in Naples.

It is a disturbingly matter-of-fact image. Salome is baffling; she turns away from the head as if to avoid seeing what has been done, her expression blank. Is she ashamed, or willful, or simply irresponsible? Certainly she seems unmoved. The executioner appears detached. Is he like those who do what the rich and powerful require of him, without question, but not without his own opinion? He is certainly not the sadist of *The Flagellation;* his expression hints, if anything, of David's compassion. The old woman, almost disembodied in the shadowy background, is a disengaged onlooker, a sister to the Greek chorus. She clasps her raised hands in dismay, but she feels helpless and her disavowal of the execution is as wraithlike as her presence. If their attitudes are not quite casual, Caravaggio has allowed none of them to convey any adequate sense of the magnitude of the crime that has been committed. It is a paradoxical image. What makes it most disturbing is the inconsequentiality of the responses: Salome callous, the executioner hardened, and the old woman too defeated to assert any substantial moral presence. There remains only the pathos of Saint John's pallid face, as tragic in accepting death as Goliath's is grotesque in rebelling against it.

Apparently an original composition, it is in fact only another step along a well-worn path. The motif of Salome turning away from the head exhibited before her can be traced back at least as far as Roger van der Weyden through the Titian painting then in the Salviati collection in Rome (and now in the Doria Gallery) to the Cavaliere d'Arpino's *Salome* of the 1590s. The executioner's gesture of extending the saint's head by the hair had often been used previously, although sometimes from a different angle of vision.

Caravaggio metamorphized these sources. The painting is like a movie close-up, focusing on the essential elements and excluding all others. It has turned the narrative description of the process of the martyrdom into a psychological study of its protagonists, and through them into a sad commentary on human heedlessness. Such concentration is certainly not novel in Caravaggio's *oeuvre,* but it revitalized the theme. Combined with his penetration of the personalities, it transformed the subject from a kind of fable into a disquieting actuality.

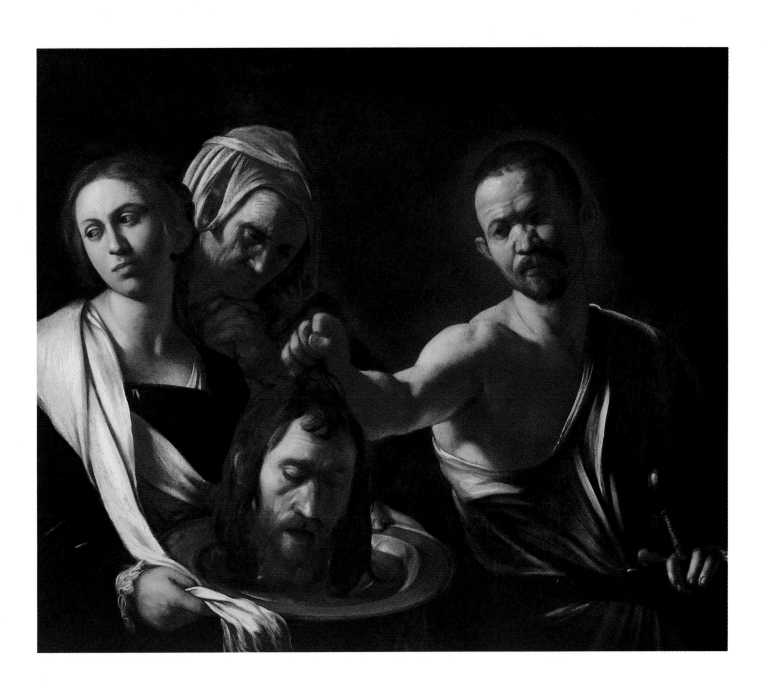

THE FLAGELLATION

1607

Oil on canvas, 9' 4 1/2" × 6' 2"

Capodimonte Museum, Naples

In May, 1607, Caravaggio was paid four hundred and forty ducats by Tommaso de'Franchis for this painting, the altarpiece of the donor's family chapel in the church of San Domenico, Naples, where it remained until 1972, when it was moved to the Capodimonte Museum.

The handling continues the fluent impasto and dense atmospheric effect of *The Death of the Virgin* and the Brera *Emmaus* (colorplate 30), and the spaciousness of the composition provides continuity between them and the great Maltese and Sicilian altarpieces. Caravaggio utilized the large scale of the canvas both to suggest a vast space overhead and to make the tormentors intimidatingly large. The shadowy repoussoir figure crouching in the left foreground serves a purpose similar to Cleophas's in the Brera painting Caravaggio increases the floor space by pushing the principal action to the middle ground. Simultaneously he relieves us from the intensity of the Cerasi Chapel paintings' impact, which would be insupportably brutal with this subject.

Caravaggio followed a well-established format in arranging the figures. The most influential precedent was Sebastiano del Piombo's *Flagellation* fresco of 1516 in San Pietro in Montorio in Rome, based on preparatory drawings by Michelangelo. Caravaggio took the fresco as his general model, and as the specific model for the pose of Christ's head, arms, and torso. Characteristically, however, he eliminated the superfluous spectators, reduced the architecture to the single central stabilizing column, and used an austere palette of warm neutrals and flesh tones. The repoussoir was an addition, but not Caravaggio's invention. Distantly derived from the ancient *Arrotino,* the figure had already made an appearance in a number of prints and paintings, most notably, more fully and much more colorfully dressed, in Alessandro del Barbiere's canvas of 1566 in the church of Santa Croce, Florence. The pose of the upper body and arms of the torturer on the left seem to have been copied exactly from the Santa Croce picture, although Christ and the man on the right, who is tightening His bonds to the column, assume different poses. From all the figures Caravaggio has taken away the lithe grace of their sixteenth-century prototypes, replacing the earlier elegant forms with the heavy brutish muscularity that in sordid reality they would be likely to have. Even Christ has become brawny.

The result of these changes has been to make *The Flagellation* convincing not merely as an idea of torture but as its sadistic actuality. The event takes place in the murky vastness of a grim dungeon. Menace fills the shadowy mass of dark figures surrounding Christ. The crouching man binding a scourge would, in himself, speak of malevolence, even without the snarling cruelty contorting the swarthy face of his companion on the left and the savagery of their gestures. Christ responds naturally, with involuntary physical reaction, His powerful physique emphasizing His helplessness and sense of degradation. He holds His head down, less in shame than to avoid the blows, and He literally writhes with His feet and body, as if struggling to escape. He is haloed; and the light, striking only Him fully, makes Him radiant, but He is suffering like any other man.

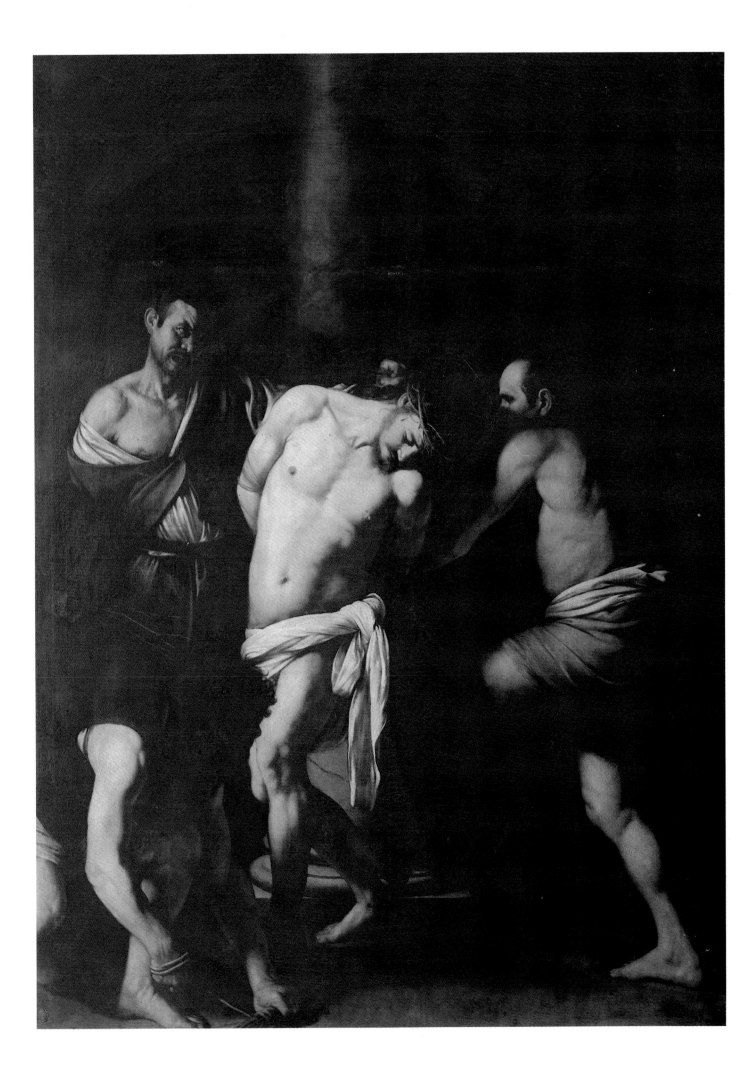

DAVID WITH THE HEAD OF GOLIATH

1607 or 1609–10

Oil on canvas, 49 1/4 × 39 3/8″

Borghese Gallery, Rome

Bellori must have been mistaken when he wrote that Caravaggio painted this picture for Cardinal Borghese because it was still in Naples during November, 1610, when two copies of it were made. It had been acquired for the Borghese collection, however, by 1613, when payment was made for its frame and Francucci dedicated four lines of poetry to it. Bellori's identification of Goliath as a self-portrait has been universally accepted, and a number of writers have looked for autobiographical implications in the image. Similar speculation has been fostered by Manilli's very doubtful identification in 1650 of the model for David as "Il Caravaggino," an apparently mythical *protégé* of the painter. Some letters partly legible on the blade of the sword have been read as H or M AC O and interpreted as meaning "Michael Angelo Caravaggio Opus," as if in self-accusation.

The date of the picture is a problem, complicated by the deterioration of the paint surface. The evidence of David's pose, reversing that of the executioner in the London *Salome* (colorplate 33), is inconclusive; the key gesture of the extended arm is as close to a pictorial cliché as Caravaggio ever came. The neutral brownish colors and the *fattura* are characteristic of the years from early 1606 to late 1608. Yet it is tempting to put the painting at the end of Caravaggio's life, and to read it as a kind of summation of his personal experience manifesting the hopelessness he might have felt just before his death. The presence of the painting in Naples in 1610 provides more objective evidence of this later date, but I incline toward the earlier one, busy as Caravaggio must have been during his first Neapolitan years.

Small wonder that Rembrandt used the image—probably known to him through a copy, perhaps the one now in the museum at Kassel—as the basis for his *Lucretia* (fig. 44). It is Caravaggio's most Rembrandtesque work, not only in the color, light, and *fattura,* and in the isolation of the figure, but also in the extraordinary characterization of David, sorrowing like some tragic elder of Rembrandt's maturity rather than triumphant, and singularly like Lucretia in his sense of inescapable fate.

Caravaggio's David assumes the pose traditional for allegories of Justice, with a sword in the right hand but with scales instead of the head in the left. The relation to Christ, who is the ultimate judge as well as savior, is evident. David may sorrow, but even in his compassion he bears the burden of the dispensation of justice firmly. Caravaggio's sardonic representation of himself as Goliath is despairing. It is a harrowing portrait, streaming blood, the forehead bruised and the eyes uncoordinated, the lingering spark of life in the left eye extinguished in the dull, unfocused, sightless, and lifeless right. The contrast of this image with the vigor of David's youth is between death and life, not only of the body but also of the soul. Caravaggio has portrayed himself as damned. But his criminal escapades and the sexual irregularity intimated in his early pictures were too banal to have in themselves inspired such a sobering image. So severe a self-judgment must have been generated by a more profound spiritual malaise, whether Oedipal or Christian in origin we can only guess.

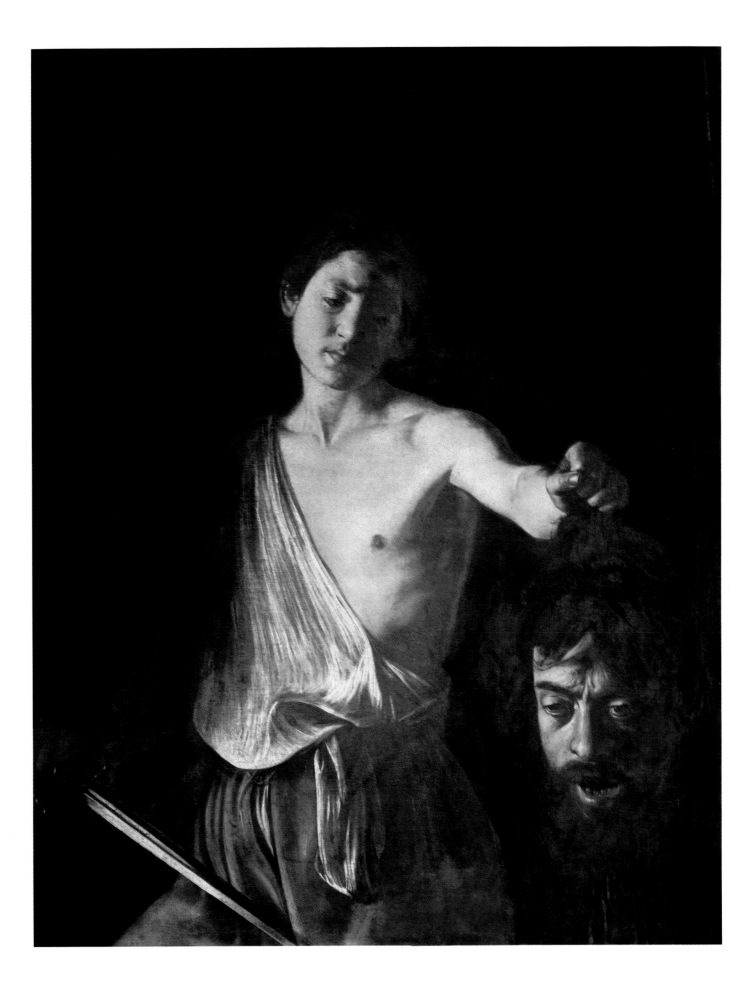

ALOF DE WIGNANCOURT,
GRAND MASTER OF THE KNIGHTS OF MALTA
1607–8

Oil on canvas, 76 3/4 × 52 3/4″

Louvre, Paris

As a reward for this portrait, Caravaggio became a knight of Malta just a year after he had arrived on the island, according to Baglione and Bellori. Three months later, he fled the island in disgrace, and perhaps the picture became intolerable to Wignancourt. Or perhaps Wignancourt took it with him when he visited France during the 1620s; by 1644, John Evelyn saw it in Paris. Purchased for the royal collection in 1670, it was in the Louvre by 1793, irreparably damaged by relining with hot irons shortly before.

These damages are particularly evident in the page-boy's hands, legs, and feet and in the background. Apart from this, there are some compositional difficulties. The helmet (the real one is still in the armory at La Valletta in Malta with the Milanese armor of about 1600) is forward of Wignancourt's left arm, and therefore the boy must be closer to us. But the position of his feet in line with Wignancourt's, in itself monotonous, contradicts the three-dimensional relation between the two figures established by the helmet. The spatial anomaly might be the result of the portrait's having been done piecemeal, the costumes from dummies or from stand-in models, separately from the heads. But another explanation seems likely.

Caravaggio may originally have intended to adhere to the standard sixteenth-century format of the warrior portrait, with the subject standing alone, as in Veronese's 1556 image of Pase Guarienti (fig. 7). Guarienti is upright, alert, and resolute, but the *contrapposto* relaxes his stand. He looms up over the low horizon line, his eyes focused on a distant view. The characterization is incisive but much attention has been lavished on the armor. Guarienti's helmet, an almost indispensable accessory, is on a pedestal beside him; Wignancourt's might have been similarly placed, on a slightly higher support.

No historical reason for the introduction of the squire is known. He was evidently gentle-born, and his blondness and fair complexion suggest that, like the Grand Master, he too may have been from Picardy, even a kinsman. If the page was an afterthought, he was probably added by Caravaggio himself. Perhaps this addition was prompted by the boy's arrival to serve the Grand Master soon after the portrait had been begun. This new format may have been inspired by one of the few but striking sixteenth-century military double portraits, such as Titian's two portraits of General Alfonso d'Avalos (see fig. 8).

This format transformed the sixteenth-century convention into an original and brilliantly effective study of character. Wignancourt, sixty-one when this portrait was painted, had been Grand Master for seven years and was an ideal subject for an official portrait, both as the commander of an independent military order and as an authoritarian ruler. Other portraits of him are less flattering: his nose was bulbous, his facial expression cantankerous, his posture less upright, and he was shorter and fatter. Caravaggio portrayed him as a middle-aged nobleman in full possession of his faculties, serious, energetic, as commanding in his personality as in his station in life, less pompous than accustomed to being obeyed. His distant gaze implies vision and intelligence as well as severity and aloofness.

The page, on the other hand, is a skinny little fellow, conscious of his privileged position but lively, bright, and curious. He has neither the discipline nor the indifference that permits his master to stand immobile and remote. So he glances out of the picture and establishes contact with the viewer. The contrast of his animation with Wignancourt's detachment has the effect of bringing his master with him into this world. Wignancourt is still symbolic, but now he is consciously so, not so much as the ideal of a commander, but as an existent leader who is aware of his power and expects lesser men to be also.

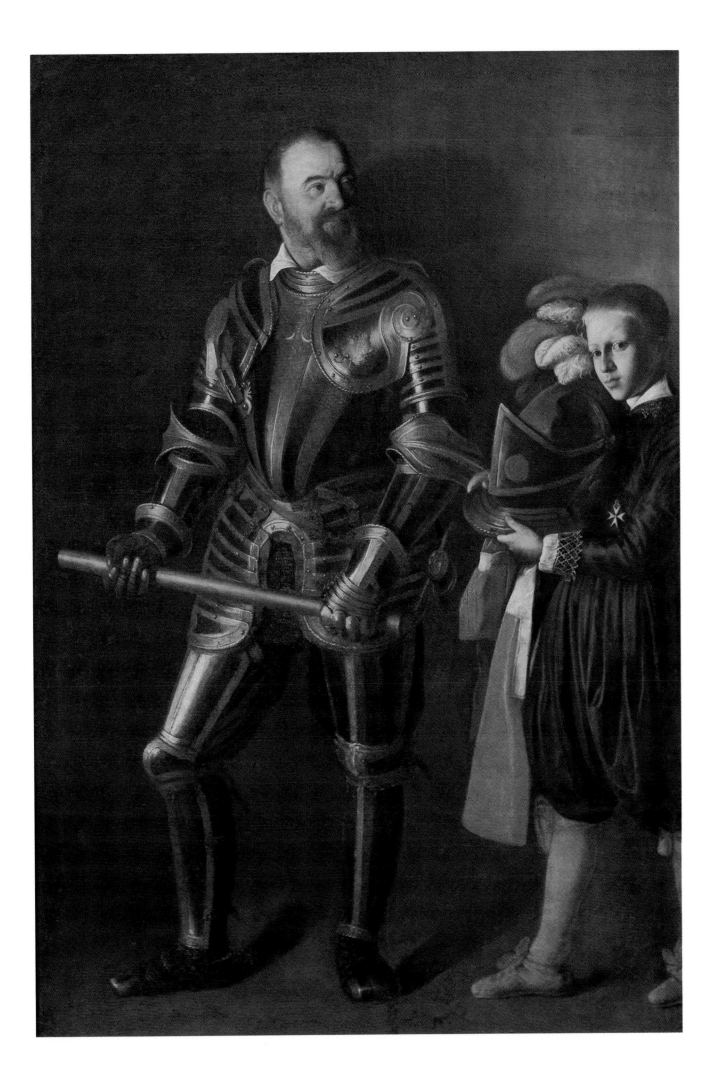

THE DECAPITATION OF SAINT JOHN THE BAPTIST
1607–8

Oil on canvas, 11' 9 1/2" × 17' 3"

Pro-Cathedral of Saint John the Baptist, La Valletta, Malta

Saint John was the patron saint of the Knights of Malta and of the cathedral, for the new oratory of which Caravaggio painted this canvas. It is his largest work, and the only one he signed—prophetically, in the blood flowing onto the pavement from the saint's neck. The Grand Master was so pleased by it, according to Bellori, that he presented Caravaggio with a gold chain, two slaves, and various other rewards; the frame bears his coat of arms. Bellori's implication that it was painted after the portrait of Wignancourt is unreliable.

The structure recalls the monumental murals that Caravaggio must have studied in Rome. No specific detail seems to be derived from them, but we can sense their reverberation—notably Raphael's Stanza della Segnatura in the combination of circular forms with horizontals, the ample space, and the integration of the figures and the building. This building is Caravaggio's most detailed architectural setting, and the only one that records an existing structure, the entrance and adjacent window in the main façade of the Grand Master's Palace (now the Armory) in La Valletta, as it was then (fig. 47)

The composition is classically simple, a large shallow space with a cluster of figures on the left balanced by a wall and a window on the right. It is held together by a series of horizontals, most obvious the base line of the wall and the line formed by the extension of the tie rod to the upper edge of the window. Caravaggio's palette was so muted, and the density of the atmosphere is so great—only the spotlight on the figures penetrates it—that the two-dimensional effect is of a single vast color field with accents placed on it.

The dramatic impact of the composition almost obliterates its effectiveness as an abstract construction. It is a silent painting, intimate despite its great scale. The focus is first on the pointing index finger of the business-like warden, who forms the single vertical axis in the figure group, directing the operation. Only secondarily can Saint John's body be found. It is over-lifesize, and the only horizontal figure. From the center of the warden's finger, the action fans out—to the executioner's left hand, holding Saint John's partially severed head in place like a butcher in an abattoir while he reaches with his right for his dagger to finish the process off neatly; to the platter, held low by Salome in anticipation of receiving the head; to the old woman. She is horrified, the only character responding sympathetically to the execution. Incredibly, she covers her *ears* rather than her eyes; are the sounds—those of the actual decapitation—worse than the sight? Or is this, like so many other gestures in Caravaggio's *oeuvre*, kinesthetic—is she making us aware that if we can see, we can also hear? Perhaps Caravaggio intended to stimulate a similar sense of projection in the poses of the two spectators, straining on our behalf as much as their own, curious to see what is happening. Finally, we must allow—or force—ourselves to look past the deadly line of the glittering blade at the pathos of Saint John's painfully bound body. A moment before he was a seeing, hearing, feeling, thinking human being like the others; now he is reduced to a mere fleshly carcass.

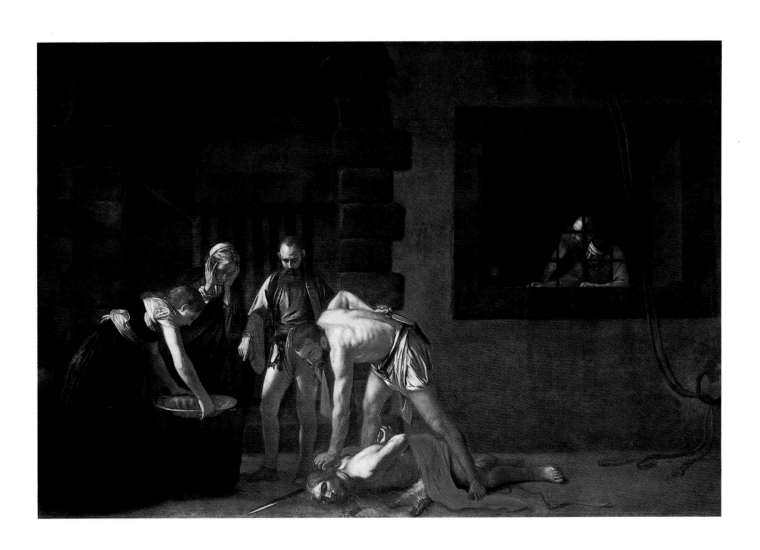

THE BURIAL OF SAINT LUCY
1608–9

Oil on canvas, 13' 4 1/2" × 9' 10"

Church of Santa Lucia, Syracuse

Caravaggio painted this altarpiece rapidly, between October, 1608, when he fled Malta, and his arrival in Messina, presumably early in 1609. The church of Santa Lucia had been abandoned and restoration just begun, so his arrival in Syracuse was timely, and the senate of the city must have commissioned the picture without delay. Its subject is rare but appropriate, for under the church is the catacomb where the Roman virgin martyr Saint Lucy was buried after her martyrdom in 304. Minniti, in addition to arranging the commission for Caravaggio, may have lent a hand in carrying it out. Time may have been short and some clumsy details that are inconceivable in Caravaggio's *oeuvre* would be unremarkable in Minniti's.

The canvas suffered severe damage in the seventeenth century. Both the bishop's head and the inept profile of the old woman in the center were repainted over holes, and old copies show a grave and some stones that have disappeared from the foreground. X-rays reveal that Lucy's head originally lay entirely severed from her body; Caravaggio must have reattached it to the body so as to accord with the legend that her throat was slit, or because it was too macabre. The only indication of her martyrdom is some cuts in her neck.

The painting, as ill-lit as it was originally, is still over the high altar of the church. But it is visible down the whole length of the nave, and Caravaggio must have considered its position in formulating his design. When it is seen from the distance of the nave, the contrast in scale between the giant grave-diggers in front of the corpse and the mourners behind disappears to produce an illusion of depth between them. Correspondingly, the illumination from the right simulates a light source from the south, corresponding to the actual orientation of the altarpiece in the church. Without this light the figures would disappear into the gloom of the painted catacomb and of the actual apse. The only hue intense enough to resist the murkiness is the red of the shawl over the shoulders of the youth standing above Saint Lucy's corpse.

This youth is a key figure. He forms a vertical contrast to the horizontal of the corpse, framed to the left and right by the gravediggers. By looking down at Saint Lucy so sympathetically, he directs attention toward her and focuses the sorrow of the pitiful little group of mourners. There are only seven of them, and three are distracted. The quiet diffidence of the other four contrasts with the powerful forms of the gravediggers, the bishop, and the soldier. The contrast is between the helpless passivity of the mourners and the empty gestures of the officials. The common people, drably clothed, mute, and ineffective, are pushed to the background, almost out of sight. But it is they who are identified with the saint, the pathetically unheroic heroine of the picture, as if in substantiation of the Beatitude, "Blessed are the meek, for they shall inherit the Earth."

The novel subject tested Caravaggio's inventiveness. He indulged in a little self-plagiarization for Saint Lucy's pose, which is that of the dying Virgin (colorplate 30). The ghosts of Botticelli's Graces seem to haunt the gestures of the youth and the woman to the left of him. And Caravaggio seems to have remembered Giulio Campi's *Burial of Saint Agatha* of 1537, in Cremona (fig. 17). Many details are different, but the compositions are similar enough to suggest that Caravaggio used Campi's *Burial* as the point of departure for the *Saint Lucy*.

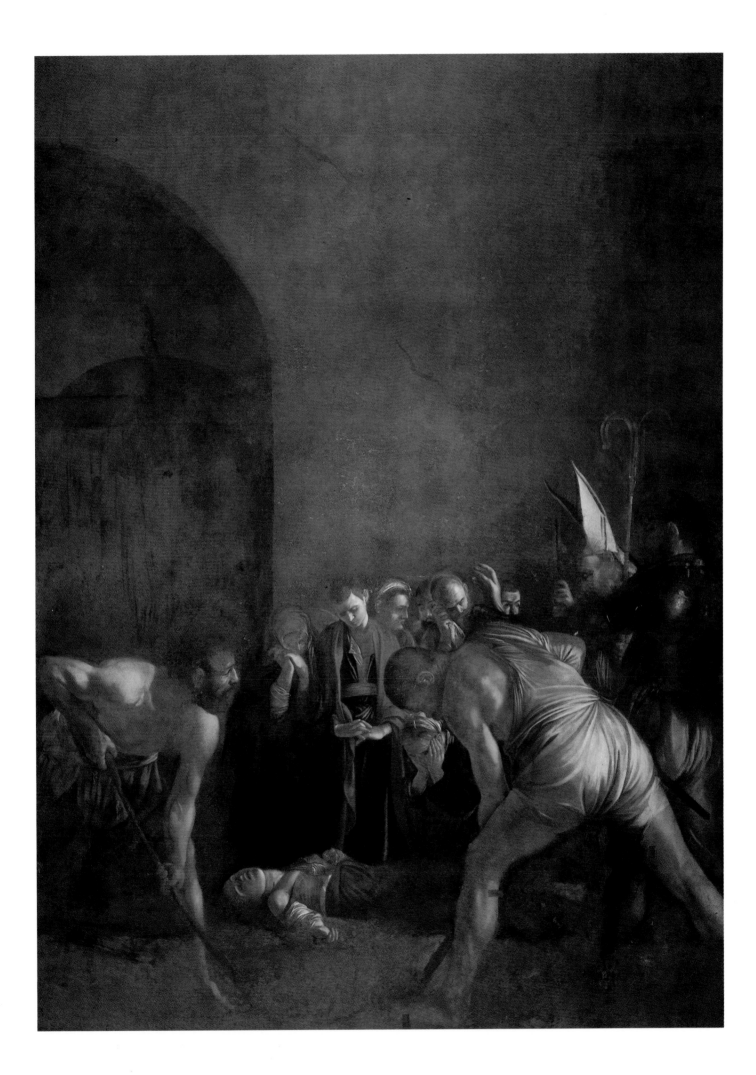

THE RESURRECTION OF LAZARUS
1609

Oil on canvas, 12' 6" × 9'

National Museum, Messina

On December 6, 1608, the Genoese merchant Giovanni Battista de' Lazzari acquired the patronage of the principal chapel of the church of the Padri Crociferi dedicated to Saints Peter and Paul in Messina, promising to provide a *Madonna with Saint John the Baptist and Other Saints* for the high altar. Perhaps Caravaggio had already arrived from Syracuse, or else he arrived soon afterward. Awarded the commission, he may have persuaded his patron to change the subject to the resurrection of Lazarus, a pun on the family name (Lazarus is Lazzaro in Italian) and more appropriate to the mission of the Order of the Crociferi, dedicated to the care of the sick. Probably Caravaggio felt more interested in the narrative and the dramatic potentiality of the alternative subject, too. He was paid one thousand *scudi* for the completed painting on June 10, 1609.

The picture is in poor condition because of oxidation of the pigments and old inept restorations. Sometime early in the painting's history, a horizontal strip of canvas about two feet high was added just below the feet, quite possibly by Caravaggio himself.

There are thirteen figures—some, according to Susinno, staff members of the Crociferi Hospital where Caravaggio did the painting—packed together intricately on a shallow ledge. Six cluster behind Christ, as if they had just entered the catacomb through the indistinct portal in the background. The others, all involved in the actual resurrection, extend frieze-like across the painting. This arrangement was in part inspired by an engraving (B. 35) by Diana Ghisi after Giulio Romano's frescoed *Battle over the Body of Patroclus* in the Palazzo del Tè in Mantua, which is derived from a Roman sarcophagus there.

Christ, His face totally in shadow and mysterious, has paused in mid-stride, His body forming the only vertical axis and His raised arm the only unbroken horizontal. Relaxed but decisive, He once again gives a languid gesture of command. Lazarus's head droops back not yet fully conscious, and his torso is inert. But he answers involuntarily, raising his right hand into the light. The miracle of this interchange would be unbearably tense without the relief provided by the ordinary natural reactions of the other figures, Lazarus's loving sisters and the incredulous, or curious, or even inattentive spectators. Caravaggio has dispensed with the traditional onlooker holding his nose against the stench of the body's corruption—a touch of fastidiousness that preserves unremitted the dignity of the scene.

Strangely enough, the two gravediggers look not at Christ but past Him, to the source of light. Is it indicative of some other supernatural presence? This detail and others such as the juxtaposition of Lazarus's left hand with the skull, and the formation of a cross by his body and arms hint at a conflation of meanings—narrative, historical, theological, and even personal. The cross may refer to that on the habit of the Padri Crociferi. But it also raises the possibility of another meaning: the still-limp left hand over the skull as representing the death of the soul wrought by sin, and the right hand reaching toward the light as suggesting man's hope for the achievement of eternal life, made possible through the sacrifice and resurrection of Christ. Lazarus's obedience to Christ then may imply both the conflict between good and evil and the possibility of human choice.

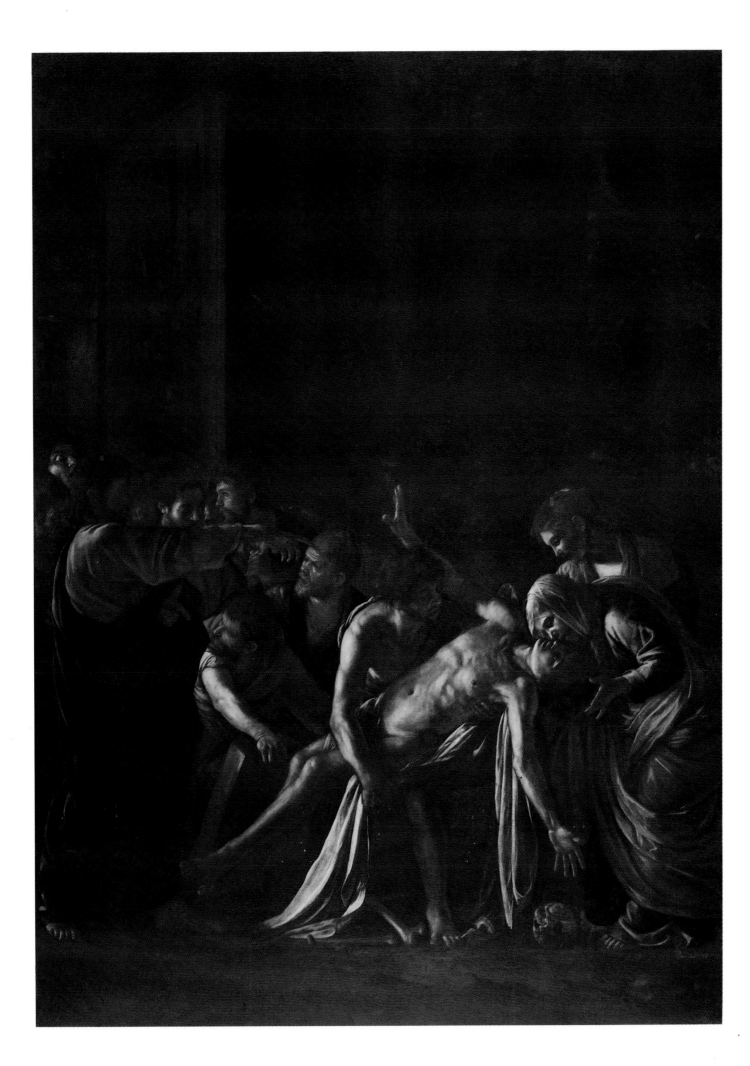

THE ADORATION OF THE SHEPHERDS

1609

Oil on canvas, 10' 3 1/2'' × 6' 11''

National Museum, Messina

According to the Messinese historians Placido Sampieri (1644) and Francesco Susinno, this painting was commissioned by the Messinese senate as the high altarpiece of the Capuchin church of Santa Maria degli Angeli. It was probably painted after *The Resurrection of Lazarus* (colorplate 39), during the late summer or early autumn of 1609, and Caravaggio was paid one thousand *scudi* for it. Susinno wrote that the picture was originally considerably taller, and was cut down by Caravaggio to fit the space over the altar. This report is unlikely, not only because Caravaggio must have known the dimensions of the space above the altar, but also because a higher canvas would be excessive in relation to its width, and the perspective effect of the roof beams would be exaggerated. The painting was moved to the museum after the devastating earthquake of 1908.

The scene is another dark interior, with a beam of light cutting across from the left, causing the figures to emerge from the general obscurity. The composition is ingenious but unobtrusive. Its effect is of restraint, tranquility, and calm immutability.

Doctrinal implications are understated. Perhaps by seating the Madonna on the ground Caravaggio was deliberately recalling the late medieval play on the Latin words "*humilitas*" (humility) and "*humus*" (earth). But the Madonna's humility speaks for itself. She is no queen of heaven, but a simple healthy young woman of the people, cuddling her baby like any other mother. Nor does anything suggest the shepherds' historical significance as the first men to recognize Christ. Only the young man in the center makes a prayerful gesture and even that is equivocal. They may be surprised to find this mother and her beautiful newborn child in this shack, but their response is to admire them rather than to venerate the Virgin and worship Christ.

No cloud of angels bursts in, no great blaze of light disturbs the tranquility, and accessories are meager and plain. The basket containing the Holy Family's simple travel necessities—a loaf of bread, a few pieces of cloth, and Joseph's carpenter's tools—is unpretentious, and its sparseness emphasizes the family's simplicity and poverty. Some theological significance might lie concealed within the other accessories, but they appear primarily as still-life details. The building is a roughly built farm shed, evidently not intended for human habitation. The traditional ox and ass seem to belong in this barn, placidly feeding from the manger.

Nonetheless, the subject, even without the halos marking Mary and Joseph, is unmistakable. Though unadorned, it lacks none of its essential earthly components. Caravaggio deliberately avoided any eloquence within it, as contradicting the homespun authenticity of the wonder at the miracle of birth. The dignity that he has recognized in these simple people in this drab setting conveys his sense of their worth, not primarily as participants in this central Christian event but as universal goodhearted common folk.

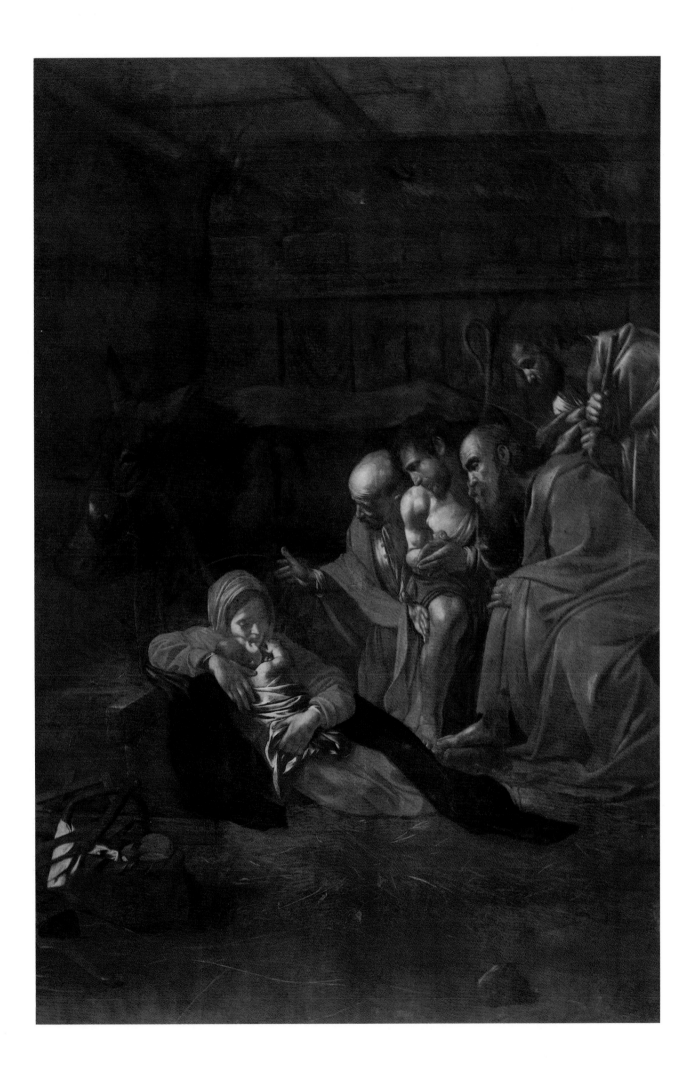

ACKNOWLEDGMENTS

I have been looking at Caravaggio's paintings and talking about him for so many years with so many colleagues, students, and friends that it would be impossible to acknowledge all the debts I owe to each of them, but I must mention particularly Bruce Davis, Howard Hibbard, Marilyn and Irving Lavin, the late Milton Lewine, and Donald Posner. Specific debts I owe to Kathleen Weil-Garris and Virginia Bonito for the *Madonna of Loreto,* to Mary Kay Duggan for Caravaggio's musical subjects, and to Dr. Giovanni Urbani and Professor and Signora Moro for the paintings restored at the Istituto Centrale del Restauro in Rome.

Gabriel Walton, Kate Flax, and Christopher Cordes typed the manuscript with patience, efficiency, and intelligence, and Karen Einaudi-Bull was indispensable in obtaining the illustrations. The staff of Harry N. Abrams, Inc., has also been consistently helpful, particularly the copy editor, Joanne Greenspun, the picture researcher, Eric Himmel, and the designer, Kenneth Windsor.

I am grateful also for the opportunity of consulting the libraries of the Istituto di Storia dell'Arte of the University of Padua, the Marciana in Venice, the Herziana and the American Academy in Rome, and the University of California Santa Barbara, and for the unfailing helpfulness of their staffs.

Just being in Italy is itself satisfying enough, but the cordiality of my friends and colleagues there made the period during which I wrote this book one of the happiest of my life, and I thank them.

Alfred Moir

PHOTOGRAPH CREDITS

The author and publisher wish to thank the museums and private collectors for permitting the reproduction of works of art in their collections. Photographs have been supplied by the owners or custodians of the works except for the following, whose courtesy is gratefully acknowledged:

Jörg P. Anders: fig. 43, colorplate 22; Archivo Fotografico, Castello Sforzesco, Milan: fig. 60; Archivo Fotografico, Musei Vaticani, Rome: fig. 65; Aurora Publishing Company: figs. 26, 45; Harry Barth, Independence, Mo.: colorplate 28; Ludovico Canali: colorplates 1, 2, 7, 8, 10, 11, 12, 13, 14, 20, 23, 25, 26, 29, 35, 38; A. C. Cooper, Ltd., London: fig. 59; Prudence Cuming Associates, Ltd., London: fig. 29; Foto Fasolo, Venice: fig. 41; Foto Rizzoli: colorplate 27; Fototeca Unione, Rome: fig. 2; Gabinetto Fotografico, Uffizi, Florence: fig. 48; Gabinettò Fotografico Nazionale, Rome: figs. 38, 51; Istituto Centrale del Restauro, Rome: figs. 21, 33, 34, 35, 52; Istituto Centrale per il Catalogo e la Documentazione, Rome: figs. 50, 62, 63, 66; R. Lalance, Meudon-la-Fôret, France: fig. 54; A. and R. Mas, Barcelona: fig. 8; Pepi Merisio, Bergamo: fig. 16; R. Pedicini, Naples: colorplate 34; Mario Perotti, Milan: figs. 6, 28; Dr. G. B. Pineider, Florence: frontispiece; Philip Pocock, New York: colorplates 39, 40; Ezio Quiresi, Cremona: fig. 17; Georges Routhier, Paris: fig. 75, colorplate 30; Service de Documentation Photographique de la Réunion des Musées Nationaux, Paris: fig. 67; Soprintendenza per i beni artistici e storici, Milan: figs. 1, 18, 19; Sotheby Parke Bernet, London: fig. 24; Staatliche Museen, East Berlin: figs. 27, 53; V. A. A. P., Moscow: colorplate 5; John Webb, London: colorplates 9, 18, 33; Joseph P. Ziolo, Paris: colorplate 37.